PROFESSIONAL TECHNIQUES for the WEDDING PHOTOGRAPHER

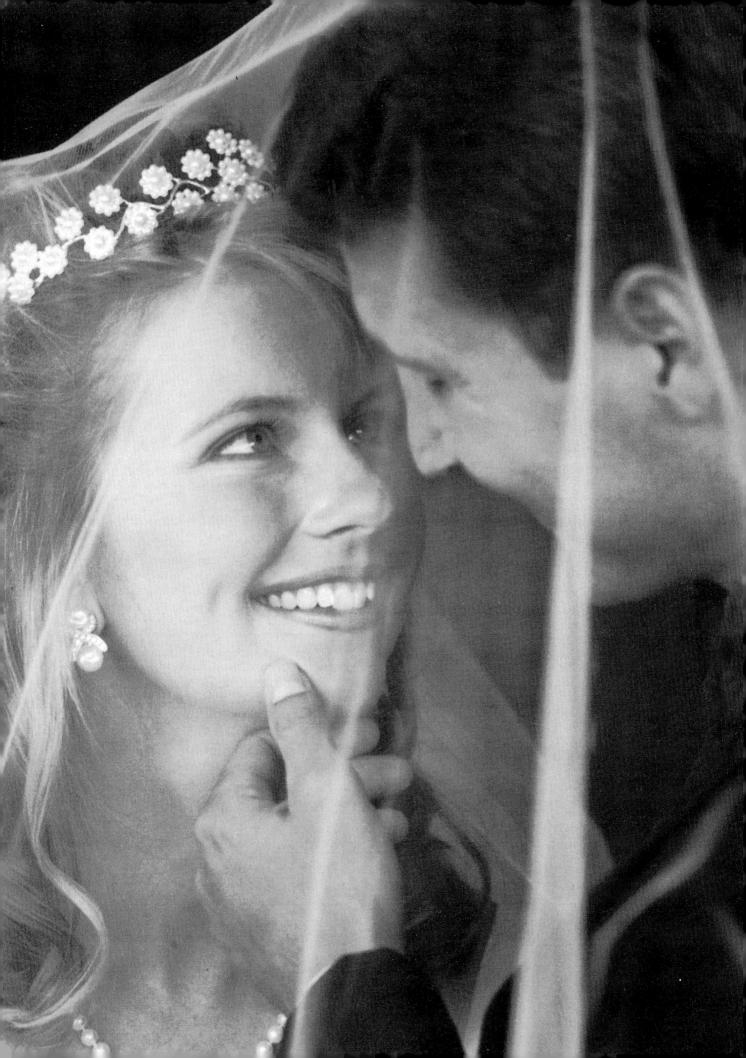

PROFESSIONAL TECHNIQUES for the WEDDING PHOTOGRAPHER

REVISED EDITION

A complete guide to lighting, posing, and taking photographs that sell

GEORGE SCHAUB

Photographs by Kenneth Sklute

AMPHOTO BOOKS

An imprint of Watson-Guptill Publications/NewYork

George Schaub is a writer/photographer whose work has appeared in many newspapers and magazines. He served as Executive Editor for *Popular Photography* magazine and as editorial director of a group of photo/imaging magazines at Cygnus Publishing, including *Studio Photography* & *Design* magazine. He is the author of twelve books on photography and digital imaging, and has been a frequent contributor to *The New York Times* Arts and Leisure section on photography. He lives in Florida.

Kenneth Sklute is an award-winning photographer and teacher and a member of the Arizona and the Phoenix Professional Photographers Associations (APPA and PPPA), and the Wedding and Portrait Photographers International (WPPI). His many awards include the Grand Award at WPPI in 1999 and APPA Photographer of the Year and Wedding Photographer of the Year in 1999. He also earned four Fuji Masterpiece Awards and a Kodak Gallery Award for Wedding Albums. He lives in Arizona.

All photographs by Kenneth Sklute. All rights to the photographs remain in the possession of Kenneth Sklute.

Text copyright © 2001 by George Schaub Photographs © 2001 Kenneth Sklute

Senior Editor: Victoria Craven Associate Editor: Elizabeth Wright Designer: Patty Fabricant

Production Manager: Hector Campbell Text set in Perpetua 11.5/11.78 First published 1985 in New York by AMPHOTO BOOKS, an imprint of Watson-Guptill Publications, a division of BPI Communications, Inc. 770 Broadway, New York, NY 10003

Library of Congress Control Number: 2001087420

All rights reserved. No part of this publication may be reproduced or used in any form or by any means—graphic, electronic, or mechanical, including photo copying, recording, taping, or information storage and retrieval systems—without written permission from the publisher.

Printed in Malaysia
First Printing, 2001
1 2 3 4 5 6 7 8 9/08 07 6 5 04 03 02 01

To my beautiful bride, Grace.

ACKNOWLEDGMENTS

My thanks go to the photographers whose stories and experience made this project possible. The community of wedding photographers is a close and sharing one. Also, thanks to Victoria Craven and Elizabeth Wright, whose editing skills and patience made this project flow. Special thanks go to Victor Avila, who opened my eyes to the beauty of this craft many years ago. Though he couldn't make the trip, he gave me a real sense of what love and thoughtfulness had to do with the whole business. I'd also like to thank my father, whom I trailed as a kid, picking up spent flashbulbs as he shot his weddings, and who later coached me on my first jobs.

Special thanks go to Ken Sklute, whose photographs adorn these pages. I have known Ken for many years and have watched him mature into a highly sought after and successful photographer. Always a gentleman, Ken spent many days choosing pictures for this project. Ken gives lectures and seminars around the country, and the care you see in his work in this book is typical of all his photographic endeavors, whether in wedding work, portraiture, or commercial assignments.

CONTENTS

Introduction	8
The Business Side of Wedding Photography	10
The Formal Portrait	20
Before the Ceremony	32
Photographing at the Ceremony: Before, During, and After	54
Environmental Portraits	88
At the Reception	104
Completing the Sale	128
Equipment	136
Index	142

INTRODUCTION

INCE THE FIRST EDITION OF THIS book was published in 1985, much has changed and much has remained the same in the wedding photography business. This completely revised edition offers updated information on what has changed and a look at what has endured. The wedding photographer of the 21st century has an entirely new set of tools both for photographing weddings and for handling the myriad business tasks that are so much a part of this profession. The photographic approach has also changed, although classic wedding photographs and the "script" that tells the event's story remain virtually unchanged.

Wedding photography is still a fascinating profession. To an outsider, each wedding may look the same, but the seasoned wedding photographer knows better. During the course of their work, wedding photographers encounter every type of nuptial ritual—from Christian to Jewish to Buddhist to New Age—and enough characters and situations to fill a book. Every wedding photographer has stories to tell that range from the sublime to the ridiculous about situations ranging from high comedy to genuinely emotion-filled moments. This is still a people business, and the maxim holds true that people who like people will have a decided advantage in this craft.

Wedding photography is hard work. The demands made during the course of the day—and into the night—can be exhausting. Yet with all that labor comes reward and the knowledge that as the photographer, you've shared in one of the most intimate and touching events in two people's lives. How you approach this shared time and the way you apply your skills as an artist/photographer will often make the difference between a mechanical and ultimately tedious experience and one that is emotionally and financially rewarding. Your approach will also make the difference between your ultimate success or failure in this business.

If you come away from this book with nothing else, I hope that you depart with this attitude, essential to every successful wedding photographer: Your job is not just to make documents of the day's events, but also to interpret those people and events and to make images that show the caring and love the couple and their family share.

Ultimately, that's what you're hired for—your eye, your compassion, and your ability to render them in images—and why you'll be sought after by others who see something special in your work.

It's true that many wedding jobs are run according to a script, just as many weddings themselves follow a set schedule of phases and events. It's also true that every job is different, and every couple and family you work with has a unique story. Every wedding means new people to meet, new stories to tell, and new challenges to face. If you see every job as the same old routine, you'll get bored and your pictures will become boring. Feeling nervous before a job is a good sign. That energy can be translated to an awareness and enthusiasm that will help you throughout the day.

Some people feel that wedding photography is simple, a rote exercise in photographing couples kissing, the wedding dance and other setup images. Nothing could be further from the truth. In the course of the events, the wedding photographer will be involved with formal portraiture, design, fashion, glamour, group portraiture, photojournalism and even architectural photography. Knowledge of lighting, both broad and sublime, and film and equipment is key. As much as technical skills are important, people skills are also essential. The photographer becomes director, bridal consultant and, unfortunately, even referee. Because of the diverse nature of these tasks, wedding photography is an excellent field for learning and practicing all your imaging and people skills.

As those who have engaged in some wedding work know, the actual photographing of a wedding can be a pressured situation. In most instances, there is simply no chance to get a second shot of certain scenes. That means you should get to know your equipment and always have a backup camera body, flash and cords. Also, time is a major factor and efficiency is of the utmost importance. The photographer must fit into the schedule of the day and not interfere with any aspect of the occasion. That means you might have to do a large group portrait in three minutes, or shoot a series of candid but elegant portraits of couple after couple between dinner courses. Within this pressured framework a photographer has to watch for details, work quickly and, most of all, care.

The real task of the wedding photographer involves responsibility—for portraying emotion through pictures and simultaneously telling a story about the wedding day. This doesn't mean relying on clichés or forcing people into unnatural positions or awkward poses. Rather, it's about taking what is natural to people and refining that with a few simple rules of color, composition and balance.

There's no one "style" that is right for everyone, no one pose that fits a situation every time. That's where timing, instinct, consistency and the understanding that every

part of a photograph has a reason to exist come into play. Clarity and understanding separate the wedding photographer from the snapshooter and are why couples still hire professionals to photograph their weddings. Modern cameras available to anyone with the right budget can make photography a much easier task than it was in the past. The wedding photographer's eye, instincts and attention to detail make the difference.

Throughout this book, in text and illustration, this "seeing," and the ability to refine what exists will be emphasized. I hope that the ability to "see" is successfully communicated, and that it will become a part of your photography. Light, composition and posing are essential elements in your work and will make the difference between creative, interpretive images and artificial, stilted poses.

While technique is essential in successful wedding photography, intuition carries equal weight. The attitude of the photographer influences the feelings communicated in the images, just as the people's attitude towards the photographer when he takes their picture can enhance its results. This sensitivity can enhance your ability to bring out the love between and beauty of your subjects.

That love is there, especially on the wedding day. That beauty exists, as people will be dressed in their finest. Projecting encouragement and good feelings will change the quality of your photographs and the way you approach the work. In this way, wedding photography becomes more than just a job—it turns into a special kind of sharing and can be a very moving experience. This concept is difficult to teach, but my experience has shown that it works.

New photographic materials—especially black and white coverage and high speed films—have expanded the wedding photographer's ability to provide even more intimate views of that special day, and wedding "photojournalism" has become an exciting new form of expression. Perhaps the most profound change has been in the way the Internet and electronic processing and proofing have affected the business side of the craft—from prospecting clients to print finishing and even album arrangement.

Even with the best of feelings and intentions and a highly honed technical skill, no one can make it in this field without taking care of business. Many photographers consider themselves artistsrightly so—but may not pay enough attention to the often hard realities of running a business. Failure to consider time and materials and the hard work both before and after the actual wedding will eventually become a real problem. As artists/photographers, many people find selling a difficult experience, but the fact remains that if you can't come to an agreement with someone on what's to be

done and for how much money, you'll never shoot a single wedding. Although high-pressure selling tactics are unnecessary and often inappropriate, selling is an important aspect of successful wedding photography.

Along with skill in organizing financial matters, a wedding photographer must have an accurate way to store, file and retrieve images as well as a way to create and present albums and additional prints. In short, the entire methodology of running a business must be carefully planned before even the first job is booked. Although each person will solve this in his/her own way, the issues of contracts, collections, bookings, prospecting and completing the order must be run as a real business. My emphasis on practical matters comes from knowing more than a few wedding photographers who made wonderful images but were poor business people and consequently left the trade.

In this book, I present the wedding photographer as an entrepreneur/artist whose work covers virtually every aspect of photography, and who has the rare opportunity to share very intimate moments in other people's lives. This book emphasizes the importance of technical, financial, emotional, and practical matters in the field. I hope that the book will function as a guide in these matters, and that it will provide information to help you create beautiful pictures and prosper in your wedding photography business.

George Schaub Sea Cliff, NY September, 2000

THE BUSINESS SIDE OF WEDDING PHOTOGRAPHY

HE WEDDING PHOTOGRAPHY BUSIness is very competitive, particularly because of the great number of weekend warriors, freelancers and established studios that go after this lucrative mar-

ket. Whatever category you fit into—whether you're someone who wants to supplement your income by doing weddings on weekends, or a commercial or stock photographer who wants to apply your knowledge to photographing weddings, or the owner or part-owner of an established studio doing weddings and events photography on a regular basis, you'll have to deal with the photography of weddings as a business.

Getting involved with wedding photography requires a substantial investment of time, money and focused energy. It's *not* the type of work you can just show up for—you'll probably spend a lot of time going out and booking jobs. Even before you shoot your first wedding, you'll need samples of your work to show (your "book" or portfolio), a prepared price list, a printed contract, and a realistic sense of the kind of images the client wants. This chapter deals with how to go about getting jobs initially and how to get more and more work as time goes on.

The Internet

BEFORE WE DISCUSS CONTRACTS, sales, ways to build your portfolio, and other important matters, let's start our discussion with the Internet and its profound impact on the wedding business. The Internet has become a way to prospect clients and show work and is also becoming more important in print ordering, finishing and even album arrangement. We'll discuss Internet prospecting and presentations in this chapter and continue the discussion in the "Completing the Sale" chapter at the end of the book. While many photographers continue to handle these matters in more traditional ways, there's no doubt that the Internet has had a profound impact on this business.

Prospecting. Nothing will ever replace face-to-face selling. It's the time when you and your clients get to know each other and when that magic chemistry that adds to the wedding day starts to work. And there's nothing that beats word of mouth—the personal recommendations of clients you've successfully served. Increasingly, however, photographers get the ball rolling by prospecting for clients via the Internet. Internet sites range from those created and placed by a pho-

tographer with an Internet Service Provider (ISP), those that represent a group of photographers from one region or association, and those that are part of a more comprehensive, established wedding planning site.

To check out some of these sites, go to any Web search engine and type in "wedding photography." While sites come and go and often change, here are some good ones that were operating when this book went to press:

weddingspot.com—regional wedding planning; includes links to photographers' sites.

theknot.com—a wedding-planning site (gift registry, limos, florists, etc.) that links to the Wedding Photographer's Network site—wpn@wedphotonet.com. As of this writing, the WPN site offered site creation for under \$300, and site hosting for \$25 a month.

sfweddingphoto.com—a great site that lists member photographers with click-on albums and images. Click on an individual image and it comes up full screen.

thephotogroup-hawaii.com—another regional site representing a group of photographers; uses motion graphics.

weddingweb.com—as of this writing, featured a list of photographers but no images.

my-wedding-album.com—posts albums for photographers.

dinostudio.com—an excellent single studio site that posts wedding shots by client name. This allows guests and those who could not attend the event to view a good sampling of images.

Most of these sites allow the user to click on a photographer's name for contact information or link directly with their Website or e-mail connection. The Web presence will continue growing, and more and more of these sites will be available as time goes by. These virtual "Yellow Pages" enable photographers to create an interactive environment that emulates a sit-down portfolio-viewing. While no one can say that not having a Web page will hurt your business, there's growing evidence that it certainly increases and expands business.

If you are interested in having your own Web page, you can create it yourself using page-building software or by using the services of a Web designer. Often, Web designers aid in site hosting and getting a domain name (Web address) as well. How much time and technological experience you have will help you make this decision.

One such service is available from Marathon Internet Services (www.marathonpress.com). Prices quoted here are current as of press time—they may change, as may the packages mentioned. These sites include a main page, an introduction to the viewer, a directory to other pages on the site, as well as a log and single image. The gallery page allows you to display up to 16 of your best images (additional gallery pages are available). The contact page allows for instant email access. An information page contains your logo, a pricing page, an area for information on specials and updates, an awards page and a guest book. Packages as of this writing range from \$265 to \$695 for the site creation, with more gallery and information pages available at the higher price. There are options that allow you to add more gallery and information pages as desired. The company walks you through the process and offers a number of design options.

If you use Marathon's services to host the page, Image Updates are included in the package; these allow you to change Gallery selections, provide free WPN listings on the knot.com, and online session proofing for uploading customer images for inspection. There are fees for hosting the site (including a monthly charge), registration and setup of your domain name (your Internet address), and various other setup fees. This is your Internet rent.

It's worth mentioning that there are two ways to go with a Web site: "virtual hosting," which means that your Web address will be www.yourname.com. or "non-virtual hosting," where your Web address is your address followed by your name, i.e., www.studio411.com/yourname. The latter is about half as expensive as the former, and is the best choice. Usually, people will type in your name with ".com" to find your Web page. A non-virtual domain means they will have to know the exact Web address you've chosen in order to find your site.

Another way to prospect is to have samples available for viewing. In the past, prospective clients would have to come to your studio to see your work. Now you can accomplish this through your Web page or with a promotional CD-ROM. A number of companies, including Marathon Press, can make CD-ROMs for you. As of this writing, the price is about \$500 for 48 images including design and backgrounds. Dupes of the master CD-ROM are about \$4 each for 250 and less than a \$1 each for quantities over 2000.

Now that we've covered some of the ways you can use the Web to build your business, let's get back to basics for those just starting out.

Getting Started

FORTUNATELY FOR NOVICES, an active apprenticeship program still exists in the field of wedding photography. Most photographers and studios that do weddings are in constant need of assistants to accompany photographers and handle lights, change film and help with the day's other myriad tasks. Eventually, an assistant can handle candids and entire jobs. Assisting is an excellent way to begin learning the trade and determine if you're interested in doing weddings solo.

If you decide to be an assistant, don't hesitate to work for more than one photographer—by working with a variety of people you'll get a feel for the approach and style of many different eyes and sensitivities. You'll also get real-world training with various types of cameras and lights, which will aid you in making purchasing decisions once you go out on your own. Although the pay may be low, assisting remains the best way to get hands-on experience.

Building a Sample Book. No one has been able to talk a great photograph into existence yet. That's the reason people looking for a wedding photographer usually want to see samples of his or her work.

You may have dozens of great travel photos and even an image that made the front page of a newspaper, but if you don't have photographs you've done at a wedding, or portraits of a bride, it's less likely you'll convince anyone that you're the best person to do the wedding. Once you get rolling in business, you can add the best images from each job to your portfolio. You can then use those samples as calling cards for other jobs, sales tools, Web pages and studio decor that will help you sell extra prints and enlargements.

Initially, however, you may have to do a lot of scrambling to build your sample book. If you're assisting, you might ask for copies of the prints you shot as candids. Some photographers might be hesitant to give you permission, but you might be able to trade some of your labor time for admittance to the wedding "theater" and the freedom to shoot on your own for a specified period of time. Virtually every photographer working weddings today began as an assistant, so many will understand and help you build your own career.

Another way to build your portfolio is to take your camera with you to every wedding to which you're invited and begin to shoot photographs like the ones you see in this book. If you do this, always ask the photographer working the job first, and don't intrude on his or her posed photographs. You'll appreciate this courtesy later when you're the one working the wedding.

If you don't get invited to many weddings, but you want to shoot samples with professional equipment on your own time, ask some friends to be models. Rent or borrow a tux and bridal gown and spend a day photographing. Follow the poses and lighting diagrams in this book and do formal shots in a house, candid shots in a park and even compose photographs using a church exterior. (Again, ask permission before photographing.) You might also have an opportunity to add to your portfolio by attending bridal shows or workshops given by professional wedding photographers. The Professional Photographers of America and the Wedding and Portrait Photographers International, (WPPI), sponsor these workshops in local communities and at their national conventions.

The idea is to build a portfolio that sells the fact that you know what to do when the bride and groom are in front of your lens. Remember that nothing sells your ability more than your actual wedding pictures. You may have the most professional Website, the smoothest sales pitch, embossed business cards and even a slick-looking studio, but you won't get the business if the pictures don't work.

Presentation. If you've seen how commercial photographers display their work, you know that you can't get away with pulling your images from a shoebox. Many of these photographers use handsome cases and even embossed portfolio boxes to showcase their talents. Of course, what's inside is what makes the sale, but there's no denying that presentation is a part of merchandising. Wedding photographs can be shown in any number of ways, from Web pages on the Internet to CD-ROMs that you or an outside source produce or, in the case of face-to-face selling, in an actual wedding album and with framed pieces on an easel or wall. Your presentation adds to your image as a professional and gets the client thinking about different ways that they might want to purchase your work.

When putting sample albums together, use a range of quality—from budget to luxury albums. You'll soon learn what your market will bear and find albums that suit everyone's budget. Send away for samples and literature from album companies. (See "Completing the Sale," page 128.)

If you have a studio or a place in your home where you can receive clients, make enlargements of the best of your samples. Have them professionally framed and hang them with good lighting. Some photographers use metal sectional frames for their work—wedding work is usually framed in a more traditional, painterly way in various moldings. One or two modern framing styles, a texturized print or two, and showing computer montages will add spice to your photo decor wall.

Having decor prints as samples shows your clients that you know how to handle and respect a treasured image and gets them thinking about enlargements for their own homes. In the case of sample enlargements and wedding albums, your samples show your ability and function as sales tools. Keep in mind that promoting opportunities for sales should be a continuing thread throughout your relationship with clients. Rather than constantly talking sales, sales, sales, you can be more subtle by surrounding your client with product and merchandising it in an attractive way. From there, the closing of sales will be simple and may even spring from clients' requests rather than from your push.

Formulating Price Lists

BEFORE YOU EVEN MAKE YOUR FIRST SALES CALL or place an advertisement for your services, you've got to get your price list in order. You can't hesitate when responding to an inquiry or make up different prices for each client. People shop for photographers and talk with one another—a consistent approach is a professional approach. Pricing is an individual matter and depends on many factors, including your level of experience, your expectations and, most importantly, what the market will bear. Here are some matters to keep in mind when formulating your prices.

Estimating Costs. The net cost (your expenses) for shooting a wedding includes much more than your time. Add in film, processing, batteries, assistants, albums, enlargements, travel, dry cleaning, insurance, studio overhead—any jobrelated expenses. You also need to consider your hourly wage for the work. You must also decide whether all the work before and after the job—sorting through images, creating suggested album arrangements, selling time—rates the same hourly scale. If you hire office assistants for scheduling and organizing jobs, add that to your costs.

You should factor in anywhere from six to eight hours, including prep time, for the average job, and about the same for finishing the sale and preparing images for final presentation.

Components. You have a number of ways to structure your price list. You can go with a package or an a la carte version. Generally, a package deal consists of one 8x10 print album with X number of prints, two 4x5 or 5x7 albums with X number of prints (known as parent albums), a set number of "thank yous" (wallets of one favorite pose and binders), and perhaps an enlargement or two. Framing may be optional.

Packages should be worked out so that you have a set profit margin. Very few photographers allow variations from the package, so they know just where they stand. Of course, extra prints and enlargements should be sold over and above the package, usually at a healthy profit margin.

The purpose of the package deal is to bring in clients at what they will consider a fair and reasonable price with the hopes of selling extra prints to them later. In a sense, a package guarantees a photographer a "minimum" for the work.

Another method is to work on an a la carte basis. With this approach, an hourly shooting fee, and expenses like film, processing and travel are charged, and the photographer

How Much is Your Time Worth?

Too often, wedding photographers don't make the effort required to calculate all their costs and end up working for less than they should. They add up film and processing costs, subtract those from their package price and figure that what remains is their profit.

Anyone who keeps his or her own books can tell you differently. You have to include taxes, insurance, depreciation on equipment, as well as overhead on everything from the telephone to rent to the electricity you use to keep your strobes charged. Even with all these costs factored in, many wedding photographers fail to take the hard work of the actual job into consideration.

How much is your time worth? As much as a skilled plumber or auto mechanic's? How much training and investment brought you to the point to allow you to provide a professional service? How much do photographers you study with or admire charge? Give all this some thought when quoting prices on your next wedding.

makes out on that basis regardless of the subsequent order. Each additional item, such as albums, enlargements, thank yous, and so forth is billed on an individual basis.

While this may seem less expensive to clients, it actually costs them more in the long run than a package deal for the same services. It does, however, give clients the freedom to customize their menu of options and seems popular with those who don't want traditional "coverage" or print presentations. They may indeed stay with the minimum, so be sure to cover yourself with that base shooting fee.

A la carte is just an option, and is usually offered as such near the bottom of the wedding photographer's price and services list. Some photographers refuse to work this way at all. You may want to consider this option, however, as you begin your career.

Competition. You should know what your peers are charging for their work, but this should not be the sole determinant for your prices. If you live in an area where most of the photographers charge \$750 for a basic package, and you come in asking for \$1500 you may get less work than the competition. If you're really twice as good as the competition, though, you'll get work, probably more work than you can handle.

Some might want to try to catch every fish in the pond by dynamiting the water with low prices and special deals, but you might decide to focus on the high end market. In wedding photography, people get what they pay for and what they charge for. Low-ball pricing will attract a certain type of clientele. Base your prices on your needs, your attitude about yourself and the type of clientele you want to attract. Of course, not everyone can afford what you would ideally charge. Make your decisions about packages and a la carte pricing on a client-by-client basis.

Keep in mind that it's easier to start a little high and adjust to the market and the clientele later than it is to raise your fees once you've established a reputation as a budget photographer. In most cases, the market will let you know if you're way out of bounds.

Keep in mind that the final sales should, and often do equal about double the original package price. The extra sales come from enlargements, framing, overtime, special albums and prints. These sales are not guaranteed, but usually work out that way.

Final words about pricing—once you've set a fee and policy, stick with them. Many people shop photographers, and they won't hesitate to quote your competition's prices to you. They may promise you big enlargement sales, their second daughter's wedding, or the moon, but my experience has shown that the bigger the promise of greater things to come, the smaller the delivery. Just remember that your prices should be determined by the way you work, not by your customers' purse strings and their estimates of what a wedding photographer is worth. People may even walk out of your studio as a bargaining tactic. Be wise about pricing, be firm with your clients and be confident that you are worth every penny you charge.

The Contract

BECAUSE A CONTRACT IS ESSENTIAL, you must have one prepared before the first client walks through your door. A contract is an agreement that spells out the work terms, dollar amounts and fee schedule, and limits on your liability. You can make up a simple or an elaborate contract, one with scrollwork or one printed from a word processor, but you must have a signed agreement before you even think about taking the first picture. In essence, you are spelling out rights and obligations, a guarantee that you'll get paid, and the extent of your liability if something goes wrong.

Stipulations. A contract should have the stipulations that follow. (A sample wedding order agreement is included in this chapter; feel free to use and adapt it when making up your own.)

- Work Order: The who, what, where, and when of the wedding, including service and reception.
- · Copyright Protection: You own the copyright for all the pictures you take, including negatives, proofs, samples and even novelty event images. Never sign what's known as a "work-for-hire" agreement on a wedding job, unless you get a hefty extra fee for surrendering those valuable negatives. Your copyright should also extend to electronic images and their reproduction, especially if you are going to post the images on a Web page. (See "Completing the Sale" for more information.) Once you have copyright protection, you have some assurance that the client will come back to you for those profitable extra prints and enlargements. If a client brings the proofs to a lab or copy shop to make prints on his/her own, and the lab or copy shop complies, both are guilty of violating your copyright. Put a copyright notice on the back of all prints and watermark your digital proofs (more on that later). Of course you can't police copying done in the home (the proliferation of desktop home scanners is a problem) or on the sly by unscrupulous shops, but you can at least make the clients aware that, legally, they need to come to you for prints from the wedding.
- Liability Release: This should cover everything from someone tripping over your light cord on the job to the lab mangling film. You also should strongly consider having your own business insurance for these matters. Check with an insurance agent or with associations such as the Professional Photographers of America on policies. The lost film clause is also important. Although professional labs take the utmost care with film, there may be a day (and if you're in this business long enough there will be a day) when you walk into your photo lab and are greeted with a look of dismay on the manager's face. Or you may get the dreaded phone call. You may want to have insurance against such awful moments, at least a policy that covers rental of tuxes and gown and baking a new cake. Many shots from the wedding day, however, can never be recreated. If film is

SAMPLE FORMAT FOR WEDDING CONTRACT

AGREEMENT FOR WEDDING PHOTOGRAPHY

	Wedding Date
Bride's Name	Phone
Address	
Groom's Name	Phone
Address	
Address After Wedding	
1. This constitutes an order for wedding photographs a understood that any and all proofs, sample prints and photographer,, and they ror any purpose thought proper by	negatives remain the property of the nay be used for advertising, display
2. Although all care will be taken with the negatives ar wedding, photographer limits any liability for loss, damany reason to return of all deposits made.	
3. It is understood that no other photographer, amateu photograph at the wedding while photographer and that any breach of this agreement will constitute a job with no liability to photographer by signing party.	is working, a reason for non-completion of the
4. Upon signature, photographeragreed upon, and will not make other reservations for all deposits are non-refundable, even if date is changed reason.	that time and date. For this reason,
5. With packages, a deposit of 1/3rd is due at signing paid two weeks prior to wedding and the remainder to photography.	
All terms of this agreement are understood and agreed	d upon.
Signature of Photographer	
Signature of Contracting Party	
Address	
	date

CONTRACT

* · · · · · · · · · · · · · · · · · · ·
Time
Time
Matron of honor
ease check off those you desire, plus fill in any
e the photographer in making pictures.
Determined the common and the committee
Between the ceremony and the reception: Outdoor shots of bride and groom
☐ Outdoor shots of wedding party
☐ Shots of groom and best man ☐ and ushers
☐ Shots of bride and maid of honor ☐ bridesmaids
Suggested location for outdoor shots
At the reception:
☐ Receiving line
☐ Wedding cake (prior to being cut)
☐ Guests signing book
☐ Introduction of the wedding party
Wedding party toasting bride and groom
☐ Closeup of bride and groom toasting
☐ Dances: Bride and father ☐ Groom and mother
☐ First dance
☐ Bride showing rings to bridesmaids
☐ General dancing shots
☐ Candids of wedding party
☐ Flower girl and ringbearer together
☐ ☐ Group family portraits (please be specific)
☐ Table shots (done on a sales-guaranteed basis only)
☐ Bride throwing bouquet
☐ Groom and garter
☐ Cutting the cake
☐ Bride and groom feeding cake to one another
☐ Bride and groom's hands with rings and flowers
Special Requests

lost, be prepared to negotiate with your lab as well. In fact, you may want to discuss a lab's policy before you adopt them as your photofinishing partner.

- Exclusivity Clause: This bars any other photographer (professional or guest) from taking pictures while you are working. Aside from ridding yourself of potential nuisance, this assures that none of your posed photographs will be snapped by an uncle, thus depriving you of a possible sale. Of course, this doesn't mean that you'll bar anyone from making pictures. It just gives you the ability to ask someone to stop intruding on your work and to make sure that no one starts shooting flash pictures while you're setting up your slave lights.
- Payment Clause: This should spell out the order and manner of payment. It should also include the fact that the client's initial deposit will not be returned if they decide to postpone or cancel the wedding. Of course, you should use discretion with this clause when family tragedy strikes. As you get rolling in this business, however, you'll find that you have slow, busy and very busy seasons. Once a date is assigned to a client you may find that you'll get three or four more requests for that date from other parties. Unless you have a group of photographers who help fill dates, you'll have to turn away the new business. Thus, a postponed wedding means lost money. The wedding hall or reception house has the same policy, and they book over a year in advance. Follow the same policy.

How should payment be apportioned? If you're working a package deal, consider asking for one-third of the total as an initial deposit, one-third a month before the wedding and one-third on the wedding day. Walk away from the job with the money in your hand—everyone else, including the band, hall and drivers do. If you're working a la carte, get half up front and the other half before you leave the reception. Your attitude, the market and the relationship you have with your clients will determine how you apportion payments. The same goes for extra prints and enlargements. Get at least fifty percent on order and the rest on delivery. Cash flow is no small matter in any business. You've already spent a lot of money on equipment, training and preparation. Once you're on the job, never work on your own money.

The contract can also be used to help guide you and the client through the wedding day. Get the name of the minister or rabbi, the location where the bride will be dressing and agree upon a time and place where the picture-taking will commence. Include the hours of coverage and add overtime charges for any work past a certain hour. Include clauses about table shots (many photographers now insist that they're purchased if requested), location portraits (have them pick a spot or choose one from your scouting), and any extras not specifically spelled out in the agreement. Use a checklist to help them understand the type of images you will make, and have them add or delete items.

In short, make the contract work for you financially and creatively. Add to or amend the sample shown here and

look at the contracts other wedding photographers use. But please, make sure that you keep the clauses and stipulations listed here. After you have your contract in shape, consult a lawyer. The money you spend on consultation is well worth it. Don't think that you have it all covered or use anyone else's contract as your sole guide.

Financial Records

BOOKS, LEDGERS and all the financial record keeping necessary for running a business should round out your paperwork. Income from weddings is taxable, and you must "pay the piper" even if you work part time. Consult an accountant on the ins and outs of running a business. Take heart—even though the money you earn is taxable, your expenses on the job are deductible. Traveling, selling, film, processing, phone, depreciation on equipment, education, insurance, publications and so forth are valid business expenses. Many emerging professional photographers build their equipment and studios this way.

You should consult an accountant on these matters and let him or her guide you through the labyrinth of tax laws. Let a professional advise you about the appropriate tax form for your business. You may choose a DBA (doing business as), corporate or limited venture route, but always consult an expert and be honest about your work load, future plans and expectations. You should also check with an accountant about tax numbers, sales tax collection (if applicable) and other necessary matters, as well as tax filing dates, etc. All this is an important part of operating a wedding photography business. Even if you begin or maintain this as a part-time business, financial matters are a big part of the game.

Business Cards

A Business card is a time-honored way to remind those you have met of who you are after the meeting is long over. Wedding photography is still a word-of-mouth business. And a very personal one. During the course of your work on the wedding day you may be approached for your card by relatives and friends of the couple, or even by the catering hall representative or members of the band. Have cards handymany of your future jobs will come from these meetings. If people see that you work in a professional manner, with a courteous, efficient demeanor, they may well consider you for their own or their child's wedding. If you change your address or phone number, always have new cards madedon't scribble the changes on an old card or rely on using the back of the napkin. All this may seem self-evident. This is just a friendly reminder not to pass up any opportunity to make and maintain contact with potential clients.

Marketing Techniques

Now that you have everything in order—price lists, samples, cards and business matters, you're ready to start work. How do you find clients? We've already discussed the

potential of the Web. This is a great place to refer clients to your posted portfolio and even a sampling of prices. But you have to make them aware of where to look for you on the Internet—no one will be able to find your Web page unless they know the address. Joining a wedding directory is a great way to promote yourself. They sort photographers by geographical location, specialty and even price level. (See page 10 for more information.)

You can begin by making contacts and leaving cards in places where potential clients might gather. These can include florist shops, limousine services, restaurants and catering halls. You might even consider placing what's known as a "business card ad" in church and synagogue bulletins. These are usually quite inexpensive and get into the homes of the local people you want to serve.

While you're making the rounds, get to know the people in charge and let them know that you are a wedding photographer. Even photo and film outlets are also good areas to explore—most will be happy to post your card, figuring that you'll be buying film and supplies from them.

Although a wedding studio will not recommend you—unless they know you and your work and they have an overflow of clients—some may want to interview you for work as a candid or day person. On occasion, one of their group may have gone off on his or her own, or they may need an extra hand for a big job. If you're just beginning, this is a great way to get known in the trade. Once you've built a reputation, those same studios may pass along a recommendation if they're booked on certain days or for a particular type of job. The wedding business is a somewhat fraternal order, and sooner or later you'll get to know everyone in your area who's in the business.

You've probably heard of bridal shows, where dress shops, caterers, florists, car services and photographers put on a mini trade show for potential customers. Bridal studios with years of experience and excellent samples of work often have booths at these shows. The first time around, attend like any other potential customer and see what it's all about. If you develop the samples and the pitch, by all means try these shows out. They're an excellent venue for meeting others in the business and interviewing potential clients.

Bridal coordinators are a relatively new development. Some weddings can be elaborate affairs, and the bridal coordinator does all the work that used to be handled by the bride and her family. In some parts of the country, the bridal coordinator controls a lot of the business and even interviews and books photographers for the job. Be aware that they do take a cut of your fee. Some photographers shy away from such agencies or get turned off by the negotiation over money. This is your call.

A traditional form of advertising is the local phone book. Not everyone out there is Internet connected or savvy, and they still let their fingers do the walking, even when searching for a wedding photographer. You can begin with a bold-letter listing and, if it brings in business, work your way up to a display ad. Local papers and "shoppers" can also be good venues. Through it all, the best marketing strategies are the way you handle yourself and the quality of your finished work. As mentioned, this is a word-of-mouth business. Once the ball starts rolling and cousin Jane tells Aunt Martha how great you were, you'll have no lack of work.

The Appointment

When People follow up on referrals from a Web directory, a friend or the phone book, the conversation inevitably starts with questions about cost. It's up to you, but it's probably best to defer giving prices over the phone. If the caller insists on price quotations, reassure him/her that your prices are reasonable and competitive, especially for the type of work you do and the options you offer. But let them know that price isn't the only consideration. Stress that you think it's best for all if you can meet to discuss the plans for the wedding and find out exactly what they want. Then ask, "When can we sit down to talk?"

Discussing a price right away is pointless. You really do have to sit down with the bride and groom to find out what they want, and you have to know that you and the contracting party can work together as people. Weddings are very personal events, and the chemistry between you and the clients will have an influence on how the pictures and the experience turn out. You don't have to fall in love with each other, but you do have to connect.

If the caller insists on a set price, you can either let him/her go or give him/her a quick idea of one of your package deals. Experience shows, however, that price shoppers can be more trouble than they are worth.

Once you sit down with potential clients, make the appointment a low-key affair where business is accompanied by personal courtesy and curiosity. In some areas of the world, this way of doing business is still customary.

The appointment should be when you formulate your plans for the wedding pictures. In your role as director of imaging, you've got to begin conceptualizing your script. A wedding picture checklist is included in this section with the contract—let this guide you. You might even want to make a copy to hand over to the client for consideration.

Obviously, the couple or family members at the appointment won't know every image they want taken, but the checklist serves another purpose—it lets you know who you're dealing with and the type of wedding and wedding coverage they desire. As the people look over the list, you may get comments such as: "My uncle is making a special cake for us and we'd really like a picture of that" or "We've seen those special effects pictures and we think they're stupid" or "We're not doing anything traditional like the garter or bouquet toss and just want lots of candids."

All this leads to a better understanding of your clients, and lets you know directly or indirectly how the script will go. It also lets you know which images will sell and which won't, though that may change. Couples may not think they want "traditional" poses before the wedding, but on the wedding day they may make a special request for such photos of

a host of couples. Let clients request any photographs they might want that do not appear on the checklist. Prior to the job, you can use the list to refresh your memory as you go and as a worksheet.

You may notice that one type of photograph—the table shot—is not given special attention on the list. Because of the difficult and time-consuming requirements of such pictures (gathering wanderers and disturbing dinner) many photographers will make these images on a sales-guarantee basis only.

As you see the type and number of images that are checked off, you'll begin to get a sense of the total pictures that the job will entail and be able to begin formulating a package or price that works for you and the couple. You can also begin to estimate album size and costs and other extras that can be included.

As you can see, the interview and checklist set up everything that will follow. That's why quoting prices during the first moments of a conversation is pointless.

The Sale

The first phase of closing the sale involves a conversation about desire versus economic reality. The middle of the sales process involves showing sample work and albums—an option list, if you will. The close of the sale involves a final discussion about prices. Throughout the process, both you and the booking party will begin to understand the most important thing—whether you can work together. It's a two-way street, and it's useless to even try to close the sale unless that bond has been established.

In truth, price is not the primary consideration for couples looking for a wedding photographer. Of course, the price must be in their particular ballpark, but this business has an intangible element that allows that price some freedom in the field. That's one reason why you should have at

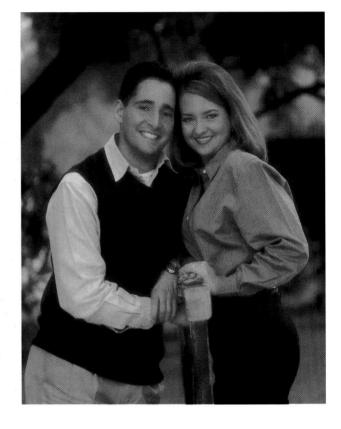

least one member of the couple at the booking session—the emotional connection is key.

Another inestimable cost is the amount of sweat you'll be putting into each job. Don't bargain with people or listen to promises of high print purchases if you drop your price. If you've done your homework right, you know what you'll make on the job. But you won't know how hard you'll have to work for your money. Some weddings are relatively easy.

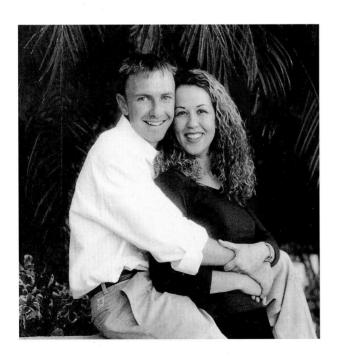

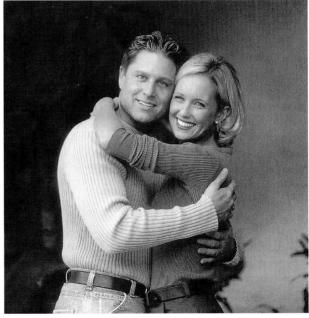

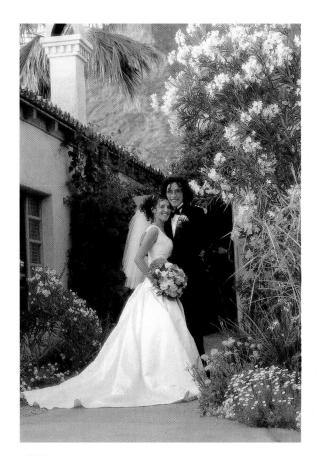

Others are more difficult and a few can be, quite frankly, nightmares. Some of the people who drive a hard bargain see it as part of the game. Once the game is over, it's shake hands and let's get to work. Others who drive hard about prices continue their less-than-friendly attitude through the wedding day. That's what makes the world go round. As a wedding photographer you'll meet all types. Your instincts are your best guide.

Once you've arrived at an agreement on packages, prices and extras, be sure to go over each clause of the contract to ensure that the client understands the terms. If all is understood, have them sign it and give you a deposit.

If, after the presentation and encounter, a client will not sign the contract because they want more time (to think about it or shop around), offer to help them understand anything that might be unclear. If they still won't sign, inform them that your wedding dates fill up quickly, and that you can't promise to hold their date without a signed contract and deposit. This may sound like pressure selling, but it is realistic planning.

If, however, you go through the whole appointment and find that you absolutely can't work with the people, then shake hands and walk away. This may never happen to you, but not doing the wedding in certain cases is better than making you, the wedding party and the photographs suffer.

You may find that your first few sales presentations and closings are difficult. This is a natural feeling. If you approach them, however, as "social" events as well as business deals, you'll probably feel better and you'll be better off. After you work your first jobs, you'll begin to appreciate the importance of that appointment and how it and subsequent meetings with the bride and groom affect both the final images and the final sales. You'll also understand that handling yourself as a professional at the meeting will mean that you're treated as a professional on the day of the wedding.

Engagement Portraits

PART OF YOUR WEDDING PACKAGE will probably include engagement portraits—photos of the prospective bride and groom for newspaper announcements, invitations and for remembrances of who and where they were when they decided to tie the knot. These photographs are often used in the social pages of local newspapers, so black and white images are more than acceptable. Of course, any newspaper can also convert from color to black and white.

The watchwords for these photographs are closeness, happiness and intimacy. Although many of these photographs should include a candid but centered pose of the couple, use the time to also capture moods and feelings using special light or locations. These photographs will have just as special a meaning as the ones used for notices and announcements.

The engagement portraits are the first time you'll be working with the couple—establish a rapport that can be carried throughout the wedding day and after.

THE FORMAL PORTRAIT

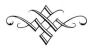

EFORE GOING INTO THE ACTUAL scripting and shooting of the wedding day, you should meet the two people who are the leading man and woman in the story that you're

about to tell, the bride and groom. The majority of the photographs you'll be taking at the wedding will involve these two people. All of the activities revolve around them and all of the energy comes from them and towards them. While everyone else plays a supporting role, these people are the stars, and should be revealed as such in your photographs.

Because the bride and groom are the center of attention, and are constantly being pulled this way and that, there's often little time to make formal portraits of them during the course of the day's events. If at all possible, try to book the formals a week or two before the wedding. You can take them in your studio, their homes, or another appropriate location. In this way, you can get your formals and have the newspaper announcement shot done at the same time. (Black-and-white prints for newspaper reproduction can be easily made from color negatives or scanned from proof prints.) This may be impossible, however, as the bride's gown or the groom's tux might not be ready in advance of the wedding day. In that case, make the formal of the bride at her home before the service, of the groom at the church before the service, and formals of both of them together either right after the service or early on in the reception.

Formals are based on classic studio portraits. Studio props, such as elegant chairs, couches, or posing stools can be used, along with very simple or neutral hand-painted backdrops. Though props can be helpful in posing, keep them to a minimum and remember that formals are quite different from environmental or more candid photographs of the couple. In these photographs, you'll rely on simplicity and elegance in design, posing, environment, and lighting.

Natural or artificial light can be used for these portraits but, as with the posing, simplicity should be the watchword. Window light through sheer curtains can give a soft, even glow to your subjects. Strobes add an element of control, and even though many beautiful portraits can be made with one light, a key, fill, and background kicker light will certainly do the job. Whichever light source you use, keep the lighting simple and have it follow a consistent, natural path toward and around your subjects.

It's quite natural for people to feel awkward during a formal sitting. As the photographer, the way you treat your subjects can either aggravate or alleviate their nervousness. Reassure the bride and groom that you won't do anything to embarrass them. Begin the rapport by sharing your feelings, and set up channels of communication as you go along. The stiffness of many formal shots often results from the photographer having a preset notion of what the people should feel or look like, and he or she forces the couple into a mold that has nothing to do with the individuals themselves. Be confident enough of your own photography skills to allow people to be themselves.

Once you feel a sense of ease, bring the couple, or individual, into the shooting space and let them go into their own pose. You'll find that many people know what to do in front of a camera, and all you'll have to do will be to refine their natural pose for them. The refining process means watching for lines, shadows, and body language, as well as facial features that should or shouldn't be emphasized. Take the time to look at who and what you're photographing.

Follow the general rules of portraiture—don't let the nose break the line of the face, don't let shadows fill the eye sockets, and have a maximum of a 1:3 lighting ratio from one side of the face to the other. Pay attention to the eyes. They are, as the cliché goes, the windows on the soul. One technique for getting effective eye contact is to have the subject look down right before the shot and then look up into the lens the instant before the picture is taken. Of course, not all your formals should have direct eye contact.

Looking at lines means that you move arms and shoulders so that they create a flow throughout the picture, rather than a series of choppy horizontal lines. Think of your composition as a diamond rather than as a series of blocks and rectangles, and visualize S curves in and around your subjects. Use the bridal veil as an object that creates an aura, not one that obstructs or makes hard vertical lines cutting through the face. Notice how the hands are placed. Go for a graceful look and make sure the fingers don't look like a pile of sticks.

The key words in formal wedding portraits are simplicity and elegance, infused with a sense of intimacy. If the stance of your subjects is too stiff and haphazard, help them by showing them how to place themselves, rather than trying to talk them through it. Don't be afraid to touch and guide (though you should always ask permission to do touch posing). Once they're in the general pose you want, go back to your camera position and begin refining.

Formals are the part of wedding photography where your studio skills are put to greatest use. Use the time available to look carefully at the design elements in the viewfind-

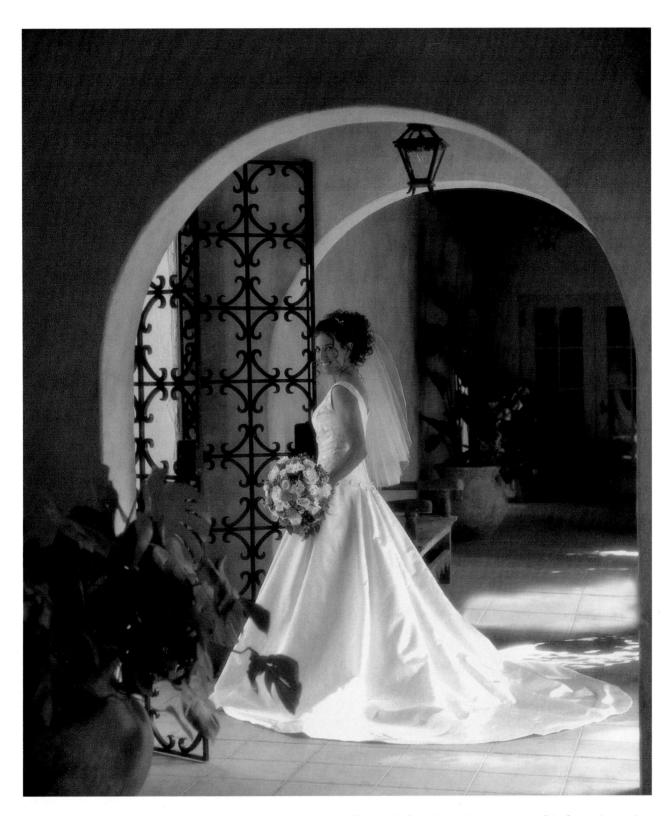

er and watch for the small details that can make or break a picture. Formal doesn't mean stiff; think of it more in terms of a classical approach to your subjects. Don't ignore the special character of each of your subjects, but don't forget the lighting and lines that make these portraits popular for album and wall enlargement sales.

The circular form that breaks the rectangle of the frame, along with the natural light coming from both sides of the enclosed arch, make for a natural location studio setting for this classic portrait pose. Note how the tip end of the gown is close to but not touched by the edge of the arch. This helps unify the forms that are reinforced through repetition in the background. Making use of such areas on location can add so much to this head over shoulder pose.

THE FORMAL PORTRAIT

The Bride's Elegance

HE ELEGANCE AND STYLE OF BRIDAL PORTRAITS should evoke the natural beauty of the woman in the bridal gown, rather than have the look of a replaceable head pasted on to a wedding dress. Capturing detail in the gown is important, but it shouldn't override the person wearing it. With this in mind, approach the bridal formals by doing a number of poses, including a full-length shot (showing the flow of the dress), a medium shot with and without bouquet, and a head and shoulders shot with the veil.

When doing a full-length shot, pick up the train of the gown slightly and let it fall naturally. Don't cut the gown off at the bottom of the image—let it be a curving design element. Also, don't fuss with the gown other than giving it a delicate flow; too many times gowns are made to look like elaborate braids that twist and snarl around a bride's feet.

The bouquet is an excellent prop for bridal formals. It should be held slightly above the waist in a natural, graceful way. Remember to have flowing lines in both the body and

the dress, and to have the arms bent in such a way that no hard angles or horizontal lines intrude on the grace of the picture. If the hands are showing, "break" the wrist for a flowing look. Also, don't have the bride standing flat-footed, facing the camera squarely. Instead have her bend her body naturally, shifting her weight to one or the other leg.

Avoid the "passport" look and watch for a diamond design created by head, body, and arms. If you use the bouquet in a medium distance or close-up shot, put it in focus if the bride is looking at it. Let it go slightly soft if it's just being used as a design element or splash of color in the lower part of the frame.

One of the chief sources for an unacceptable bridal portrait is the burnt-out look created by the gown reflecting too much light in comparison with the rest of the tones in the picture. This may cause under-lighting on the subject's face, but in order to get good skin tones in printing, the detail in the dress is lost. Be very careful with your lighting ratios.

One way to avoid this problem is to keep the main source of light away from the front of the bride's gown. Have the woman turn to the side and have her head turn in toward the light source. If you're using artificial light, feather the light across the subject rather than have it blast directly onto the gown. Feathering means that the light is pointing across the plane of your subject, resulting in a skim effect. Use of a soft box or diffuser on your light source will also yield a mellower light. The point is that you should pay close attention to the contrast in your bridal lighting, and to try to keep the lighting as soft and low key as possible.

Most bridal formals benefit from the use of a light vignetter or diffuser on the lens. The veil at the top of the frame and the gown or bouquet at the bottom serve as beautiful borders. Slight diffusion might also be desirable, depending on the light source

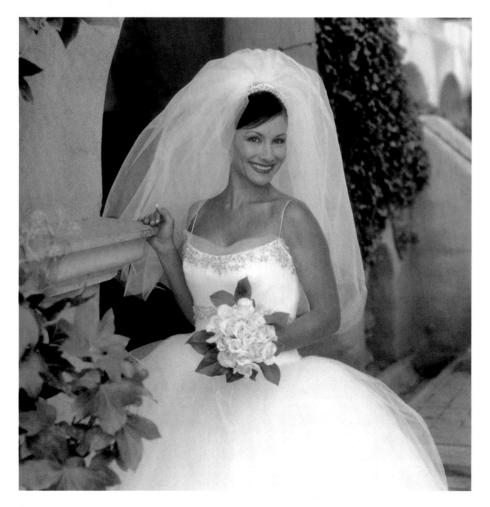

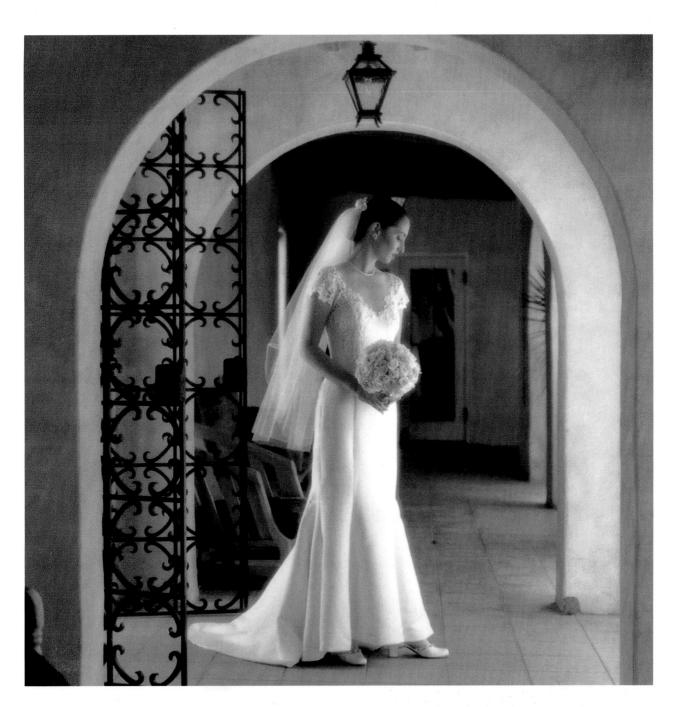

and the subject. Natural light through diffusing curtains can create an excellent light in which to shoot bridals, although you should be careful of too strong a light source. If the scene seems too contrasty, move the bride further away from the window, thus decreasing the intensity of light striking the gown.

The stronger, more directional light is used to illuminate the face in this beautiful portrait. Note how the veil is placed to catch the light and serve as a soft background for the shadow side of the neck and shoulders, acting almost as a fill card. The gown train is placed carefully to touch the edge of the encompassing form.

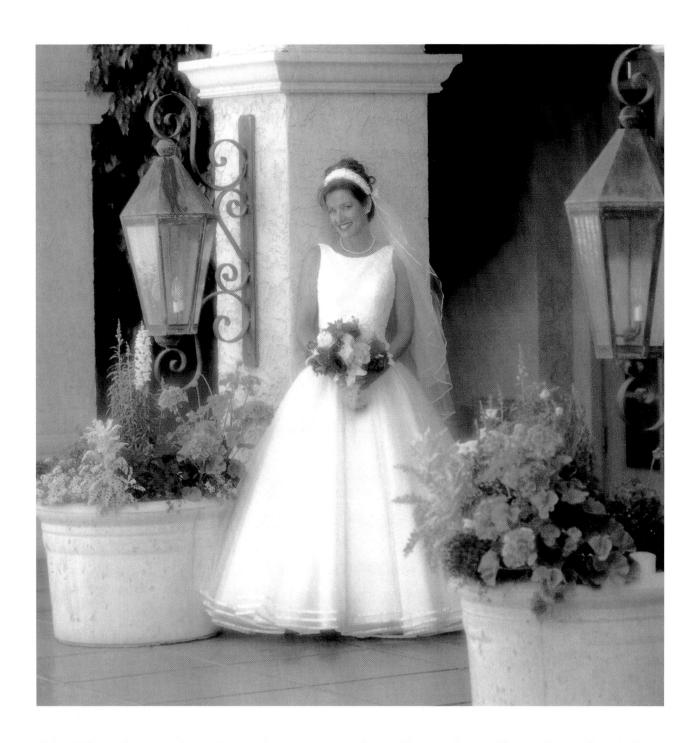

The Bridal Veil

The bridal veil is an important part of the bride's attire that can be put to good use in photographs. It can be used to create a soft glow of light around the bride's head and as a "catcher" of light that defines shape and form. As you look at the bridal photographs throughout this book, take note of how the veils are arranged and their importance in any close-up photograph.

When setting up the veil try to avoid hard, straight lines and any interference with the bride's features. Be attentive to

any shadows the veil throws, especially those that might cast a net-like appearance across the bride's face.

Use the veil as part of the picture's flow. Have it bring the viewer's eye from the face down into the rest of the image. Perhaps you can use the veil to accentuate shapes and forms or to reinforce the entire visual flow and pattern of the composition.

The veil can also serve as a diffuser. As you experiment with different directions of light in your posing you'll see how this gauze-like material can add so much to the feeling of a scene.

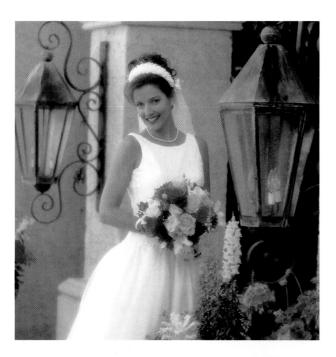

Posing Techniques

When doing formals and candids, there are three basic kinds of posing—talk, touch and show. Talk posing means giving verbal directions to your subjects and requesting that they turn their head this way or tilt their shoulders at an angle. This is best used after you've set up your basic pose and are standing at the camera, ready to release the shutter. It is a quick refinement of the pose. Classic talk pose instructions include "lean in" or "kiss the bride" or the classic "smile!"

Touch posing is refinement by physically moving a person with your hands. When your verbal instructions might be confusing or the subjects just can't get it right, use this method. Always ask permission before you move someone physically, as some people are sensitive to being touched. And when you touch pose, always work gently.

Show posing is an effective method for getting pose cooperation. This allows the subject to mimic your stance. Once you get them into the basic pose, such as weight on one foot and shoulder in, you can then touch and talk as required. Show posing is great for weddings as it gets the job done fast and allows you to get the people into position in an often time-sensitive environment. It can also be fun and make posing a game rather than an exercise.

This sequence of portraits illustrates different techniques with different camera-to-subject distances. Note how the placement of the bouquet shifts with each distance, held waist level for a full, a bit higher for a three-quarter and as a colorful frame for a close-up. Note also how the body shifts with a more squared-up look for the full portrait, a slight turn of the shoulder for the threequarter, and a similar turn with a tilt of the head for the close-up. Each distance also works with the location props at hand. The full shot uses both lamps and planters as side frames and the column as the backdrop. The closer photograph still uses the lamps, while the close-up necessarily drops the foreground lamp and softens the background through use of a shallower depth of field. Each of these shots works, although the close-up is probably the most successful in the formal category.

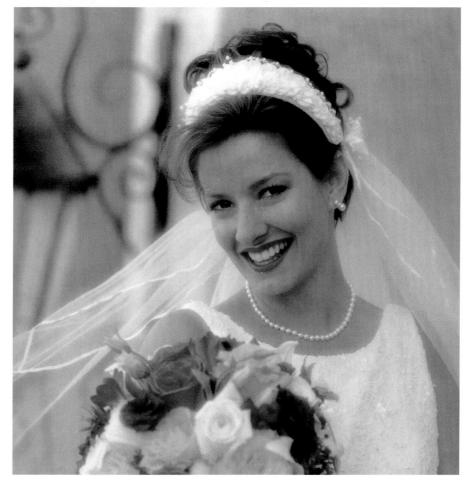

The Groom's Style

HILE THE BRIDE'S PORTRAIT IS USUALLY bathed in soft light, or has an almost mystical quality about it, the classic shot of the groom is one that's more defined, and has a somewhat darker tone. The photograph certainly shouldn't be hard or moody, and it should be a reflection of the man's character. Too many photographs of the groom are heads and shoulders, with a broad smile or caricatured, serious look that more often than not resembles a grimace. Aim for a natural look, and be aware of the small details that go into the making of any formal portrait.

Because the groom's clothes are much "straighter"

than the bride's, and can't be fluffed out to create paths of design and light, you'll have to be much more conscious of how the lines of the jacket, vest, or waistband fall. Watch for the jacket riding up over the shirt collar and make sure the cuffs of the shirt come out from the sleeves of the coat. Even though the facial expression in the shot might be great, a portrait can be badly hurt by your missing any of these seemingly inconsequential details.

It's rare to see or sell a full-length formal of the groom, so concentrate on medium-distance shots. Using a lighting setup similar to the one for the bridal portrait (skim or softbox) you can have the groom lean in slightly, one foot

on a stool and an arm resting on the knee, with the other hand in a pocket. Remember to watch for lines by making sure that the groom's shoulders aren't parallel to the top of the frame, and have the head turned to one side or the other so the shot doesn't look like a wanted poster.

It's okay for the groom to have one or both hands in his pockets as long as the hands fit. Some formal wear is very tight or just has decorative pockets, so hands may seem bulky if shoehorned in. If the hands are left out of the pockets, do something with them. Don't just let them dangle in space. Putting hand in hand is better than interlacing fingers. You can also have a thumb hitched into a pocket or belt, creating a jauntier pose.

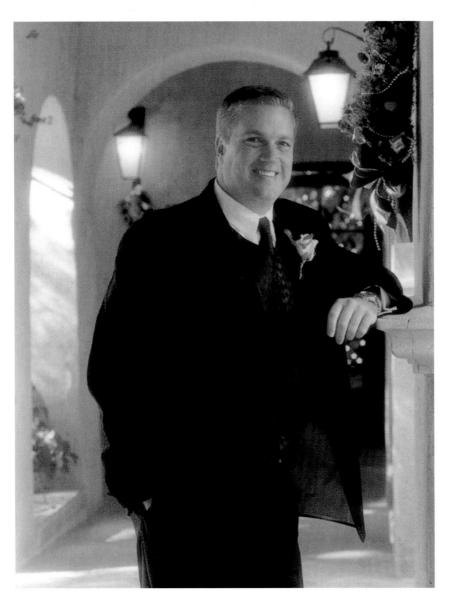

Each of these photographs of the groom uses location props to help in the posing and stance of the subject. The column, door handle and even the pillar help the groom strike a more relaxed pose.

Although not necessary for every shot, Ken has asked the groom in each of these poses to place his hand in his pocket.

This fits with the more relaxed pose and eliminates what for some people might be an awkward question—what to do with that free hand? Note also the handsome smile on each groom's face. You don't want to have your grooms look stern or nervous. A pleasant smile always helps.

Many men's portraits seem stilted when compared to those of women. This may be caused by the photographer and subject feeling as if they are trapped into portraying the "male image." Go with your feelings about the individual and don't get caught in stereotypes. This will make your subject more comfortable and allow you to make a more honest photograph. Look for motion, movement of lines, and dynamism as ways to break any stiff, visual looks. Once the subject has posed himself, or you've helped him find a comfortable position, request an extra lean-in towards the camera. This extension does wonders for male portraits.

Use your judgment about diffusers with the groom because some benefit by its use and some don't. Though these filters aren't in general used for pictures of the groom alone, they can help create an idealized rendition of the subject. Smiling is not against the law in the portrait of the bride or groom. The demeanor of the groom's portrait needn't be serious or moody. His warmth and glow are what you should aim to bring out.

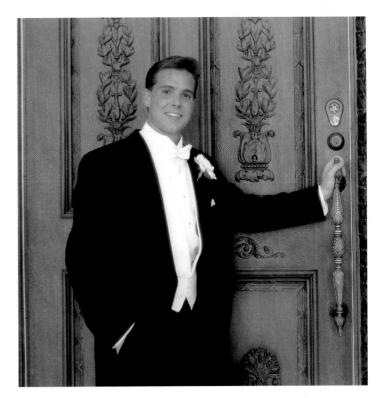

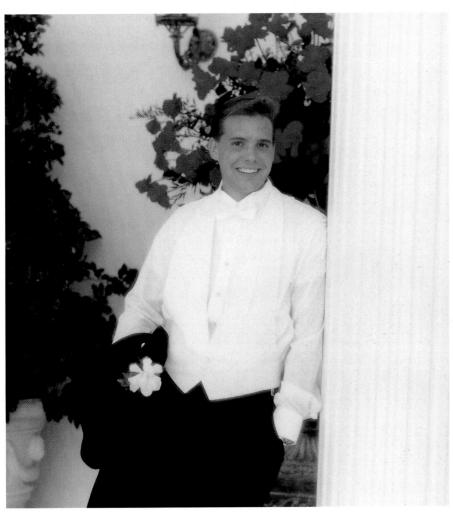

The Couple's Affection

pose in the world. They want to touch, to be close, and to share their happiness with others, all in a natural way. Most wedding couples want their pictures taken together, and their individual shyness is usually overcome when they pose together. Most of all, they're eager to make the shot turn out well; it's up to you to help them.

Skim lighting should be used for the bride and groom shots in the studio, with the main rule being that the bride should be furthest away from the light source. In this way, the dress doesn't become a hot spot, and it can serve as a natural reflector bouncing light back to the normally darker groom's clothing. When photographing outdoors in natural light, use the bride's veil and white dress to best advantage. When taking a light reading in either situation, meter for the shadow area where you want detail, and watch out for too deep shadows falling across the faces.

Though the bride and groom want to be close, initially pose them so that they're standing slightly apart, then have

them lean into, or toward each other when you're about to take the picture. This creates a dynamic motion, and a final lean-in toward the camera finishes the pose.

Use hand in hand rather than interlocking fingers for your medium distance shots or close-ups. The other hands should be entirely visible or entirely out of view. The bride may have both hands on the groom's shoulders as she stands to his side, but make sure that her hands are placed gracefully and that no fingers are "amputated" out of the picture. Don't let a stray thumb spoil an otherwise flowing composition.

Avoid placing the bride and groom next to each other in "lineup" shots. This is a terrible waste of a wonderful portrait opportunity. Seek a dynamism by creating different levels of motion, have the groom sitting and the bride leaning in from behind, or the bride standing in slight profile with the groom looking on with affection, and so forth. You needn't have the couple do gymnastics, but you shouldn't have them pose statically either.

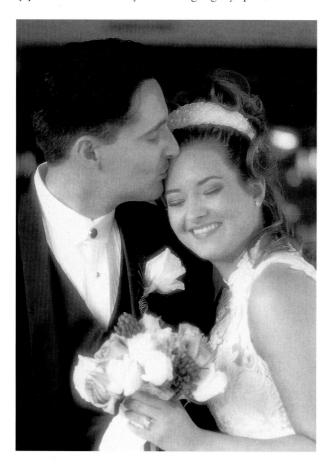

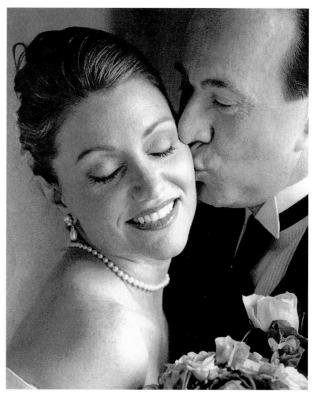

When photographing the bride and groom together have them give an extra lean-in or kiss to add the finishing touch to the picture. In each of these photographs, Ken has encouraged communication of warmth and affection by asking the groom to give the bride a tender kiss. Black and white formal portraits are gaining increasing popularity.

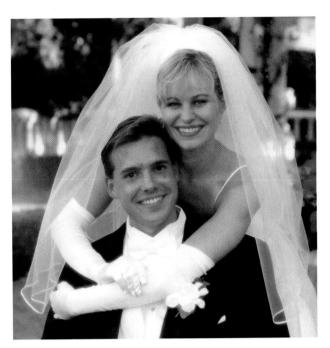

The happiness and affection of this couple is obvious from this very simple, straightforward pose. Note the placement of the heads and how the veil is used to encompass the couple in a soft surround.

Always strive for a genuine expression in your portraits—contrived shots look forced and rarely sell. A picture that involves direct eye contact between the bride and groom can be great because in the midst of posing, the couple just might want to kiss. Hold them in this pose a little longer than usual, and let them move their faces closer and closer together. This creates a wonderful sort of tension that is resolved by the click of the shutter, and the kiss. The idea isn't to keep the couple from kissing, but to help set up an emotional, real pose.

A light vignetting filter can be used for bride and groom pictures, and a diffuser can be helpful for creating a romantic mood. Many times you can work with a posing bench, and by arranging the train of the bride's gown on the platform you can create a naturally soft border that also throws beautiful highlights into the rest of the picture. Backlighting can also be utilized for the creation of mood. Meter for the faces so that important details aren't lost, and allow the backlight to spill through hair and over shoulders to create an aura. You may need a brief fill flash or reflector card to help light the faces, but be careful not to overlight and watch for flare in your lens.

The key to bride and groom formals is the connection between the man and the woman—their love, caring, and shared humor. To capture this is a challenge, but it's made so much easier by the fact that it's their wedding portrait. It's an emotional time, one filled with anticipation and affection. Make your pictures so that those feelings are shared with future viewers.

Enhancing Portraits with Light

Portraiture is a subtle art that requires your constant judgement of how a scene's light, color and mood affect your subjects. Light should be used to bring out the beauty in your subjects and to enhance their features to their best advantage. Avoid harshness and strive for a sense of restfulness in the final print.

The play of light is a natural balance of highlight and shadow. No lines on the face should be too deep, neither should the face be flat and bland. While some images may benefit from a high contrast look, wedding portraiture should have an open look and feel and avoid too much contrast. This does not mean that faces should have no modeling created by contrast ratios. It does mean that the "look" is one of friendly warmth.

As photographers we create with light. Part of that creative process is being able to "previsualize" how light and exposure will interact in creating the final image. Remember, many things can be done with a negative or scanned image as it goes from the negative to the print stage. But those changes should be concentrated on creative, rather than corrective moves.

Study light in your own tests as well as in other photographers' work and in painted portraits. A week spent in the museum with Rembrandt, Monet, Bonnard and Memling will be most instructive.

Have light work for you and learn how to control it to express mood and feelings. The mastery of light is your life's creative work as a photographer. Know how to work with it, and it will be your ally on each and every wedding job.

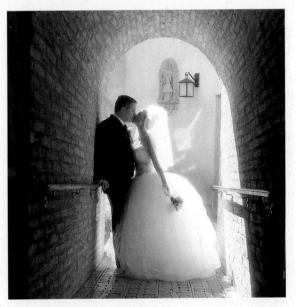

Natural backlighting was the main source of illumination for this intimate moment. Ken metered for the background and let the light play in the foreground, which added a soft glow to the image. The forms and play of light around the image give it a magical feel.

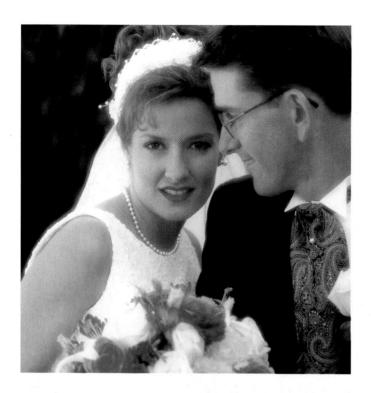

This is a classic sequence of an effective pose and verbal prompt leading to a winning picture. In the first photograph the groom is posed to the side with the main concentration on the bride, who looks directly into the camera. A soft kiss garners a wonderful reaction from the bride and a beautifully tender photograph.

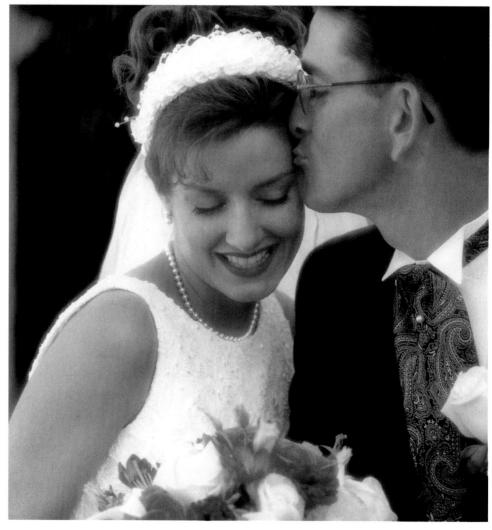

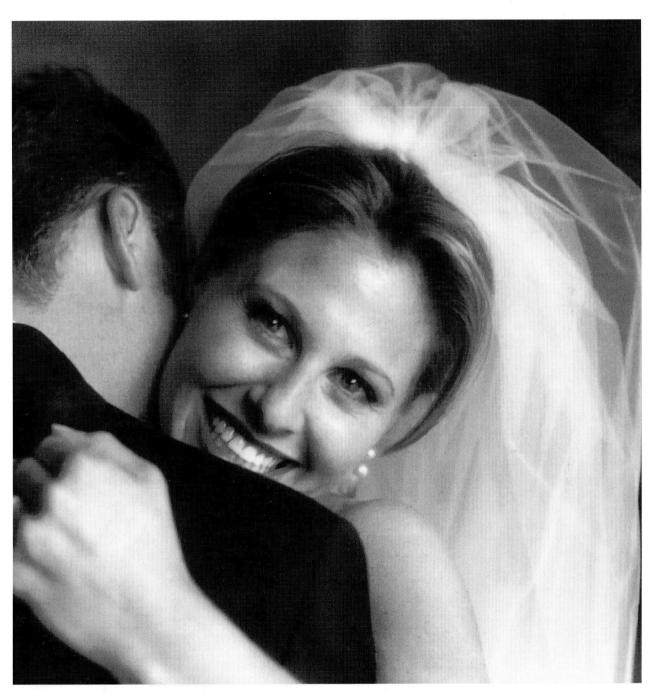

The affection and happiness of this bride is evident as she shares this moment with the camera. Note how her veil is used to entirely fill the right side of the image frame, a romantic posing that uses the light-catching quality of the fabric to full potential.

BEFORE THE CEREMONY

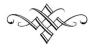

HE TIME BEFORE A WEDDING IS ONE of hurried preparation, when the bride and her family are preoccupied with the endless details of the coming day. The mood in the household is similar to that

backstage before a play, where the actors are frantically getting on their costumes, makeup, and rehearsing their lines. The scene is usually emotionally charged and nerves can be high-strung, to say the least.

During your initial appointments with the client, you should agree upon the time when you'll be arriving at the house, that the flowers will be ready when you arrive, and that most everyone will be ready for taking pictures at a certain hour. Coming three hours early, when everyone is still drying their hair, will be a waste of your time and make everyone else more nervous than necessary. While timing is a personal matter, some photographers plan to arrive at least two hours before the bride is to leave for the wedding ceremony.

Scouting Shooting Areas

THE FIRST TASK YOU'LL HAVE is to take a few minutes to scout your location. Find an area where you can take bridal and family portraits, one that doesn't have too busy a background or clashing colors. If you can combine this with an area that has a nice fall of natural light, so much the better.

If the light isn't right in any area of the house, choose an open space where you can set up your strobes. While you're doing this, check to see if there are exposed staircases, easy chairs, bookcases, mirrors, and other items that can serve as posing props. If there are lamps in your posing location, leave them turned on except, of course, if they're harsh spots or fluorescent lights.

Many people may be coming in and out of the house during this time. Don't push them out of the way for your pictures, but make sure they don't serve as distractions either. Once you set up the shooting area (and this may entail moving furniture, opening blinds, or drawing curtains) make it off limits. You're creating a set, and once it's prepared don't let others disturb it.

Enlisting Aid

WHILE YOU'RE ACTING AS STAGE DESIGNER, it's a good time to enlist the aid of someone who will become your assistant director in all matters having to do with the bride and her family—the maid (or matron) of honor. It's her job to help the bride throughout the day, and she'll serve as an excellent go-between for you and everyone else who's part of the festivities. Many things will be going through the bride's head before the ceremony—don't add to her preoccupation by making too many direct demands. The maid of honor can help you organize the people for the pre-ceremony pictures since she often knows the extended family and where the veil, flowers, and other necessary items are located.

When to Begin

START SHOOTING A MINIMUM OF TWO HOURS before the bridal party leaves for the service. This will mean that you have at least one hour in which to get your pictures, and will give the bridal party an hour after you leave to make their final preparations. Any smaller period of time will result in rushed shots and possibly poor pictures. Give yourself and the subjects enough time to relax into their poses. As it is, you'll have to work hard and fast—you always have a deadline in these situations. Allow for time to shoot, pack your gear and get to the church to do some shots of the groom, his ushers, his family, and his friends.

The order of shooting will depend upon who's ready once you're set up. Since the bride is the key subject in most of these pictures, try to arrange with her to be ready first; discuss this during your pre-wedding day appointments. It is a good idea to get shots of the ring bearer and flower girl early on; the children may become restless if they have to wait around for a picture. After this, do shots of the bride in her room or dressing area, posed shots of the family, and finally some shots outdoors.

Starting Off Right

This is the first contact you'll have with the bride and her family on the wedding day, and the rapport you establish at this point will set up the relationship you have together for the rest of the day. Regardless of the ease of your prior appointments, this is pressure time, and your behavior during these moments establishes the mood for all concerned.

Blundering around the house and barking orders is not a good idea, no matter how nervous and pressured you feel.

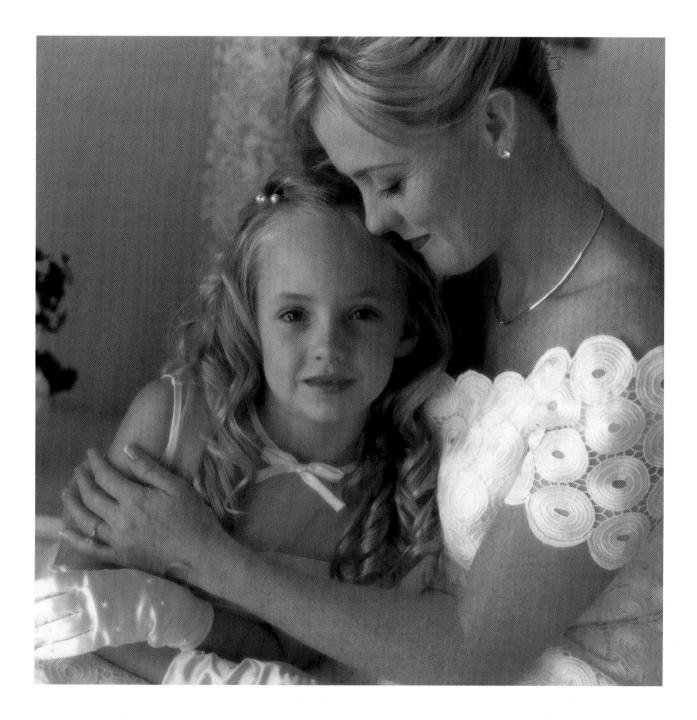

It's unfortunate, but some wedding photographers are too callous or unsure of themselves to handle people gently during the wedding day. It's gotten to the point where some people expect wedding photographers to be bullies. Don't live up to people's worst expectations, treat them with care, and they'll probably return the favor.

If all is chaos and confusion in the household, at least get some shots of the bride getting ready and a few pictures

of her and her close family. Quite frankly, you never quite know what you'll be walking into on the actual day of the wedding. So don't worry if you miss some of the shots mentioned in this section while you're at the home. You can always get them later at the reception. Don't put the shots off if you do have the time and the people are ready. It's always best to make the most of picture opportunities and get the main shots out of the way when you can.

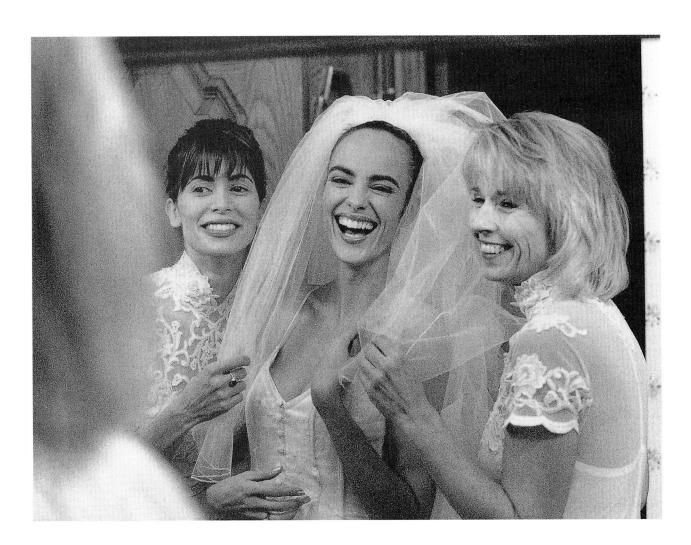

The "Dressing" Shot

CLASSIC SHOT FOR ANY WEDDING ALBUM IS one of the bride getting ready for the wedding, usually called the "dressing" shot. This doesn't mean that you burst into her room and get shots of the woman drying her hair. Generally, these shots are set up when the bride is ready and show her putting on the finishing touches or arranging her veil.

The pictures should convey a sense of intimacy, and are usually made with the bride and maid of honor, with close friends or with a group that includes the mother and perhaps even the mother-in-law to be. Among popular shots in this series are those using a mirror as well as pictures of the bride looking out a window. The mirror shot can be particularly evocative because it portrays the bride contemplating herself and this special moment in her life. Doing a straightforward shot of just the mirror with the bride's face reflected in it would be like taking a picture with the bride

holding a picture frame around her face. For that reason, most of these shots are made over the bride's shoulder, including some details of the dressing table.

Lighting is accomplished with a bounce flash, which eliminates glare from the mirror and fills the room with a soft glow. Or if room lights are bright enough you can use a fast film and handle this as a candid. Whatever way you do it, don't just have the bride staring into the glass. Create some movement by having her apply some makeup or arrange a part of her dress or veil.

Natural light can be used to good effect in the "getting ready" shot, and a vivid picture can be made of the bride looking through a curtained window, with her hand gracefully parting the material to let a shaft of light fall on her face. Not only does this yield a good light to work in, it also tells the story of the bride looking toward the future. This is a preparatory moment; don't have the bride wear a veil, but

Opposite: The preparation right before the wedding is a time of nervous anticipation and fun. This photograph was made with high-speed black and white film with a 35mm camera. The photograph was made over the subjects' shoulders into the mirror.

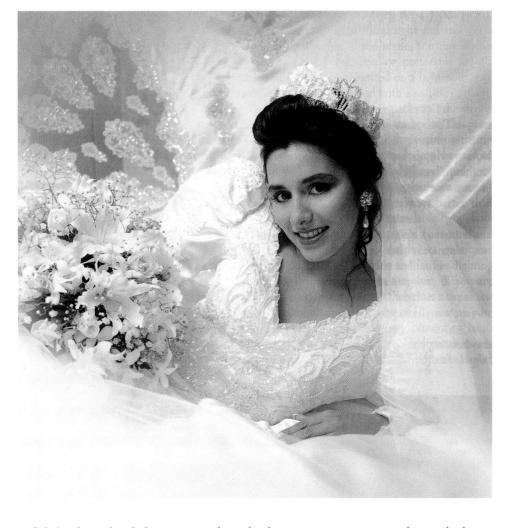

This intimate portrait surrounds the bride in a field of white using the gown and bouquet to best advantage. When making such photographs always take care with readings so the "field" of white does not cause underexposure. A flash meter, incident meter if its ambient light, or exposure compensation and bracketing, will insure correct exposure of this type of photograph.

photograph her in her gown as if she's taken a break from dressing and is giving a moment's thought to the day ahead. Keep in mind that all the shots you take during the day should be in the context of the story you're telling.

Other shots you might consider include the bride con-

templating her bouquet, sitting in an easy chair, and relaxing in her room. None of these should be "formal," and the light should be kept as soft and warm as conditions allow. Available light is always the illumination of choice, so scout the house for a relaxing area that will enhance the mood.

Dressing for the Occasion

An appropriate appearance helps you handle a wedding professionally. Along with your attitude and technical expertise, the way you look on the job can affect the way you relate to people and the way they relate to you. You don't have to outdress everyone at the wedding or have a manicure before every job, but you should project an appearance in keeping with the occasion.

"Dress like a guest" is a good motto. Slacks, sports coat and comfortable dress shoes are fine for men. The decision to wear a tie depends on what others are wearing. Some photographers dispense with any doubts by having a tailored tux ready for every job. For women, tailored slacks and business dress works well, with either a nice blouse or suit top that coordinates with the rest of her outfit. Never wear a formal gown, as this will most certainly get in your way.

Running sneakers and jeans might be fine for a studio photograph but just won't do for most weddings. Of course, if the wedding is a glorified beach party, then go with the flow. But sloppy clothes, poor grooming and an indifferent attitude about your appearance will not help you on the wedding day or in getting calls from guests to handle their family's photographs. Just blend with the surroundings and don't embarrass yourself, or the people who hired you.

BEFORE THE CEREMONY

The Bride and Her Mother

ENDERNESS, AFFECTION, AND CARING ARE THE emotions you should seek to portray in the photographs of the bride and her mother. Lighting and pose that communicates those feelings become very important. You can help communicate these feelings by working touch, by the motion of the hands and bodies, and by eye contact. When you request that the mother and daughter stand together, they may go right into the pose you want, or you may have to explain or actually help them pose. If you have a definite shot in mind, such as the daughter seated in a comfortable chair and her mother next to her on the arm of the chair, have the bride take her place. Then, act out the pose you want the mother to take. Showing is so much easier than talking subjects into a pose.

Avoid the lineup type of shot where the mother and daughter stand side by side in the middle of the room. This may show off their fancy gowns, but it does little to express the feelings between them. If you photograph them standing, have the mother doing something, fussing if you will, or have the bride pinning the corsage to her mother's dress.

After the pose is set, start talking and enhance the mood with your words. Generate or reveal feelings by talking about the affection you feel coming from the two of them toward one another. Bring them closer with your words. Watch for the special moment when both forget that they're having their picture taken, and when they connect with their eyes and touch. When you feel that moment, refine the shot quickly by having them move closer, look into each other's eyes, or move their hands so the composition is tighter. It's okay to have them hold the pose you think communicates best as long as you don't have them stand in the same place and pose for minutes at a time.

You have the advantage in these situations because you see the subjects through the viewfinder, and you should work to enhance what you see with a few small adjustments. Rely on your instincts for the right shot, but remember to look carefully at the whole effect. Always keep in mind what you want to say, but also give a parallel thought to how you're saying it. Awareness of technique is important, but it should not be the overriding matter in your pictures.

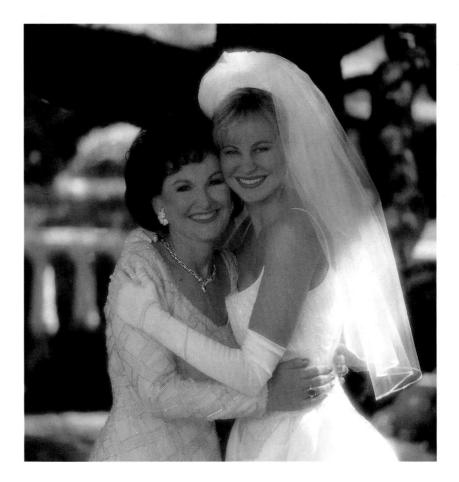

This beautiful pose highlights the closeness of mother and daughter. To soften the background a shallow depth of field is created with a 250mm lens at f/8. Open shade and a touch of fill delivers excellent tones on the subjects.

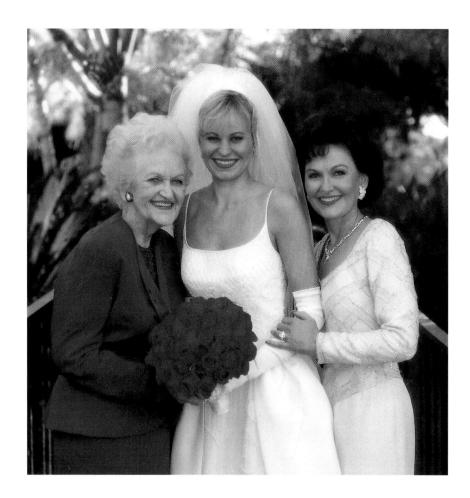

This photograph of three generations—bride, mother and grandmother—should always be taken, if possible. The warmth and tenderness of the family is clearly shown. People will treasure this photo for many years after it is made.

Enhancing Through Pose and Light

There are many subtle touches you can bring to a photograph which might not be noticed at first glance, but which definitely enhance the image. When you have a subject in front of your camera, you can choose the way the light falls across her face and body, from what height and camera angle you will photograph them, and ways in which you will refine the pose as you get ready to make the picture.

Each of these considerations goes into making a successful photograph. Successful meaning how effectively you communicate the moment and the person in that moment and how you enhance it all by technique and visual mastery, rather than by merely following all the rules.

Note how the light falls across the subject from the window and the face seems to give off a beautiful glow. Consider how the dress becomes a form of fill card and how its line and shape endow a classic look to the figure. Follow the line of the pearls and see how the oval is continued at the chin, and note how the subject's nose doesn't break her cheek line. Then study the placement of the veil, the hand and even the way the elbow is bent.

These compositional and posing matters are important considerations when making photographs. Although you needn't be self-conscious or nervous about all this when working in the heat of the wedding day, you should begin the process of having these refinements become second nature to you. As they become more natural, your eye will become more aware of posing and light in every image you make. It's an exciting process that rewards how you see and the pictures you'll produce.

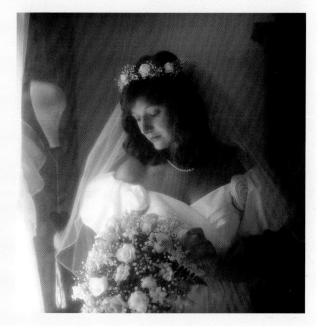

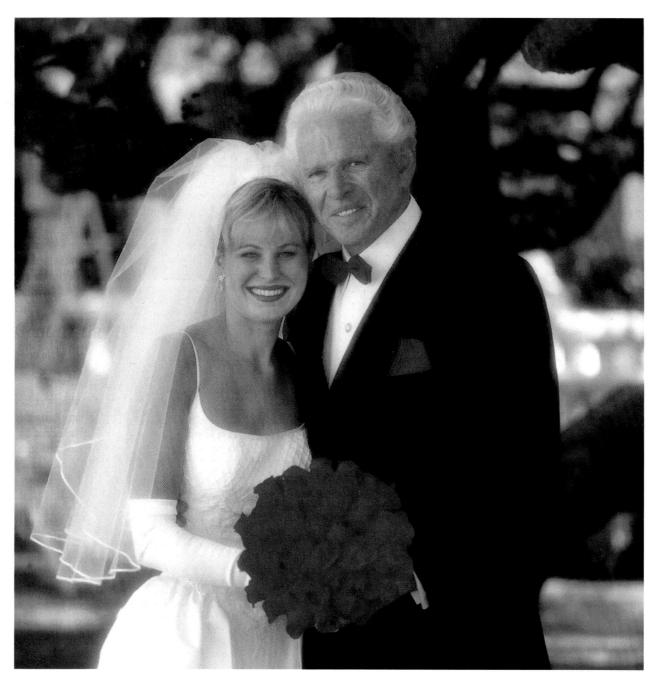

This beautiful portrait of father and daughter was made at 1/60 second at 1/60 with a 250mm lens (on a medium-format Hasselblad camera). The shallow depth of field created with the telephoto lens made for a painterly background. Placing the heads close together in a portrait such as this is very important to the sense of togetherness it portrays.

BEFORE THE CEREMONY

A Portrait of Father and Daughter

HE EMOTIONS BETWEEN FATHER AND DAUGHter on the wedding day are strong, and your photographs should convey the feelings of warmth and affection they share. Although it seems traditional that these statements are less intimate than those of mother and daughter, there's no reason for the poses to seem stiff and proper. While many people may take a natural pose for this shot, you may have to work harder to get the feelings into the picture with others.

You can approach this shot from a number of different angles. If the father seems particularly nervous, you can have the bride helping him get ready for the day. She can be posed straightening his tie or putting a flower in his lapel. If he's calm and collected, you can pose them together arm in arm, hugging or sitting quietly with one another.

Though shots portraying the dependent, protected daughter looking up to daddy may still be popular, societal roles and attitudes have changed. If you force people to adopt a pose that isn't natural to them, you won't be doing

your job and you'll get a false picture in the bargain. Rather than fall into a clichéd pose, try to get a real sense of the father-daughter relationship and use your posing ability to express it.

One of the emotions you may sense is the pride the father has in his daughter. You can express this pride by having the father relating strongly to his daughter's presence, by the look in his eye or the stance he takes next to her. As in the mother-daughter shots, have the two relate strongly to each other through look and touch.

These are people who have shared a good part of their lives together, with all the time and emotions that implies. You might find an area in the house where they've shared meaningful times, or an activity that has helped them bridge the gap between them. You might inquire about these matters, and ask them to help you tell the story in a way that only they can know. These details can help you express the story of these two people, and put real meaning into the pictures made on a very important day in their lives.

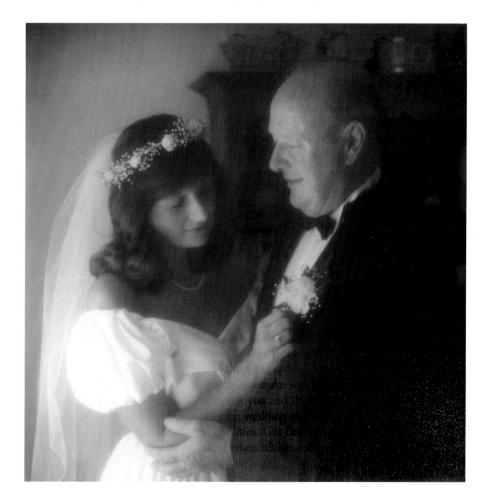

Window light provides a wonderful touch in this tender moment between father and daughter. Having the daughter straighten the father's tie or attach the boutonniere is an excellent pose.

BEFORE THE CEREMONY

Highlighting the Family's Closeness

HOTOGRAPHING THE TRIO OF BRIDE, mother, and father allows for many posing choices, and all should feature the love and caring that binds them together. Since this is a special day for all concerned, capturing their emotions, particularly through touching poses, is important. Because you have a threesome, you can use a diamond-style setup, with two people seated and the third standing behind them. Add the bouquet or train of the gown as the bottom tip of the compass.

If you're doing a straightforward picture, shoot a waistup shot with the trio arm in arm, and have them snuggle in together. Don't revert to a stiff pose. Talk them into a pose that conveys a feeling of closeness. Although most people will fall into a natural pose in this situation, keep your eyes open for refining touches. Watch for the way lines flow and move through the image and how the light enhances each subject.

Using props can be extremely helpful with a small group such as this, and staircases, armchairs, and couches

should be used to the fullest. Whenever you have people seated, make them sit "on the edge of their chairs" so to speak, or have them sit laterally across the seat of the chair. Don't allow them to plop back into the seat, and be aware of how jackets and/or dresses ride up.

Hands can become a problem in small groups, and a general rule to follow is either show all of the hand or none of it. Don't allow a thumb to stick out over a shoulder (if they're in a "huddle" shot) or two fingers to peek out from a waist. Make being aware of these distracting elements a part of your visual once-over before you snap the shutter.

This will be the last picture of the bride and her mother and father before her marriage. To say that emotions were strong at this time would be an understatement. Don't get in the way of those emotions, and don't pose the people unnaturally so they feel confused by your directions. Get them together for the picture, help them pose in a comfortable way, and you'll get all the pictures you need for a successful take.

Chairs and the arms of chairs make for great extemporaneous posing tools for groups of four to seven people. They allow you to create poses with multiple levels and help rescue you from "lineup" photographs. Here, the pose and placement of the family creates a strong inverse triangle and an overall diamond form.

In this pose, a single chair is used with family members leaning in to create a sense of closeness. Keep a balance between the lean-in and the off-balance, but always keep in mind that leaning in can give a strong feeling of group togetherness to an image.

Two chairs and the arms of the chairs are used to good effect here in this larger-size family pose. Note the balance and equilibrium of the pose in a two-three-two rhythm. Flash from the side and fill creates a balance between foreground and background and eliminates possible harsh shadows.

The pride of the family is expressed strongly here with this congratulations handshake pose. Each member of this handsome family projects the feelings of the day.

BEFORE THE CEREMONY

Posing the Bride and Her Attendants

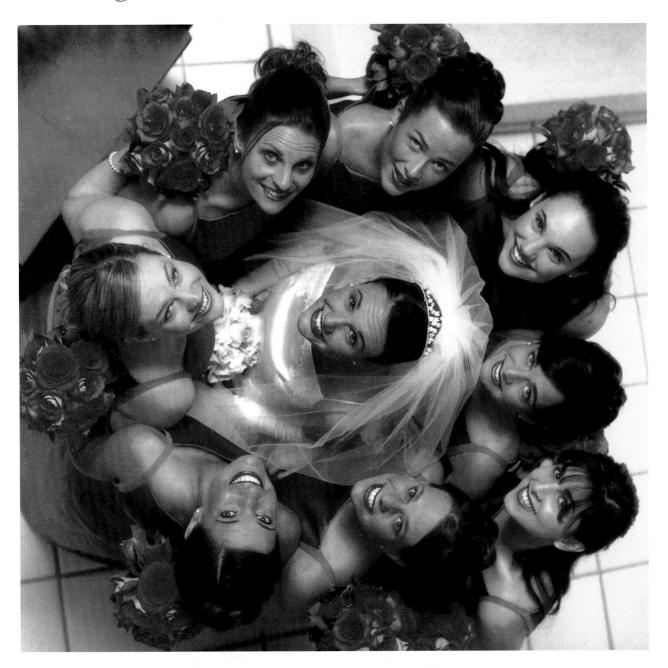

bridesmaids are stiff, and the resulting shots look like high school yearbook material. You may have a small party of four, or a group as big as ten. The type of posing will, to some extent, be determined by the size of the bridal party. Small groups lend themselves to more intimate settings, such as around a chair or couch, while larger groups may require that you step outside for the

shot (depending, of course, on the size of the shooting area in the home and the weather.)

The bridal party consists of friends, colleagues, and honored guests of the bride. They're usually attired in the same style and color gown. Although the bride almost always wears white, the bridal party may wear pastels, dyed lace, or other "party" style dresses. Always consider your backgrounds when shooting the bridal party, making sure you

don't have color clashes. Purple drapes and bright orange dresses can make for a visually alarming photograph.

In all shots with the bridal party, the bride should be the center of attention. This can be accomplished by posing her in the middle of the group, with the bridal party arrayed around her, or by having the group arranged so their motion is toward the bride. With a small group, you can have the bridesmaids around the bride like a halo, or have some sitting with her on a couch and the others leaning in from behind.

For larger groups, you can line the group up, but only if there's a sense of motion involved. Turn each person three-quarters facing the bride, with the dresses fully flourished, or have the bridal party arranged in groups of diamonds with the bride in the center. (A diamond group is composed of four people, or three people and an implied fourth; this shot has to be taken from the front, at a high angle.) Watch for flowing lines throughout the group, just as you would in a close-up of the bride herself.

It's okay to have fun with this shot, and not every pose has to be a setup shot. You can have the bridesmaids crowding around admiring the ring, or each involved in arranging a part of the bride's attire. Get one or two formals, but don't be afraid to get loose with this group shot. Never be afraid to experiment with the group's personality, as you may end up stifling the good times that are a part of the day.

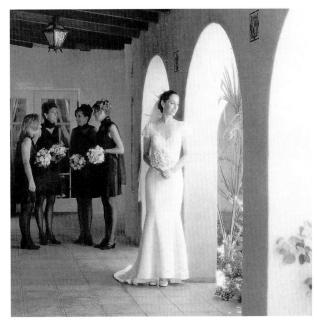

Natural light provides another interesting take on the bride and attendants photograph. The bride stands somewhat apart from the group contemplating the day and perhaps her life ahead. The happiness in her expression is evident. The supporting attendants are present and provide a visually interesting balance but not in a standard pose.

Opposite: Always on the lookout for unique angles, Ken made this photograph from above with a 120mm lens (on a Hasselblad medium-format camera) at f/8 at 1/15 second.

This large group photograph uses diamonds and triangles for a sense of cohesion and balance. The bride stands in the center surrounded by the attendants. None of the faces of the women sitting next to each other is on the same horizontal plane.

BEFORE THE CEREMONY

The Bride and Her Maid of Honor

s MENTIONED PREVIOUSLY, THE MAID OF honor has a special place in the wedding day. She's there to make sure everything runs smoothly, to serve as stylist, to do errands, and even to occasionally hold the bride's hand. Being maid of honor means that the woman is one of the bride's best friends and confidants. Therefore, pictures of the two of them together should express this closeness and intimacy.

Many picture opportunities involving these two people will present themselves during the course of the day. You can capture them together during the preparation at home, at the church, or at the reception. Effective shots include the maid of honor helping the bride with her veil, helping the bride with her train, or even sharing a quiet moment or a laugh together.

Cheek to cheek is a great way to show closeness. The bride and her maid of honor posed here with bordering bouquets for a colorful edge and shallow depth of field to eliminate any distractions in the background.

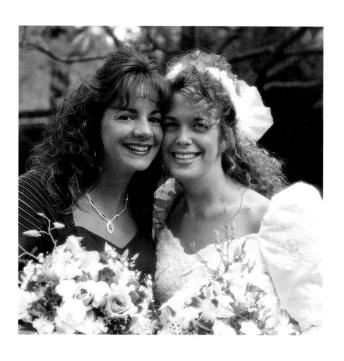

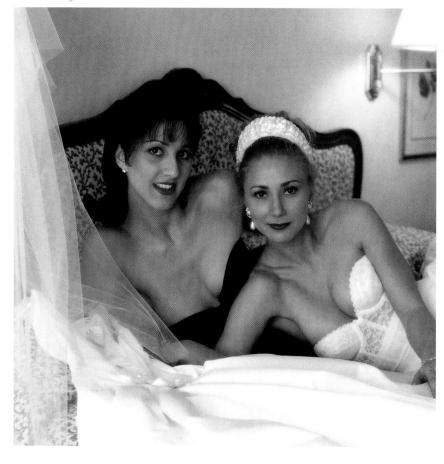

Taking a break in their preparations, the bride and her maid of honor are photographed using a combination of room and window light and flash. Arrival at the house or dressing area at an appointed time helps make photographs such as this possible. Work with your clients so they have enough time to prepare and you have enough to make your photographs.

Opposite: Ken uses the bridal bouquet as a lower border, placing it out of focus to add a splash of color to the scene. Heads together suggest closeness and intimacy and help make for a more cohesive composition.

Dealing with the Nervous Bride and Groom

A bride and groom's nervousness is a natural reaction to the heightened state of emotion on the wedding day. Sometimes this nervousness can spill over into some odd behavior like giggling or withdrawal. This is more likely to happen before the ceremony than after, so if you find that posing either the bride or the groom is difficult at that point, wait until later for the images described in this chapter. Above all, don't panic yourself or begin to make unreasonable demands.

Calm the couple with words and actions. There's little sense in elaborate poses now, so take your time and back off. Sit with the couple and talk with them about how you can work together later or calm them enough to get a few photographs now. You

might even make a bit of a game out of their nervousness and play with it to get some fun photos.

Most important, reassure them that you're there to work with them and that you're there as a friend as well as their photographer. As the day progresses, you'll see how this helps you get the photographs you want and need and makes for a more pleasant experience for all concerned.

Above all know when you're licked and hold off on pictures until later. After the ceremony everyone is calmer.

In most instances it is a good idea to remain calm when everyone about you seems to be losing their cool. It's a hectic time for all. Get the photographs you need, but not at the expense of making everyone more nervous than they already are.

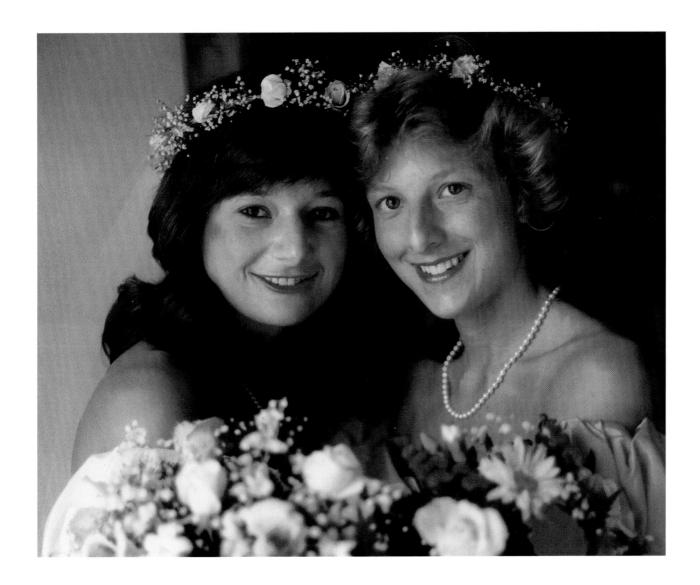

BEFORE THE CEREMONY

Focusing on the Ring Bearer and Flower Girl

source of some very precious photographs, and ones guaranteed to be good sellers, is the ring bearer and flower girl. Seldom are children so charmingly dressed and well behaved as when they appear in these roles. Children tend to take these jobs very seriously, and the attention they're given makes them feel very special during the day.

These shots may be made with each child separately, with the children together, or with the children with the bride and/or groom. Usually, the flower girl will be in attendance at the bride's home, so take shots of the bride and her together at that time. The child can be posed next to the bride seated in a chair. They can be exchanging flowers, relaxing together, or admiring the bouquet.

As the flower girl is usually the picture of innocence, photographs with her and the bride can be made even more ethereal with the use of a light vignetter or soft-focus attachment. Center the two in the middle of the vignette, and use a soft backlight to add a halo to the scene.

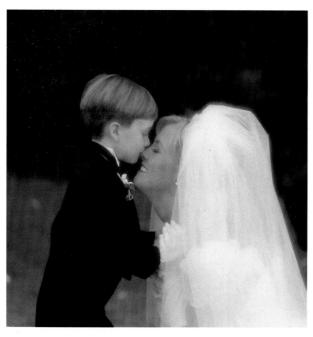

The bride has come right down to the level of the ring bearer to give him a friendly snuggle. This wonderful image appears as if it were made against a painted backdrop, achieved by shallow depth of field from a 120mm lens at f/5.6.

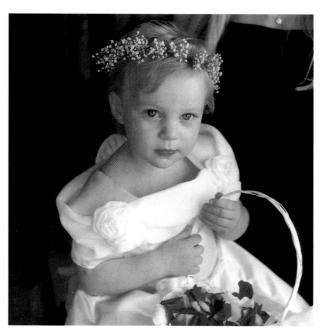

This lovely flower girl was photographed from slightly above her eye level to get her to raise her eyes expressively. She is posed right on the lap of another member of the wedding party.

Pictures of the girl and boy together can be very charming. You may have little luck making them stay in a preconceived pose, but don't worry—kids being kids, they'll give you plenty to work with. The little boy may have never dressed in such a tailored fashion, and in almost mock gravity, he'll walk around with a sense of importance mingled with a great deal of shyness. Asking him to hold hands with the flower girl, or to stand still for a kiss from her, may be too much for his dignity, so just put the two together and get ready to photograph.

Shots of the ring bearer with the groom can also be special. Although this will have to wait for later, you can have the boy sitting on the groom's knee or holding the ring out for both to admire. The boy will probably be taking the job quite seriously, so don't pose him in a way that will be embarrassing. He will probably be blushing enough already.

One word of advice: get the shots of the children early; as the day passes they may become tired and cranky. They'll certainly become more rambunctious. While this also holds true for adults, the older folk generally don't act it out as much as children.

BEFORE THE CEREMONY

Designing with Diagonal Lines and Curves

N EACH PICTURE YOU TAKE, THERE SHOULD BE a rhythm, a flow of form, a consciousness about the fold of fabric, and a sense that there is a logic to every line in the frame. While this may sound like nitpicking, it's important that your composition be tight and disciplined. The same holds true for every other form of expression. In music, a piece loses its flow if the drummer falls out of rhythm; in ballet, a dancer is careful not to waste a move. The pleasure a viewer derives from a photograph comes from more than just the subject matter—it's determined by the subtleties of where and how the center of light

falls and how the eye is coaxed along as it moves through the frame.

One of the most visually captivating techniques photographers use is to provoke the eye through the use of diagonal lines that run from one corner to another. This needn't be an obvious line or object that crosses through the frame. Diagonal lines can be induced by having a hand and the head held at a certain angle or by a prop, such as a staircase, that leads the eye through the frame.

A variation on the diagonal line is the S curve, another way of leading the eye through a print. Here, posing is

A photographic composition relies on a number of design elements to make for a visually exciting picture. You will develop your own sense of design as you work and study the work of others. Here the placement and direction of the arms echoes the shape of the stuccoed handrails and stair supports. The flow of the veil can be followed to the top of the groom's head and down through his arm to meet again to create a circle in the center of the frame. Within all that we also have a very handsome expression on the couple's faces.

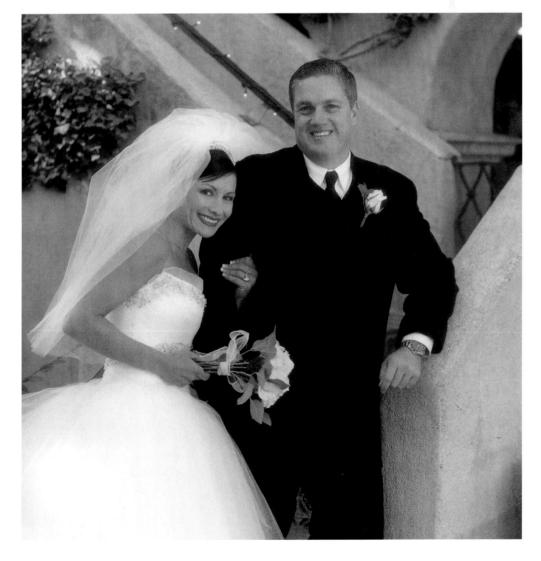

enhanced by visually superimposing this graceful sweep of line onto the picture. By removing the burdensome horizontal composition, or breaking it up with diagonals and S curves, you create a flow and rhythm in your work. You, therefore, entice the viewer to linger a bit longer with the image. Don't let subjects get too loose, or have them bend in uncharacteristic fashion, but just keep these visual techniques in mind when looking through your viewfinder.

When composing, attention should be paid to your background as well as your main subject matter. A strong

vertical, such as a straight-backed chair or even a fence post, will detract from even the most graceful pose. If you do make a shot with a fence in the picture, consider making it a diagonal line rather than a straight horizontal or vertical line. You'll notice a dynamic difference in the composition.

The most obvious example of strong vertical or horizontal backgrounds detracting from a picture is the classic telephone pole emerging from someone's head. You've trained your eye to look out for that problem; now go one step further and keep a flow and sweep in your images.

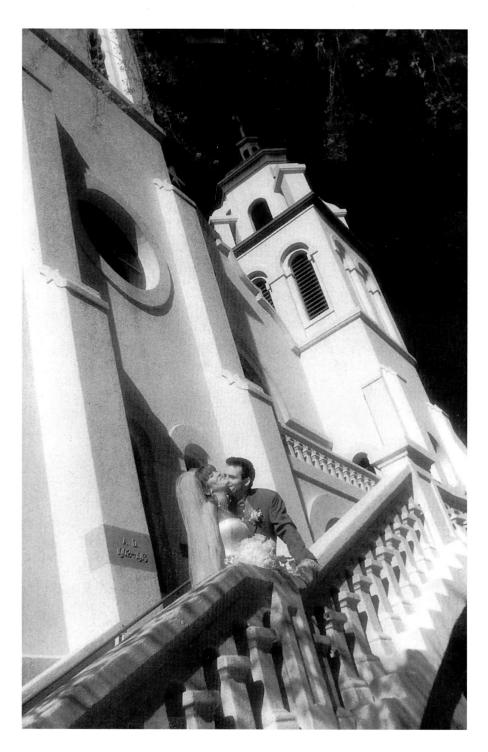

As a practitioner of infrared photography, Ken can visualize results when working with certain types of light and subject matter. Here he uses a wide-angle lens to emphasize the diagonal composition and to exaggerate the tilt of the church. The infrared effect creates even more dramatic shadows and depth.

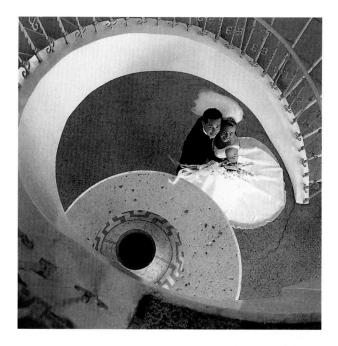

The downward spiral here brings the eye around the picture to the bride and groom at the base of the stairs. Note how Ken has arranged the dress in a circular fashion to echo the shapes and forms of the surrounding.

The location here is a photographer's dream, but making the image right can be a challenge. The light at the top of the steps provided some illumination, but a backlit flash also helped to separate the couple from the background. The sweep and curve of the stairs made for a great sense of "negative space" in the foreground right that enhanced the graceful curve even more.

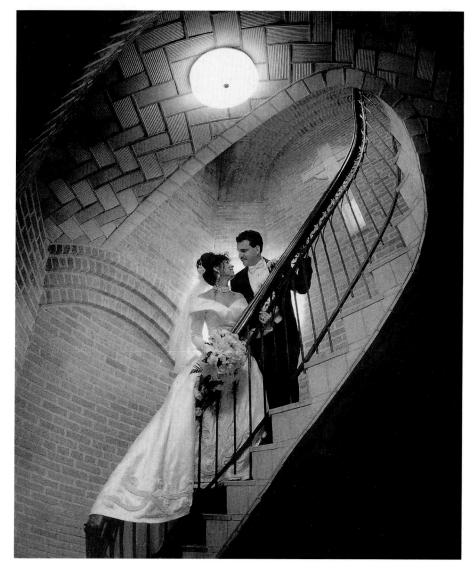

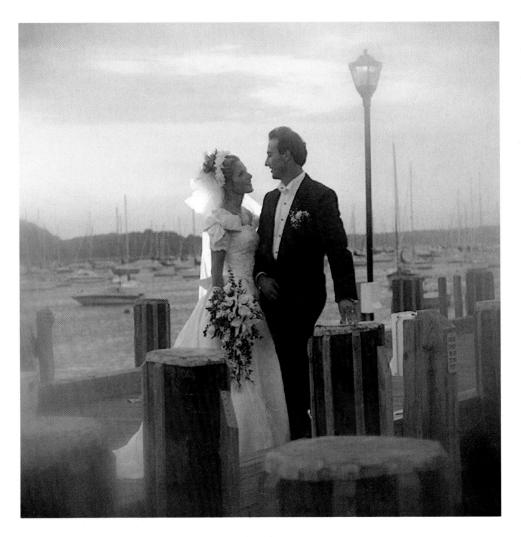

The soft light of sunset provides a wonderful mood in this portrait of bride and groom. The potentially obtrusive pilings have been softened through the use of selective focusing techniques, while a diffusion vignetter has softened the edges. Moviemakers call the time of day right before sunset the "magic hour" because of its light. Photographs like this help explain why.

Using Existing and Artificial Light

sing and controlling light is the key to making good pictures. During the wedding day, you'll be dealing with both natural and artificial light and combinations of the two. Knowing how to read light and make it a creative resource is important to all types of photography, and wedding photography is certainly no exception. In fact, utilizing light during a wedding can often be more demanding than in any other type of setting. You can return to a landscape for a picture if conditions on a particular day aren't favorable. You can take hours setting up studio lighting for a commercial shot. No such luxury exists on the wedding day—you have to work with what you've got and make the best of it. That's why you've got to be flexible and think on your feet to use the light you have to best advantage.

Generally, natural light is preferable to artificial light, but there are many times when fill flash technique must come to the rescue. If there is a contrast problem, use the natural light as your main light and fill with strobe. Lightly curtained, large, bay windows yield soft, rich light. Once you find this light, how do you make best use of it?

The first step is knowing how to read the light. Let's say you want to make a portrait of the bride using the light coming through a window. When posing, keep the front of the bride's dress away from the light source. The white field might throw off your exposure and cause her face to be underexposed. Turn the bride's head toward the light, letting it model her features as it skims over her face.

Take a light reading from both the highlight and shadows (that is, from the shadow area in which you want to

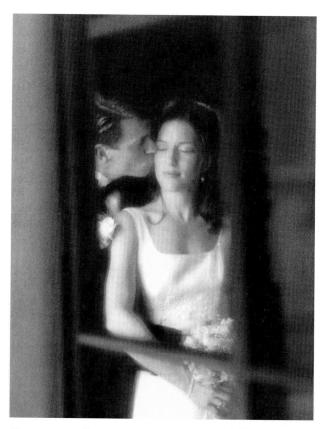

This image was illuminated by window light and is actually a reflected image. The photograph was made at 1/15 second at f/5.6. It is a great use of the expressive quality of light.

show detail). If using a reflective meter, take the reading right off the face. If using an incident meter, take a reading from the light falling on both sides of the face from subject position. If these readings yield more than a two stop range, you're probably getting too much contrast. Adjust your pose accordingly. You can decrease contrast in pose by moving the bride further away from the window (thus decreasing light intensity) or by using fill flash or setting up reflector cards to fill the shadow side of the face.

Take readings after your adjustment, and look for a range of no more than two stops (1.5 stops is preferred) between highlight and shadow. Expose for the shadow reading or a half stop above the shadow and you'll get a full-scale negative that can be printed to perfection by the lab.

If, for some reason, you want a high contrast look, set the picture up so that the difference between highlight and shadow is greater than two stops. Expose at one stop below the highlight reading and have the lab print for detail in the highlight. If you want to create a silhouette, set the scene up for a difference of three stops or more between the highlight and shadow and expose at the highlight reading (the background).

Intimate pictures in the home are easily done when you have a good diffused light source and you make the readings bring out the rich values on the film. These images always possess a quiet elegance.

If the day is heavily overcast or the home has no natural light to offer, you can use artificial light and still get a sense of intimate illumination in the scene. You can use an on-camera strobe bounced or filtered or, preferably, an off-camera light with your strobe mounted on a light pole. Any handle-mount strobe can be diffused with a soft box attachment. The best bet is to use mini power packs and the strobe mounted in a softbox or diffused with an umbrella. This gives you more control over the light and allows you to set it up for any type of angle shooting. Whatever you do, always avoid the direct burst of light from an unfiltered or undiffused oncamera flash. This point source of light is the least complimentary. Light coming from the side is always better than light coming right from the camera position.

There are a host of soft boxes that yield a beautiful and diffused light source. They come in oval, rectangular and even star-shaped varieties. Each yields a different lighting effect, but all diffuse the light in a pleasing way. If you are using an umbrella setup, use a matter rather than a super silver variety. Specular light from the silver reflector may be too "sharp" for your purposes here.

Creating even, modeled light or high contrast scenes is achieved by a method similar to that used with natural light,

Wedding photography usually involves a subtle balance between available or natural light and flash illumination. The trick is to create a natural look with flash while maintaining enough ambient light to make it believable. This takes time and practice and is one of the main feats of mastering the craft. Ken used a long shutter speed to evoke a glow from the lamps, yet needed to use flash to properly illuminate the bride and groom. To a photographer, it's obvious the lamps could never provide the right or even enough light to give this result. To the client and viewer, it may look as if the romantic glow of the lamps is what illuminated this image. Study of lighting in movies and working with a balance of flash and ambient light will help you master these techniques.

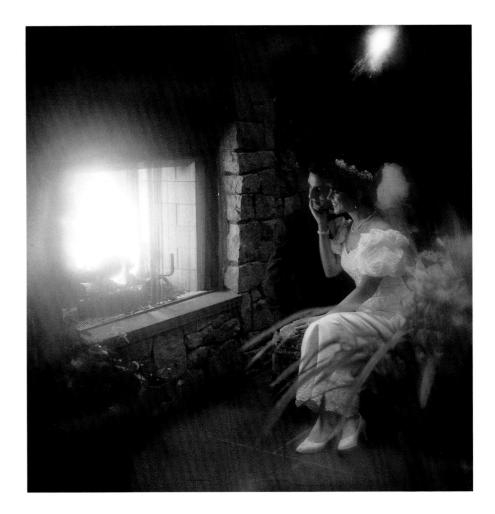

The glow of the fire is supplemented here, with a flash placed off to the left of the photographer. A long exposure time creates the sense of light, but the flash handles the actual exposure of the subjects. Working with and enhancing light is an essential part of mood portraits such as this one.

except with strobes you create highlight and shadow by using two light sources, and sometimes a third kicker or background light. Set up your lights so that they skim across the picture plane (from the sides) rather than have them punch directly at the subjects. Too strong a light bouncing directly back from a wedding gown can cause problems.

Your two lights will consist of a key light and fill light, much like the sunlight and natural reflector card setup described before. Set the key light for full or half power and the fill light for a quarter power setting below the key light. This has the effect of yielding one less stop of light from the fill, thus providing modeling through shadow and highlight to your scene. Use the modeling lights in the strobes (preview lights that show the ratio, though not the intensity, of your lighting setup) to help set up the lighting, and move the lights around until you get the look you want.

Always have the brightest light source coming from the darkest part of the scene. For example, if doing a couples shot and one of the subjects is in a dark tuxedo, put him on the side of the key light. That way you avoid harsh reflections from the bridal gown, which will throw off your exposure, and allow the gown to serve as a natural reflector into the darker clothing.

For scenes where you want high contrast, you can either turn off the fill light completely, have it two steps

below the key or use a background slave to throw glowing highlights around your subjects. Another popular use of strobes is directional lighting, where the strobe is off to the side of the subjects and is definitely "off-camera." This is great for pictures of singles or couples, but isn't recommended for large group shots because you may get uneven coverage.

Strobes can also be used as a way of lightening or darkening areas in the scene. If you have a room where there's a certain amount of ambient light created by lamps or a brief shaft of sunlight, expose at 1/15 second. This will illuminate the subject plus allow the glow of the lamps to record on the film. If you want to isolate the subject in the room, expose at 1/250 second. This will darken the surrounding area and allow little, if any, ambient light to be recorded. This slow sync technique is essential in many wedding photographs and should be mastered as part of getting great light in many scenes.

Combinations with two or more strobes can be used for many creative lighting setups. Note how Ken often uses a backlight strobe to add edge glow and definition to a single or couple photograph. The solutions are endless, depending on the power of your strobes and how you direct light around the scene. Practice with your lights, learn how to read strobe output with a flash meter, and be able to predict the effect you achieve with each variation.

The "Final" Farewell

HE FAREWELL TO HEARTH AND HOME IS A traditional shot requested by many couples, and although it's chronologically the last shot in the home "script," you should try to set it up prior to the actual departure to the ceremony. If you wait around until everyone is ready to go, you'll have to race to the church to get the shots you want there before the ceremony. Once the bridal party arrives at the church, everything is set in motion. Besides, you'll have to give yourself time to pack your gear and reload your camera for the next series of photographs.

The departure shot is what's called a "grab shot," so it shouldn't take more than a few minutes of everyone's time to set up. An easy way to pose this shot is at the front door or steps of the home. Have the bride and the bridal party at the bottom of the steps and the family at the top waving good-bye, or have the father open the front door for the bride while the mother looks on or waves so long. If the limousine or bridal car arrives early (don't count on that happening) you can get a shot of the father opening the car door for his daughter with the mother helping her with the gown. Another option is to have the mother and father at the bottom of the steps, and the bride descending the staircase helped by the maid of honor.

As this is a staged shot, any of these variations will do, so let your directorial spirit take over and design new setups on this basic scenario. The idea is to get the shot and get moving because the next hour or two of your life will be very busy. Make sure that you get to the church way before the start time of the ceremony.

The father helping the bride into the limousine prior to the ceremony is a classic wedding photograph. Note the low viewing angle of the image, the quiet demeanor of the subjects, and the sense of grace projected by the fill-flash lighting, the scene and the subjects themselves.

Father and daughter are posed here as the limo is about to leave for the church. A flash from the side properly exposes both subjects without overwhelming the car door or white of the dress.

PHOTOGRAPHING AT THE CEREMONY: BEFORE, DURING AND AFTER

HE PICTURES DESCRIBED IN THE FOLlowing sections all take place in and around the church, synagogue or wedding site before, during and after the ceremony. When they take place is often out of your control, as some churches allow pictures to be taken during the ceremony, some allow a few discreet shots during the service and others absolutely forbid any pictures while the wedding is taking place. In order to help smooth the way, it's best to check out a few things before the day of the wedding itself.

Contact the Wedding Site

Soon after the wedding is booked (or at least a month before the service, as some weddings are booked a year in advance), call the priest, minister, or rabbi and inquire about the institution's policy on photography during the service. This indicates that you're willing to respect the church and its policies, establishes a spirit of cooperation between you and the minister, lets you know what you can and cannot do, and subsequently, helps you plan your shooting strategy for the day.

If you get permission to shoot at will during the service, it still doesn't give you license to blunder about the altar with whirring motor drive and popping strobe. Discretion is always the name of the game so consider using a moderate telephoto lens and standing back a bit for the service. Some photographers spend so much time on the altar you might think they're getting married too.

If you get permission to take a few pictures during the ceremony, such as the "giving away of the bride" and the ring ceremony, honor that understanding by getting those pictures and then moving out of the way. You can also get good pictures from the back of the church or the balcony, should the building have one. Ministers have been known to stop in midservice and order an over-enthusiastic photographer to stop shooting pictures. Save yourself, and your clients, this embarrassment by respecting the presiding official's wishes.

If no pictures at all are permitted during the service, request that the couple stay a few minutes after for a reenactment of a few scenes from the wedding. Although this

may sound a bit artificial, it's actually a successful method of obtaining the best possible pictures from the key points in the proceedings. In fact, it may be the best and most discreet way of getting the pictures you want from the service since you have absolute control over posing and camera angle. You certainly can't be calling out directions for posing during the actual service. Also, by getting permission to shoot in the church after the service you'll have an opportunity to make great portraits of the couple and the whole bridal party in the context of the church. Keep in mind that you should get permission for making pictures after regardless of whether you've been able to shoot during the ceremony or not.

Scout the Location

Another way of preparing for the shots in and around the site is to scout the location before the day of the actual shooting. Not all churches or synagogues are alike, and some will offer advantages and others disadvantages in your shooting script. See if you can move around the altar, or if it's right against the back of the room. Is there a balcony or choir loft for long range shooting? Will it be available to you during the ceremony? Again, talking with the minister or rabbi beforehand opens a door that might otherwise have been locked. If possible, visit at the same approximate time of day as when the ceremony will be taking place in order to get a feel for the light. This will help you preplan some shots.

The Wedding Rehearsal

An optional preparation is to attend a rehearsal of the service itself. More and more couples are structuring their own ceremonies to reflect their own lifestyles. Some have chamber orchestras performing, guitar solos by younger sisters, or even friends reading passages from favorite works of literature. Knowledge of these or any special events will help you become a better visual storyteller. If you can't make the rehearsal, at least get a good idea of the script of the wedding beforehand. Don't miss those moments that make every ceremony unique.

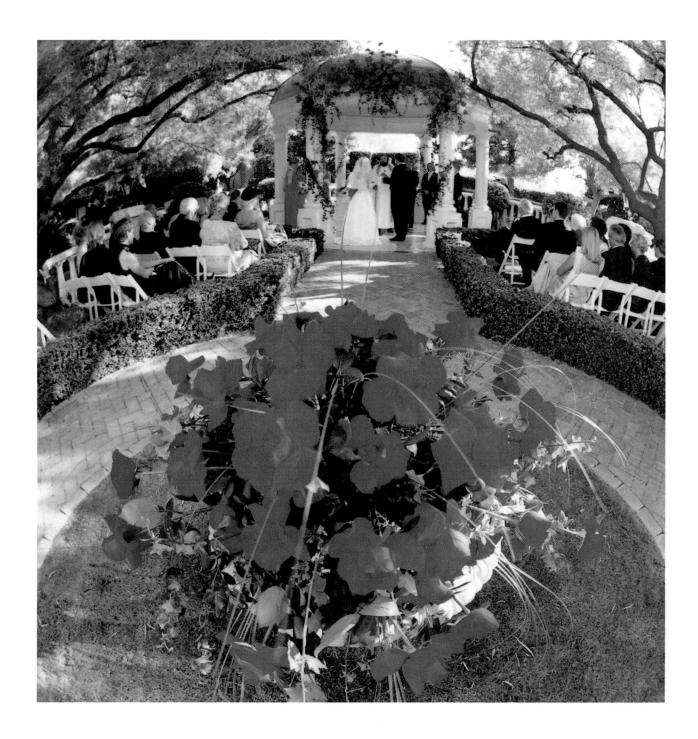

Talk to the Best Man

When you finally arrive at the church or synagogue after your shooting session at the bride's house, find and enlist the help of the best man to act as your liaison. He can help you identify those important people that need to be photographed as they are escorted down the aisle. He can also gather the rest of the wedding party for the various shots you'll want to take prior to the ceremony.

If you're doing outdoor shots of the groom, or the groom and the ushers, don't stray too far from the grounds of the church and make sure there's some line of communication between you and the people inside. As with all location work, the wedding site will present a set of challenges and opportunities. Get familiar with the location and you'll be prepared when it's time to get down to work.

The Groom's Reflections

HE FINAL MOMENTS OF BACHELORHOOD ARE an interesting time in a man's life. If the couple has been going out for years, living together prior to being married, or is getting married soon after being swept away, the man (and of course, the woman) always has a few moments of thought before the wedding. These thoughts may cause a transformation in facial expression, a twinkle in the eye and a joyful or anxious look. Your being present at this time gives you a unique opportunity to record and interpret these feelings. Rather than look for formal poses, choose more candid ones that capture the natural and spontaneous emotions of the groom.

Just as the bridal shots often mirror a contemplative mood, the shots of the groom can be made with him looking out a window, awaiting the arrival of the bridal party or just wistfully thinking of his wife-to-be. Since he may feel a bit awkward in front of the camera at this time, help with some verbal encouragement and touch posing.

Unlike the bride, who is wearing a beautiful dress with

ruffles and flourishes, the groom might be clad in the somewhat austere fashion of a tuxedo. This clothing is meant to accentuate lines and angles and offers little of the bridal gown's visual play. For that reason, you'll have to be more conscious of posing and helping the groom look less stiff than his clothing makes him seem. Having him turn his head or lean against a support can give motion to a potentially straight-line shot. Be aware of the collar of the coat riding up over the neck, the sleeves coming out from the arms of the coat, the dreaded "helicopter" (askew) bow tie, and other details that can turn a well-tailored look into a poorly worn garment. Many tuxedos are rented and aren't always tailor-made for the groom.

Posing should be casual. A good source of ideas for shots are men's fashion magazines—emulate the "look" you see there or design your own to fit the individual. Resting a leg on a chair or other prop, with an arm across the knee and head and shoulders leaning in towards the camera can yield a very dynamic look. Hands can be in the pockets or thumbs

hitched in the pocket or waistband to convey a relaxed, confident mood.

A dark vignetter can be put to good use at this time because it helps to eliminate a less than staged background plus it focuses the light and attention on the groom's face. If you use this filter, you can shoot from a low or medium angle to give a sense of presence to the subject.

Too often, shots of the groom before the ceremony make him look like he's waiting for a bus. Use motion and dynamism in the shots to reveal the sense of heightened awareness that is so evident in the individual at this time.

Although photographs of the groom throughout the day will show many different emotions, use the time right before the ceremony to catch him in a thoughtful pose. This photograph works with light, architecture, posing, and expression to capture his mood.

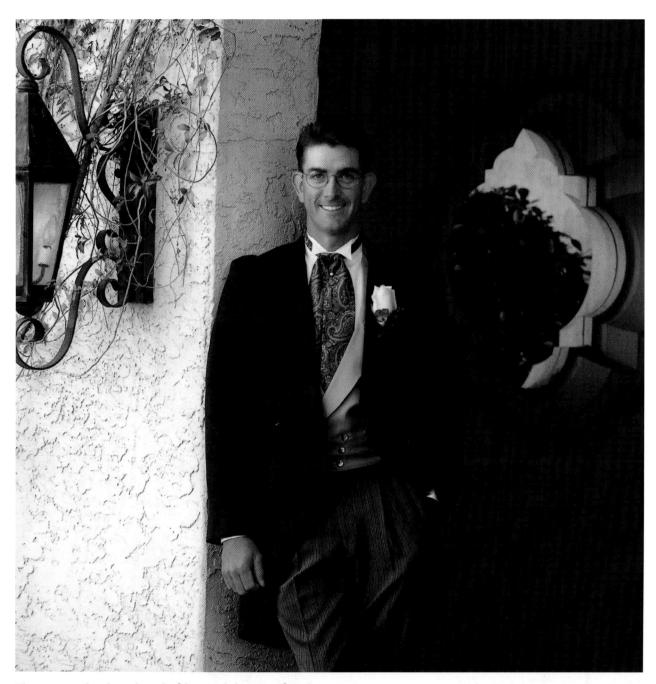

The groom stands right in the path of direction light coming from the left making for a strong and exciting lighting ratio on his face. Note how Ken has posed the groom in a comfortable position against the wall without having him leaning too far. Note also the position of the hands and the handsome cut of the coat. Styling has much to do with the success of this image.

The Groom and His Best Man

HE BEST MAN IS USUALLY THE GROOM'S BEST friend or closest male relative, and serves as valet, bodyguard, and confidant before, during and right after the wedding ceremony. The bond between the two men is an important part of the wedding story, and it should be a part of your photo record. Stress this bond in your pictures and make images that show the camaraderie and caring the two men share.

Easy ways to handle this shot, though poor excuses for pictures, are to either line the men up against a wall for a double "passport" photo or have them standing next to each other for a long shot in the context of the church. If set up and taken properly, this shot has the potential to be a very warm and sometimes humorous photo. Encourage the men to interact, and interject some comments about the impending wedding.

Popular shots include posing the best man looking at

his watch, informing the groom that the time for the wedding is drawing near. With the camera slightly behind the best man, his profile and hand with watch showing, position the groom on the right side of the frame. Other set shots include the best man offering a handkerchief to the groom, or the best man having a heart-to-heart talk with him.

The best shots are those depicting the real friendship that exists between the men. Hugging, clasping hands, high fives, or photographs of them with their arms around each other's shoulders are effective. These shots allow them to show affection without the need for a setup. Encourage this sharing, and get shots that are spontaneous without being affected. The days when men had to be stiff and formal with each other are, we hope, over. While you're picturing these spontaneous moments, always keep an eye out for the details that can make or break the shot. Having people pose informally doesn't mean you can take sloppy pictures.

The best man is usually a close relative or friend of the groom and photographs of them together should communicate this bond.
Refrain from doing lineups or passport poses. This action, although posed, shows the friendliness between the two men. When showing personal bonds have people relating to one another, not to the camera.

The Groom and His Ushers

F YOU GET TO THE SITE EARLY ENOUGH BEFORE the ceremony, you'll have time to get a few shots of the groom and his retinue. Although you can get shots later in your environmentals, or even at the reception, this is an opportunity to get a fairly formal portrait of the group. After the ceremony, the group may be much less serious about getting their formals done. At this point they are still involved with the task at hand, they'll be on their best behavior, and they'll still be impressed with themselves and their outfits.

Although this shot may be more formal, that's still no excuse to just line up the group and make a "team" picture. Scout locations in and around the church and find the architecture and landscaping that lends itself to posing. Arrange the group in and around the environment, and have the best man serve as your assistant director.

A number of poses are possible in this situation. You may line the men up with their bodies at a three-quarter angle and shoot from a low vantagepoint—about waist-high. This camera angle lends strength to their stance and makes everyone look taller and quite "formal." Another pose places the best man shaking hands with the groom in the foreground, with the ushers arrayed behind them or to the right side of the frame. Set your aperture so both the foreground and background are in focus. You can also use the church steps as a posing area, and have the men forming a V with the groom in the center. You needn't rely on stock poses here, although you can't take all day posing the group either.

For interiors, you can have the groom sitting in a chair and the ushers leaning in towards him from behind, all with a hand on his shoulders, thus showing a feeling of support. Also, you can pose the entire group with one leg up on a bench and one arm resting across a knee. The other hand can be hitched in a side pocket. Have them lean in toward the camera.

After the ceremony is complete, you will have time for more relaxed, informal and even humorous shots of the groom and ushers. Take advantage of the time before the ceremony to get strong formals, but pose as quickly as you can because everyone is preoccupied with many details.

These two photographs illustrate two distinct approaches to a group photograph of the groom and his ushers. The long shot makes great use of the architecture of the building, with a perfect balance of details, flowers and people. The groom stands at the center.

This fun photograph was made with a fisheye lens held quite close to the group. The shades and posing make it look more like a CD cover than a classic groom and ushers photo.

Arriving at the Church

TATIONING YOURSELF IN FRONT OF THE CHURCH prior to the ceremony and getting shots of the arriving bridal party and/or the father and the bride can add a number of good pictures to your coverage. It can also be a way of getting candid pictures of these groups. These shots can also effectively convey a sense of "real time" to the event.

In traditional weddings, from the moment the bride leaves her home, her father is usually by her side. He ushers her into the church, down the aisle, and finally "gives her away" at the altar. Though you'll probably be getting a shot of the accompaniment down the aisle, another good shot, and one that gives you a bit of insurance, is of the father escorting the bride from the car into the church. Here, use the limousine as a prop, and have the father help his daughter take the first steps towards the ceremony.

Most churches or synagogues have steps leading to the entrance (you'll be using these later for a group shot after

the ceremony), and you can use them to get a good vantagepoint for this picture. If the steps are too high or too far away from the curb, get closer and shoot a full view of the action.

Depending upon the time of day, you might need a fill flash to help balance your exposure, especially if you choose to take the shot with the bride just emerging from the car. Some brides may arrive alone, or with a close relative or friend as their escort. Pay close attention to shadows and the gown's high reflectivity. Try to click the shutter when the bride and her escort are moving gracefully.

If the bridesmaids happen to be in the same limousine or car, or are close behind, you may have time to get a quick shot of the group on the steps of the church. Gauge your time carefully here, as the participants are concerned with upcoming matters. Whatever shots you take at this time, be aware that they'll have to be of a candid nature. As with all candids, be an observer not an intruder upon the moment and the way it unfolds.

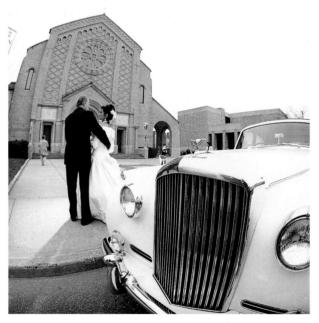

Each of the elements of the arrival are shown in this wide angle photograph, the bride and her father getting to the church and the vehicle that got them there. The father's arm around his daughter adds a tender touch to the scene.

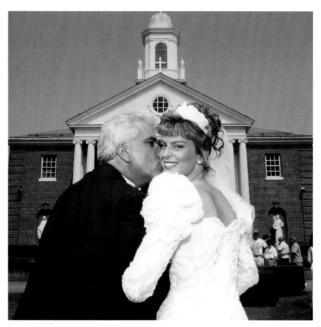

Fill flash creates a balance between foreground and background and eliminates any chance of shadows or harsh daylight marring the scene. The picture tells a perfect story of the moment.

Coming Down the Aisle

FORE THE ACTUAL CEREMONY STARTS, guests arrive, are led down the aisle and seated by the ushers. Both families are also graciously guided to their appointed sides of the aisle by the groomsmen. Though shots of this procession are optional, clients may want pictures of relatives being escorted by brothers, uncles, and other family members or friends. Also, mothers who rarely see their sons so well-groomed may want a shot of themselves coming down the aisle with them.

If these shots are requested, you'll have to find a way to determine who's who in the group being led into the church. Enlist a family member or the best man to serve as spotter for you. Station your contact person at a strategic point on the aisle, and have them signal when the important people are being escorted. Place yourself at the bottom of the aisle (most times the key people will sit down front) and get ready to shoot.

Focus your camera and set flash distance on a seat or pew that's about ten feet from where you're standing. Snap the shutter when they reach that point. One shot is all you'll need at this time—if people want a more formal shot, you can take it later on location at the reception.

While you're there, and when everyone is seated, take a shot of the bride and groom's families. You certainly won't have time to pose the picture, so just make a record shot. Some people may be craning their necks toward the back of the church or nervously fixing their hair—this is all part of the story of the day and may sell as candid shots later. These are transitional moments. While they certainly don't represent key pictures, they're part of the thread that keeps the whole story together.

The bridal procession usually begins with the ushers and bridal party, interspersed with the ring bearer and flower girl, who are followed by the groom and best man (unless they are already at the head of the aisle). Then comes the most important photograph, that of the bride and whomever is "giving her away," usually her father. If shots of each couple in the procession are requested, arrange beforehand that they maintain a certain distance between them. Many times they'll bunch up together and a decent picture

Top: The wonderful, candid expression on this bride's face was captured with a 35mm SLR with a 70-200mm telephoto lens and by using fast film and no flash.

Bottom: The bride and her father coming down the aisle to the marriage site is a key photograph in any wedding coverage. Although this is an outdoor service, a fill flash was used to guarantee elimination of harsh shadows. Timing is everything with this photograph, as is setting up focus beforehand.

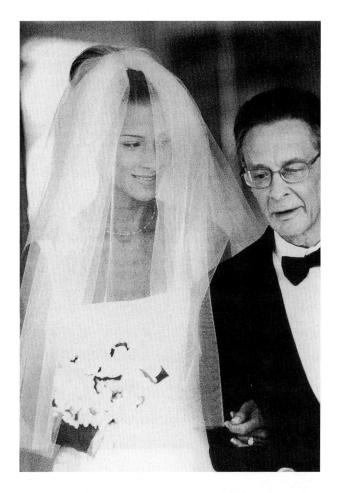

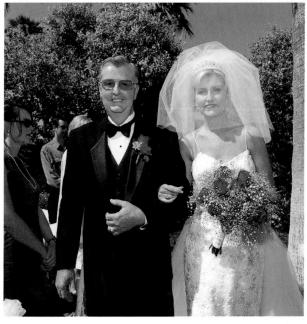

Using high speed film and a telephoto lens, Ken made this very unique take on the "coming down the aisle" photo with a combination of luck and timing. He was able to accomplish what is usually impossible; showing the anticipation and happiness of the groom with the smile of the approaching bride.

becomes impossible. Sometimes, in their nervousness, they'll bunch together anyway, so do the best you can.

Inexperienced wedding photographers, often out of shyness, sit in a seat along the aisle and expect to get a clear shooting angle of the couples in the procession. The best bet is to stand at the end of the aisle near the altar, right in the middle of the path. There, the inevitable cousin who's decided to try his hand at taking pictures won't obstruct your view. If someone does, request politely that he/she step aside. For them it's a quick snapshot—for you it's hard work.

Two techniques can be used for these shots. Try both and see which is the most comfortable for you. With the follow-focus technique you keep the oncoming couple in the viewfinder and rack your focusing knob back as they approach and fill the frame. This is good when two people have much different heights or when they're moving at a measured, predictable pace.

Another, and probably easier technique, is to again focus on a point on the aisle, set the aperture at f/8 (which gives you some leeway), and snap the shutter when the couple reaches that point. A drawback of this technique is that when the couple reaches the predetermined point, one or both of them may have closed eyes, one may be tripping over a fold in the runner, or they may have their heads turned in the wrong direction. Experience will help you choose the best way of handling this shot.

The Giving Away of the Bride

NCE YOU'VE PHOTOGRAPHED THE KEY people in the procession, move down the aisle toward the back of the church, turn, and get the shot of the father or other person giving away the bride. This sequence will happen fairly quickly, so set your lens and flash as you move. Prior to the ceremony, you should pick a spot from which this shot can be made and figure the distance to the head of the aisle where this action will take place. Be sure to refine your focus right before making the picture.

Be ready to shoot two or three shots in this sequence. The first action is the man (usually the father) lifting the veil of the bride. He then kisses her, takes her hand, and puts it into the hand of the groom. Key moments are right at the kiss and the moment the three people have their hands together. Try to angle in so each face is visible, and be especially aware of the beautiful moment when they are all touching.

Sequences at the wedding site during the ceremony require that you keep an accurate count of exposures left on the film in your camera—you don't want to be caught short just as the action reaches a peak or a unique moment occurs. While you're shooting the procession, give a glance at the

frame counter and note where you stand. In the heat of shooting, you may lose count or find that you have taken more pictures than you thought you would.

All this emphasizes the importance of having extra film backs loaded and ready to go, or having an extra camera body for those models that won't take auxiliary backs. Keep at least one extra back in your pocket, and gain practice exchanging backs on the run. With 220 film you'll have 16, 24, or 30 shots per roll, depending on the format, so keeping track should prevent you from running short. Whatever the roll count, it's always a good idea to have an extra body ready to go.

At the point when the father gives away the bride, and at other moments within the ceremony, you won't be able to stop and reset your subjects' poses.

Position is all-important, and instinct should get you where you need to be. After your first few weddings you'll gain that instinct, so don't kick yourself too hard if you miss the occasional shot. Know your territory, move easily to find your spot, and shoot from both high and low angles. Keep loose, and don't let one error throw off the rest of your rhythm.

This photograph was made from back down the aisle with a 250mm lens at $\frac{1}{4}$ second at $\frac{1}{5}$.6. The timing of this photograph is crucial since the action can be over in a split second. Always try to include the groom within the frame.

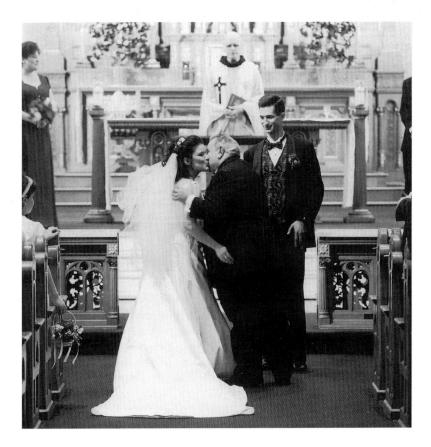

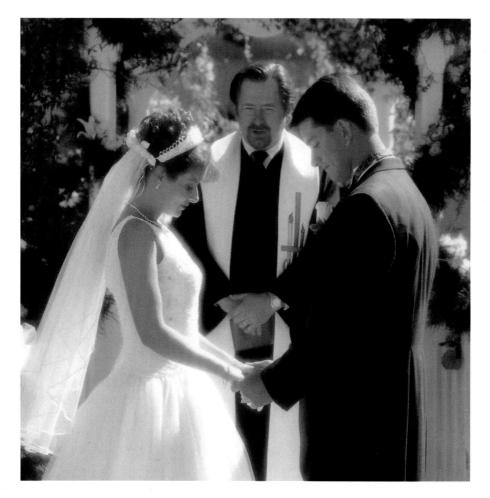

Photographs made during the ceremony have a special grace and charm. Your job is to capture the special moments without intruding on the beauty or solemnity of the service. A beautiful light graces this couple during a very tender moment. Take note of the triangle formed by the figures.

Opposite: This photograph has the feeling of "being there" due to its candid nature and depiction of a wonderful moment during the ceremony. The use of flowers as a soft focus frame is deliberate in conveying this intimate sense. The smile and the kiss show the emotion that makes it successful.

AT THE SITE: DURING THE CEREMONY Exchanging Vows

he exchanging of vows is one of the high points of the wedding ceremony, and if you're cleared to shoot during it, record this moment. After the service, mass, or other procedures that make up the middle of the wedding ceremony, the bride and groom move close together in front of the presiding official (minister, priest, rabbi, or justice of the peace). This is your cue to also move in and be ready to take pictures.

Hopefully, you've scouted the area and know where your vantage point will be. Shooting from behind the service, among the guests, may be of little use. All you may get are the backs of the bride and groom, and the pictures will resemble those you made from the back of the church earlier. The bride and groom may turn and face each other during the vows, but don't count on it. If you do shoot from the front of the altar, kneel down between shots so you don't obstruct the view of others in attendance.

If you can, position yourself behind or to the side of the

altar and make use of your telephoto lens. Make an incident light reading and shoot with a high enough shutter speed so the picture is steady (usually 1/60 second is the minimum speed for hand-held, telephoto shots). Get as close as possible while still maintaining a discreet distance. Move around until you get a profile of both the bride and the groom, and include the presiding official in the frame. Shoot a medium shot of the couple holding hands and then wait for the official to make some use of his hands, such as a blessing, before taking another picture. You can also use flash for this picture, but available light is less obtrusive on this special moment.

If you must, move in closer for the picture. But once you've made it, get right back to the side. Don't hang around waiting for the next picture or start rewinding film in the middle of the altar. Although you're an important part of the wedding, you're not the one getting married. Your continual presence on the altar can only serve as a bothersome distraction to the gathered wedding participants and observers.

Using Filters Effectively

Filters can be useful allies on the wedding day. You might carry diffusion filters, diffraction filters, vignetters and color-balancing filters. The vignetter is often used for portraiture and to help remove or diminish the visual effect of distracting elements at the edges of the frame. Diffusion filters can be used to break up harsh highlights. Soft-focus filters or even soft-focus lenses may be used for portraits to help diminish the effects of age or to add an ethereal look to certain moments.

Cross-star or diffraction filters can break up light in a dramatic fashion, but can be quite distracting or clichéd if overused. They can be quite amazing when used with stained glass windows if the light is right.

Color balancing filters can be used to add warmth or balance color in a scene. They may be unnecessary, as your lab can add warmth or balance color as required in most situations. If you use a filter incorrectly the lab will have much more trouble balancing the scene.

Keep in mind that many filters are more effective at wider apertures. At narrow f-stops they tend to show too much of the filter effect rather than blending with the scene. This holds especially true for diffraction and vignette filters.

Don't overuse filters. They can overwhelm the subject matter and look too obvious. Some filter effects go in and out of fashion, and some are now downright clichéd. In many cases, you can add filter effects by working with your lab or with computer imaging programs such as Adobe Photoshop. Don't use filters as a crutch for poor lighting or posing and avoid too many tricks. Used properly, filters can add a lot to a scene without being a visual burden.

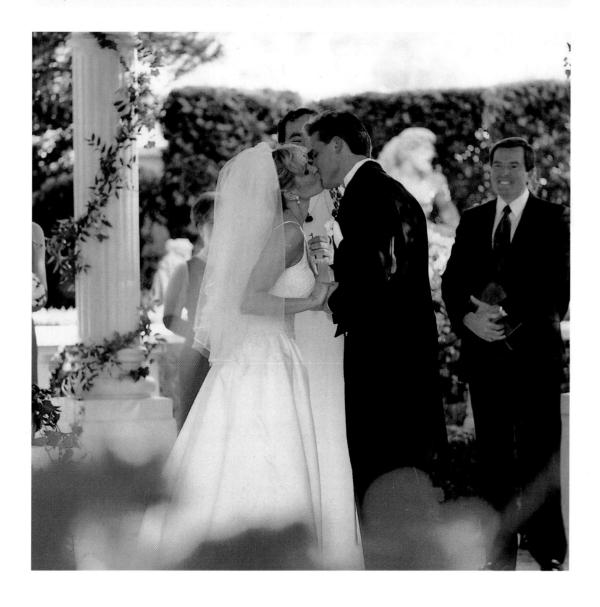

Exchanging Rings

ERHAPS THE MOST SYMBOLIC PART OF A wedding is the exchange of rings. When the words, "With this ring I thee wed," or "You may now kiss the bride," or others to that effect are spoken, the bonds of matrimony are complete. Both bride and groom say a few words while they're holding the rings and looking into each other's eyes. These can be very meaningful pictures.

You have a number of options with this shot. If you can get behind the priest, you may be able to get a few pictures, but generally the moment is so sacred and climactic that any movement on the altar can be distracting. Shooting from the side with a telephoto can result in a nice profile/full-face couple shot. This shot is taken with a camera angle that reveals a profile of, say, the groom, with the full face of the bride shining her eyes into his. If you can get to a level higher than the altar, you can shoot down over one of the couple's shoulder into the other's face.

Most times you'll be on ground level at this point in the service—a good idea because you have to get ready for the

moment when the couple comes back down the aisle. Because the couple always turns toward each other for the exchange of rings, you can get a good shot of them from the front of the altar. Use a moderate telephoto to get a close shot, and then move back and capture the moment in the greater context of the church. Don't be afraid to include some of the guests in this shot—the picture will show their involvement during this special moment.

Compose the picture so that the couple's eye contact is evident and include the priest, minister, or rabbi if he or she isn't standing too high above the couple. If you have time, slip a vignetter or diffuser over the lens to add to the pictorial magic of the moment. Some photographers shoot all their ceremony shots with diffusers, and although this creates a nice effect it can be overdone. You can also add a diffusion effect when the images are printed or scanned and retouched later. You might also have time to do some special effects, though once the rings are exchanged the couple may spin and move back down the aisle quickly, so don't get caught with your equipment down.

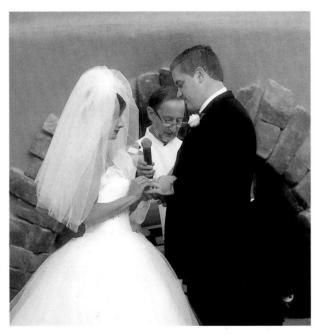

A key moment in the ceremony is the exchange of rings. Although the microphone is a bit of an intrusion, the placement of the ring on the groom's finger has been recorded.

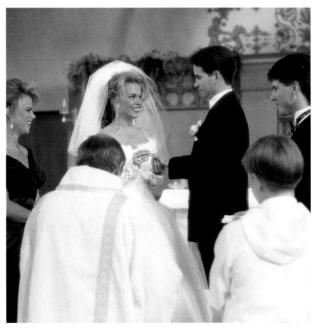

Ceremony photographs require positioning to make the image, even if there is no clear sight line to the subjects. Consider vantage points before starting, and be prepared to work with long lenses to get the photograph. These moments also require you to be mindful of working quietly and discreetly. Although there are some figures in the foreground, this image still contains the most important elements—the bride and groom, the ring exchange, and the best man and maid of honor.

Using Available Light

OME OF THE BEST WEDDING PHOTOGRAPHS made during the ceremony, and certainly some of the most evocative, are the result of creative available light photography. Available light work has two advantages: it eliminates the use of intrusive flashes during the ceremony and, because of the naturally warm light in most churches, evokes a mood that can only enhance the feelings of the occasion.

Of course, not every wedding location lends itself to this type of shooting. Some halls are illuminated with fluorescent lights or have paneled walls. But the vast majority of religious sites are built around a concept of and appreciation for light. In some faiths, light is a symbol of the word of God, and many houses of worship pay homage to its wondrous gifts.

Some churches have large windows that let in abundant quantities of side and back light during the day, but at night

use altars filled with candles or elaborate chandeliers to fill the hall with a warm, dazzling brilliance.

It seems a shame to miss out on doing some available light photography in these places. Luckily, fast films with good color and grain and fast lenses (those with a wide maximum aperture) have allowed for greater freedom in doing available light shooting during the ceremony. Films as fast as ISO 1000 and lenses with maximum apertures of f/2 (and even f/1.4 or f/1.2 with 35mm format) are some of the tools that make this type of work possible.

Even if you work with standard ISO 160 or ISO 400 film you can do some great available light work, even without a tripod. A tripod can be helpful for some shots, however. If you can, leave the tripod at the back of the church and bring it to the center of the aisle once the initial part of the ceremony is over (after the bride's been given away). Mount the camera on the tripod (you can get a quick release mount on pro models), put on a moderate wide-angle lens and expose at around f/5.6 at ½ second with ISO 160 film. Take a reading to verify the light, or bracket up and down a few stops for insurance.

If the church has a balcony, bring your tripod rig upstairs and cover the scene with both wide-angle and telephoto lenses. A ball head (one that allows easy movement on both horizontal and vertical axis) will allow you to move the camera to any desired angle quickly. "Overheads" can be quite effective to show either the entire scene

or for candid views during parts of the ceremony. This vantage point also allows you to get great shots without being obtrusive. Your clients may wonder where you went, but you'll get great shots with a decidedly different point of view. If you're working with, or as an assistant, a second camera in the balcony (or choir) can do wonders.

Lack of a tripod doesn't preclude available light shots even with moderate speed film. When you go to the back of the church after the giving away of the bride, set your camera on the floor propped up slightly so the lens is inclined upward and encompasses the scene at the altar. (Likewise, the balcony shot can be made by resting the camera on the railing.) Expose at the prescribed setting of f/5.6 at ½ second, using a cable release to prevent any camera or hand shake. With tripod or without, these available light shots are always effective, and are excellent sellers for both album and photo decor sales.

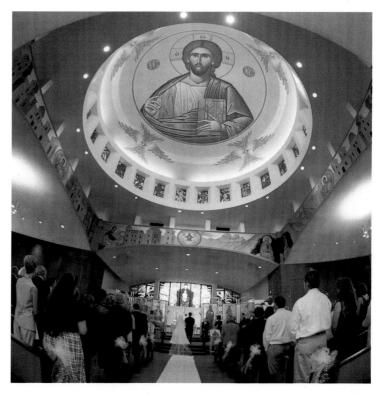

If the service or mass is long enough and you don't have to be at the altar or service site all the way through, take a moment to step back and create a "context" photograph showing the beauty and splendor of the church or hall. If you are working with an assistant, let him or her handle the photo for you. Don't use flash for this image as it won't carry and provide the kind of coverage you need. Some photographers swear by $\frac{1}{8}$ second at $\frac{f}{5.6}$ with ISO m160 film as the right exposure for over 80% of the venues.

Using Candid Moments

HE LIGHT AND HEIGHTENED EMOTIONS evident in the wedding ceremony all make for excellent picture opportunities. Because of the atmosphere of the occasion, you won't be able to be as freewheeling in your shooting as you will be during the reception or after-wedding activities, but this shouldn't stop you from making candids as you go along. Some services go on for a long time, or have a celebration of a mass attached to them, so you'll often have time to make quite a few good pictures. During shooting, move quietly and refrain from overshooting or bursting your flash continually. A few select candids will tell the story.

Candids have become an increasingly important part of wedding coverage. Their importance is evident from a "movement" that has swept the trade—so-called "wedding photojournalism." Many photographers are now using 35mm cameras loaded with fast film, black and white, and even infrared film for these photographs. The approach is intimate and casual, but definitely not as amateurish or ran-

dom as a snapshooter's. At their best, candids are unposed photographs that are made with technical skill and a sensitive eye. They reveal true emotions and a sense of active involvement in the event.

Wedding photojournalism has been a boon and a blessing to wedding photographers. Rather than limit coverage to a series of posed photographs, they allow for a more expressive approach and help keep the photographer thinking in an "artistic" mode during the day. This doesn't mean that posed photographs are not artistic—a break from tradition does ensure, however, that each event and day will be unique for both the client and the photographer.

This trend is referred to as wedding photojournalism because it resembles the way news photographers cover events. It utilizes available light, high-speed film and 35mm format, all of which lead to spontaneous reactions to unfolding moments. It forces you to focus on more than just the set shots and to keep a sharp eye out for the interaction of peo-

ple within the context of the wedding day.

Some photographers have gone full bore into wedding photojournalism and shoot the entire event in this fashion. This may or may not appeal to your clients; you should show samples of this work to them during your sales presentation to gauge their reaction. Some people love it, others may be hesitant to have the full day photographed in that way. In fact, some wedding photographers are offering this type of coverage at different rates than a "traditional" approach. Some charge less for it while others charge more. Again, gauging your clients' interest and excitement about this approach is important.

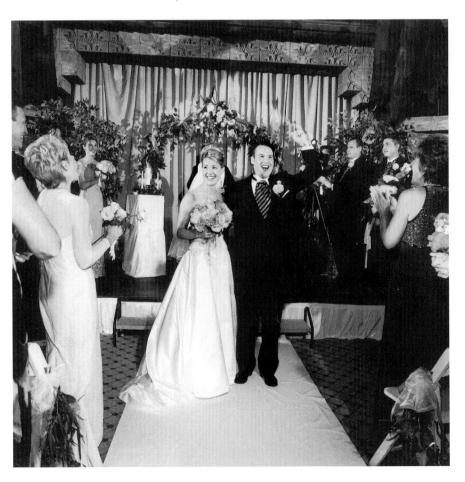

The role of a candid is to tell a story within the frame. This photograph was made right after the end of the ceremony.

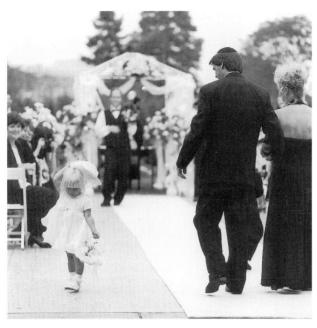

Ken titles this image "I'm Outta Here." The flower girl is making her exit right in the middle of the processional.

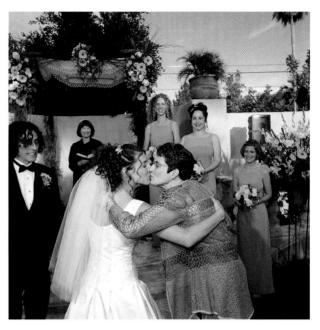

Moments such as this during the ceremony are priceless. The expressions on the faces of the people around the main subject are as important as the moment of the affectionate kiss.

There will be plenty of opportunities for candids after the actual ceremony, but this doesn't preclude their use at the wedding site. The bride and the groom are the stars of the show and should be the focus of your candid work during the nuptials. They may be seated on opposite sides of the altar or proscenium giving each other warm looks, or the bride may have a particularly beautiful smile on her face. A long lens comes in handy here for both close-ups from a discrete distance and use of a shallow depth of field to soften the background. Use of fast film will allow for higher shutter speeds to ensure a steady shot and eliminate the need for flash. If light is low, consider push processing as a way to raise your effective exposure index (EI). Check with your lab on speeds they can push to and recommend.

The gathered family and friends can also make for good candids, as can the ring bearer and flower girl. Stand back with a long lens and keep your eyes open, waiting for spontaneous moments of emotion. Capture people relating to one another. Use the candids as a way to photograph people who are involved in the ceremony, such as a brother or friend who may read or perform during the service. This also goes for special moments, such as candle lighting and any other part of the service the couple may have incorporated into the event. Working without flash you have a better chance to incorporate the ambient light and context of the scene within each photograph of these moments, and your work is less obtrusive in the bargain.

Candids are more than just grab shots—they're moments that tell a unique part of the day's story.

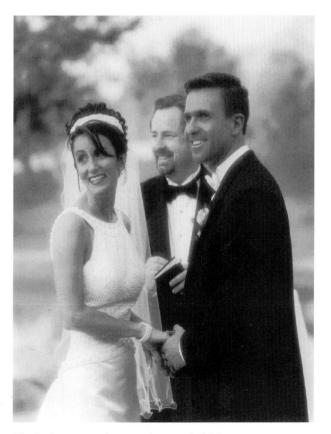

This bride, groom and minister have wonderful, happy expressions. Many times only a candid captures such moments.

Capturing Special Traditions

N THE COURSE OF YOUR WEDDING CAREER you'll come across many types and styles of ceremonies, some unique to the people getting married and others to the religion to which they belong. In these ceremonies, certain moments and customs are as important as the exchange of rings, and failure to photograph them could leave a real gap in your wedding coverage. A procession, a walking around the bride and groom, a sharing of a cup of wine, or other movements and moments steeped in history and tradition may be included. Every wedding ceremony is a little different

For example, one shot that you shouldn't miss in the Jewish ceremony is the breaking of the glass. A wineglass or other fine glass is wrapped in cloth at the end of the ceremony and the groom is supposed to break the glass with the heel of his foot. (In some instances a light bulb is used because of the loud pop it emits when broken.) The gusto with which this is carried out is usually accompanied by a cheerful response from the congregation.

Watch for this moment, and when it occurs, have

yourself in a good position for the shot. Take the shot as the groom's leg is raised and imply the motion that follows with the sense of balance in his stance. Take another shot once the glass is broken, moving back to include the faces of the wedding party assembled under the hupah. Most rabbis appreciate the importance of this picture, and will allow you time to set up the shot and a good position from which to take it. Confer with the rabbi prior to the ceremony.

A Jewish wedding is usually conducted under a hupah, a trellis-like arch that shelters the couple, the rabbi, and other close members of the family at one point or other during the ceremony. This framework may prevent telephoto shooting from the sides, so be sure to confer with the rabbi before the service as to your best behavior during the ceremony. All weddings are intimate affairs, and the Jewish service is particularly so. But you may find yourself right in the middle of the ceremony making pictures.

As with all services, check carefully with the rabbi before assuming that you'll be able to take pictures during the ceremony. Some congregations allow and encourage it,

while others strictly forbid it.

The hupah may be bedecked with flowers so use its structure and decorations as counterpoints in your pictures. Definitely have a wide-angle lens with you if you're to shoot under the hupah during the service because you'll be right on top of the action. Care must be taken not to have your flash work against you. Remember that you're close to your subjects, so be sure to check the viewfinder for objects that may reflect harshly back into the lens.

The wedding photography business is a wondrous one because of all the walks of humanity it involves. Learn the basics about each type of service, and remain open to variations on the theme. And be sure to discuss any special needs or events with the couple prior to the wedding day.

to discuss any special needs of events with the couple prior to the wedding day.

The candle-lighting ceremony is quite meaningful to many couples and should be part of your coverage. This shot was made with flash.

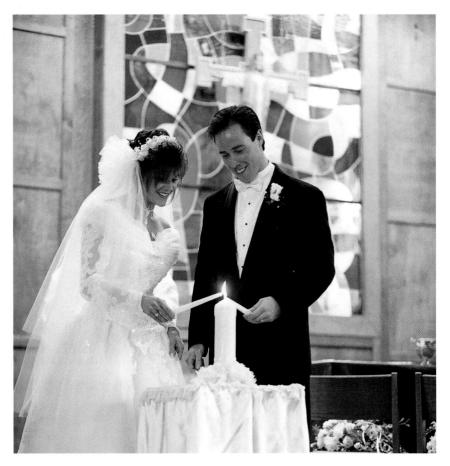

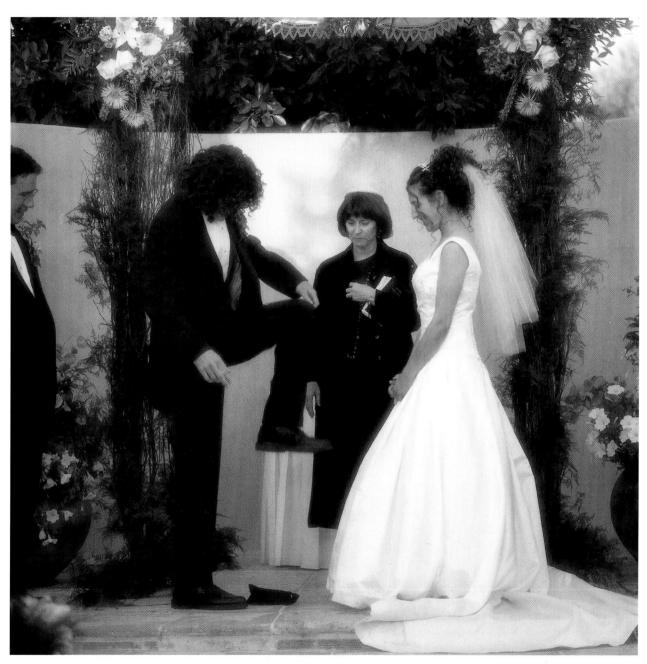

One of the most important moments in the Jewish wedding ceremony is the breaking of the glass. The decisive moment is captured here as the groom has raised his foot prior to breaking the glass.

AT THE SITE: DURING THE CEREMONY The Aisle Shot

NCE THE CEREMONY IS OVER, MOST COUPLES will turn quickly and make a mad dash down the aisle. Be prepared for this shot—as it can be over in an instant. While the minister is giving his final benediction, station yourself at the end of the aisle or nearest to where the last rows of people are sitting. Set your focus for a particular point in front of you. Don't expect to be able to follow focus or backpedal as they come racing towards you. This is like sports photography, and you've got to be quick to get the shot.

Once the couple reaches the appointed spot, take a picture, then move back and see if you can get another. If you can't, follow them into the vestibule and get one or two candids of them. Don't even consider posing them at this moment. Their excitement is running high and they probably would ignore you anyway. These candids can be great, however, and you may even get people rushing out

after them and hugging them.

The aisle shot is one that definitely can't be repeated, particularly if you happen to capture some of the happy faces of the congregation as they look on the faces of the bride and groom. Don't stand in the way of their departure, but shoot away and hope for the best.

After this, a reception line may form and, unless specifically requested, refrain from shooting at this time. Shots of the line often look crowded and confusing and rarely sell. You may be requested to get some quick candids of people who attended the wedding but who can't get to the reception with the bride and groom. These should be simple on-camera flash shots of handshakes and hugs. You might also consider doing some non-flash candids at this time, but these moments are better spent checking gear, reloading film, going back into the sanctuary and getting things ready for the next phase of shooting.

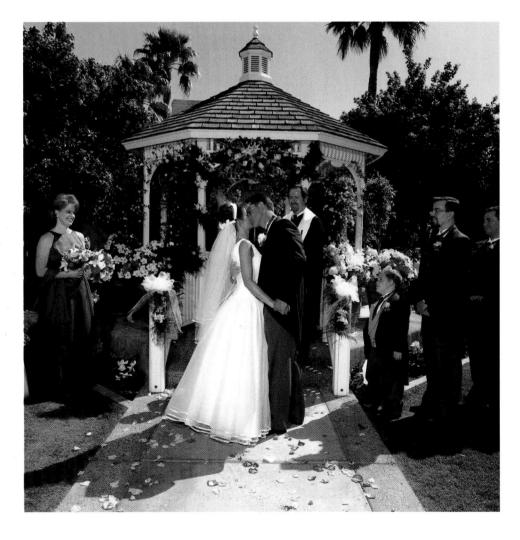

As the ceremony ends and the bride and groom leave the altar, be prepared for a sequence of photographs. After the kiss at the end of the ceremony the couple usually turns rather quickly and moves down the aisle. The final photograph in this trio is rare to get since the couple usually moves too quickly to the back. Note the inclusion of the celebrants in the last two frames and the depiction of the altar and some of the wedding party in the first. Note the strong shadows that fall toward the camera, a real giveaway that fill flash is needed. Fill flash was used for every photograph in the sequence. This points out the need for having your flash on fast recycle for certain moments during the wedding day.

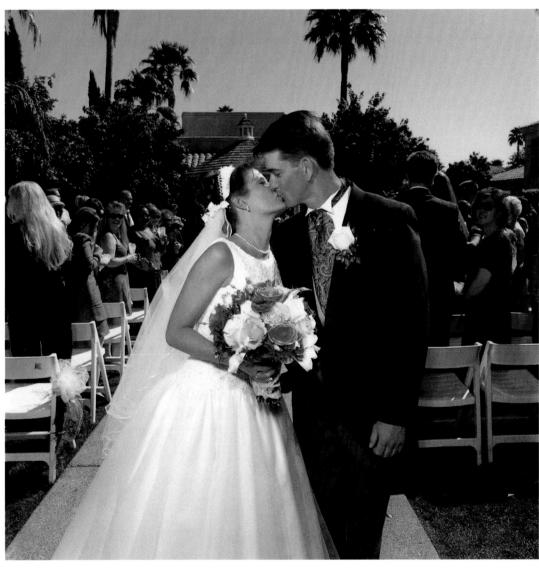

Portraits in the Church

F YOU AND THE COUPLE HAVE PLANNED THINGS right, you should have made time to do a series of photographs right after the ceremony in the church or at the wedding site. After guests have been greeted on the reception line you should have the best man and maid of honor remind the couple of the pictures you arranged to make at the site. It will be difficult to get them to break away from guests, and this reminder should be handled gently and with patience. While you have an agenda and schedule, the bride and groom are caught up in the events and people of the day. Don't become an enforcer—go with the flow.

Some of these images will be reenactments of some parts of the ceremony, posed and styled photographs that ensure good angles and quality of light. The first pictures you should make in the reenactment sequence are those that involve the priest, rabbi, or minister. Assure the person that you'll only be taking a few minutes of his or her time, and be respectful of the fact that they may be very busy people.

To the couple, and perhaps to you, the wedding is a very unique event, but to someone who does four or five a week it's not a matter to dawdle over once the service is finished. Some may outright refuse to cooperate if asked on the day of the wedding (due to prior commitments or an objec-

tion to the whole process), so arrange the time beforehand. Also, when setting up the appointment with the minister, assure him or her that you'll be respectful of the church and the objects in it. Some ministers or other presiding officials have banned photographers from shooting after the ceremony because of the mess they've left behind.

A good selling point in convincing the official to hang around for a while is that this will eliminate the need for you to shoot during the service itself, or that any shots you take won't interrupt the mood of the ceremony. If you treat the minister with respect, you'll make it easier on yourself (and all your brother and sister photographers who'll be working in that particular place in the future).

Once you've got the bride, the groom and the official together on the altar, request that certain parts of the ceremony be acted out. This may be a benediction or blessing, a passing of a cup of wine, or any actions that caught your eye during the original service. You may be surprised at how helpful the minister may be in this process. Many seem to be potential movie directors, and they'll suggest shots and angles. Don't discourage this, as it gets them involved, but don't let them run the show either.

Arrange the group so the viewing angle gives a clear picture of everyone involved while it depicts an implied motion.

There's no sense in having the pastor there if everyone stands around like they're made of wood. Shoot over the couple's shoulders with their faces inclined towards the camera and the minister slightly out of focus in the background. Or have the couple exchanging rings, with the pastor's hand extended in a blessing motion. If you have a secondary strobe on a pole, use the second light to add drama to the scene, or just rely on the natural light to give a warm glow to the occasion.

Try different angles on the basic themes of the ceremony, and don't be afraid to get in close and use a wide-angle lens. This reenactment allows you an intimacy that's often barred during the actual wedding, so take advantage of this situation to get some special shots. If the minister and couple are close to one another as often happens in smaller parishes or congregations pose them in a gentle group shot, perhaps with the minister's arms around the couple.

This classic church portrait was made with an edge diffuser to break up highlights and an off-camera flash coming from the right side of the camera. Ambient light was recorded by working with a slow shutter speed, about 1/15 second.

Using Candlelight for Atmosphere

ANDLELIGHT IS VERY BEAUTIFUL, AND IF THEY'RE available, candles make great props for portraits. Many services feature a candle-lighting sequence. The flames from candles held by the bride and groom are used to light a third candle, which signifies the one light created by the union of their two lives.

Candles, though beautiful, don't provide enough illumination alone, so natural or strobe light will have to be used to fill in the picture. Take care not to have the ambient light so bright that it overwhelms the candle glow and ruins the desired effect. Successful candle photographs create the illusion that the flame provides all the light in the scene, even though it's likely that a fill light was used.

Long exposure time is the key to having the glowing flame from the candle record properly on film. This can be done in natural or artificial light. If you're shooting in natural light, pick an area where there's sufficient illumination to light the scene, but avoid direct, hard sunlight. Set your camera on a tripod and expose at 1/8 second. This slow speed will allow the flame to etch on the film. When shooting with a strobe do the same, although you should make sure the flash is bounced or softened by having it reflect off a topmounted reflector card. This is when slow sync technique

comes into play. Directional strobe fired from the side via cord or radio remote works wonders.

Don't blast the scene with light; use the minimum flash power required and have the burst come in the midst of your long exposure. If working with a 35mm camera use second curtain sync, if available. You might even consider underexposing the frame a half or a full stop to

warm glow to the subjects you're portraying (a light yellow or warming filter). The warming filter can be put over your camera lens or strobe light.

If you're doing a candle-lighting shot, have the couple lean in toward the candle as they light it, so the warm glow partially illuminates their faces. Take care that the bridal veil doesn't get near the flame.

If you're working with an on-camera or bracket mount flash, use a moderate telephoto lens so that you can move back from the couple and get a broader light source from the strobe. This will give you more control over the effect.

Candelabra, or long rows of candles, make great props, and you can use them for highlighting or as balancing elements on one side of the frame. Pose the bride and groom with the candles, step back, and use a telephoto to shorten perspective. Again, this gives you more lighting control, and avoids too close a brush with the flames. Use depth of field creatively and have the candles sharp or soft, depending on your taste.

Use candlelight to evoke softness and warmth, and let the flame light up your pictures, but don't use a candle for the sole source of illumination—the result may resemble a still from a horror movie.

add to the illusion. pictures, and their purpose is to transform the flame into a glowing halo (diffusion filter), a spiraling rainbow (diffraction filter), or even to add a

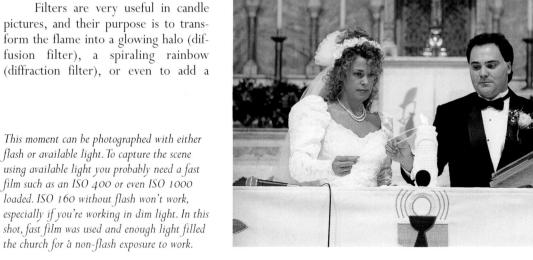

Using the Architecture of the Site

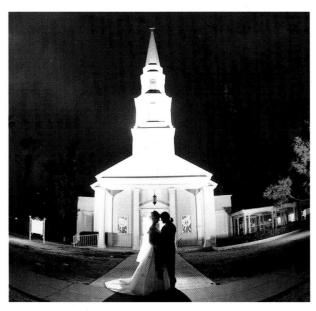

This classic church building is the center attraction of this bride and groom silhouette. Make sure that the couple's profile is evident in the scene. A small flash sits behind the couple to provide the silhouette while a stronger flash is pointed up toward the building.

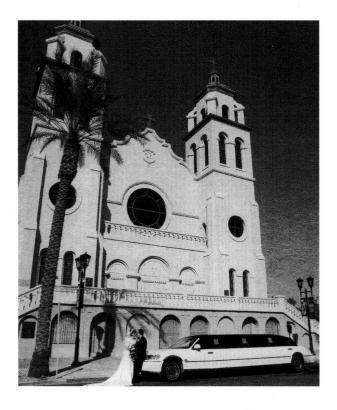

HOUGH NOT EVERY CHURCH OR TEMPLE will have the gem-like quality of a Chartres or the magnificence of a Notre Dame, most will have unique architecture that should become part of your photographic "set." Whether it has stained glass windows, graceful archways, or the perspective gained by shooting along aisles, the church or synagogue has great potential as a set for many wonderful photographs. Use the architecture as an element in your pictures, and allow your photographer's eye to play when seeking compositions.

Some churches and temples have large supporting columns of wood or stone, many with carved designs. These can be used for vertical accents in your pictures and can serve as wonderful posing props. Vestibules and anterooms may have more intimate columns, and these curving lines can be used as vignettes or a "frame within a frame" in your pictures.

While the larger forms are of interest, the textures that cover and enhance these forms should be given equal attention. Note any cloth or tapestries that are hung on the walls, and make use of them as backdrops or design elements within your pictures. Wood and stone carving, statuary and other icons, and objects of veneration can also be used as forms within your compositions. You can use them to interplay with the prime subjects of your portraiture.

The exterior of the building may have stonework or landscaped areas that can be utilized in posing. Small gardens and chapels may be a part of the grounds, and once you gain permission to photograph in these areas you can handle many of your outdoor portraits or "environmentals" there. These places are generally designed for meditative purposes, and their peaceful nature should be respected. All in all, though, they do make excellent posing areas.

Even if the edifice is of simple wooden design, with no ornamentation whatsoever, it can still be an excellent place to take pictures. Imagine having a studio over 100 feet long, with light spilling in on both sides, and you'll get the idea. You can use the perspective afforded by the aisle and use the pews as posing benches in your portraits.

Scout the building as a location set before and during the ceremony and open your eyes to the building's potential. Allow yourself time for a number of shots and use the architecture to enhance your pictures.

This photograph includes the beautiful church, the limo and the couple within one frame. The photograph was made on high-speed black and white film.

A soft diffusion filter to break up the highlights and an edge diffusion vignetter helps control the light from candelabra in this magical scene. Flash was used both in front of and behind the couple. A longer shutter speed helped bring in the ambient light.

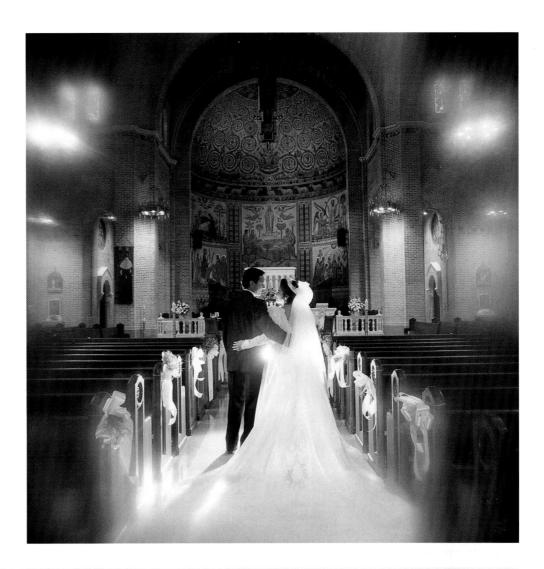

Using a Matte Box for Special Effects

Double exposures or matte box effects can be used to add a special touch to certain moments within the service. These effects can also be recreated later with computer imaging techniques.

If you'd like to try this on the job you can do it two ways. One is to use a compendium matte box and block portions of the frame while double exposing; the other is to create the same effect via double exposure but blocking portions with your hand.

Both techniques involve the same procedure. On the first image of the double exposure you leave one portion of the block-out mask (or your hand) in place and position the subject so that it will record on the other part of the frame. Then find the other element you want to record and reverse the blocking and light passage. Blending is a key element mastered through experience and practice.

In this in-camera double exposure Ken used his hands. The top exposure of the exterior of the church was 1/500 second at f/16. The interior photograph was made at $\frac{1}{2}$ second at f/5.6.

Of course you can easily create such images in the computer later. Doing it on the job, however, can add some adventure to the day.

Working with Church Light

CHURCH OR SANCTUARY PROVIDES A virtual playground of light, whether it be the illumination that spreads through the building or the windows that transmit it. Art historians note that churches were built as temples of light. Renaissance painters worked with light as the symbol of the word of God. Architects often design religious spaces to enhance this play of light. As the sun shines through the windows, it highlights different areas and statuary within the structure. So whether it be window light, soft ambient light, or the beauty of stained glass windows, work with the light in the chapel to create beautiful pictures.

Stained glass windows can be utilized in a number of ways, including using the transmitted colored light or having the design of the window itself as an element in a scene. In some churches, stained glass panels are independent of windows and are illuminated by artificial light. Although they lack some of the qualities of sunlit windows, the panels can also be used as colorful elements in scenes.

Keep in mind, however, that when lit by artificial light the color temperature will be different than that of daylight and that the windows may not record as you see them on film.

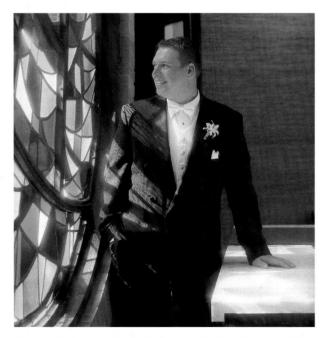

The stained glass provides the illumination for this photograph of the groom. The colors that play on his jacket make for some interesting visual play. Note that his face is lit with a more cohesive block of color and light. Having two colors fall across his face would be less than complimentary.

The main technique for exploiting the beautiful quality of church light is fill flash with slow shutter speed. In this charming portrait the stained glass window is used as a backdrop and placed off to the side of the frame. Fill flash provides the illumination on the two women. A slow shutter speed allows the backlight and lit wall to come through. Remember, in flash exposure aperture controls the flash coverage on the foreground subject while shutter speed controls the ambient light recording.

The first step in using the church light is taking an accurate exposure reading. Walk around the church with your meter right before you plan to make the pictures. Doing this earlier might not help because the light may have shifted in the interim. Notice if the light falls from a high or middle angle, and how deep the shadows are; in most cases the light will be soft and diffused—perfect for portraits.

Once you've picked your spots, place a model or your subject in the posing area and make highlight and shadow readings on their face and clothes. The light may be too strong, resulting in too contrasty a picture. If you're working with a bride and groom, place the bride away from the source of light, as her gown will be reflective and serve as a natural fill card onto the groom.

If you're working with stained glass windows and the light they transmit, it's likely that there'll be dappled colors falling on your subjects. Capturing this effect will require exposure with natural light or long exposure times with a flash burst to fill in detail. You can enhance this transmitted light by putting a soft light vignetter on the lens, or diffusing

the entire subject. Watch out for splotchy colors and move your subjects around so that the light plays over them in a refined manner. Having a blue ear and a red spot on the nose won't help the sale of the picture.

For a silhouette effect with stained glass windows, move in close to your subjects and have them give you their profiles, but make sure their noses and chins don't overlap. Take a reading of the light coming through the stained glass and expose for that reading. The white of the bridal gown may throw some detail into the couple's faces, but don't count on the features to be apparent. You can bring up some detail with a fill card, or let the subjects go to silhouette with the window light enhancing their forms with a soft halo.

You'll have to use flash for shots when you want the light from the stained glass to serve as background and still have full detail in your subjects' faces. Use a slow shutter speed to ensure that you'll record the ambient light. This requires that you use standard fill flash or slow syncro techniques. Many dedicated flash systems today will perform automatic fill calculations for you—all you need is to set a slow shutter speed to aid in the ambient light ratio. Some handheld light meters can be used to calculate the percentage of fill-to-ambient in a scene.

If you lack such a rig, set your shutter speed to $\frac{1}{8}$ or

1/15 second and take a reading from the stained glass window. Note the aperture. Next calculate the distance at which that aperture will give your foreground subjects proper exposure using the Guide Number formula (Guide Number of the flash divided by distance equals f/).

For example, say you make a reading of the stained glass window and you get 1/15 second at f/8. The Guide Number of your flash is 80. Divide 80 by 8 and you get ten feet. That's the distance at which you'll get a balance of fill and ambient light. Many times you'll want to dampen the flash further for a softer light, so consider using a diffuser or flash compensation to lower the output—experience shows that a -1 EV flash compensation works best. This technique takes some time to master and testing prior to trying it out on the wedding day is highly advised.

This shot can be made even more effective if you take the strobe off the camera and burst it from a high, side angle. Keep the direction of flash in line with the natural direction of the light from the window, thus strengthening the illusion that the whole scene is lit with ambient light.

You must always be aware of angles when using flash toward or near glass. Even the most studied pose can suffer if there are harsh light reflections in the scene. Posing the couple to one side of the window and using a directional flash, can eliminate this problem.

Many churches have large, high windows that let in great shafts of light. On bright days the light streams in as if the clouds have parted over the ocean or prairies. Use this light as if it's a spotlight in a theater, and take advantage of its potentially dramatic effects. When making your light readings inside the church be sure to include these "hot spots" in your calculations. You can have the bride and groom standing in these "spots," and have the rest of the church recede in the shadows. You can also take long shots using the shafts of light as compositional tools. Make sure the light isn't too contrasty. It may be so bright that it knocks all your other exposure values out of the recording range of the film.

Filters can be used to enhance the beauty of the natural light in the church. A light diffusion filter, for example, can make the light appear as if it's falling through a cloud of incense. You can also use low-density color-compensating filters to shift the light toward warmer hues, or use a blue filter to shift a warm light back toward a more neutral tone.

Approach the play of light in the church as you would the light in a late afternoon landscape photograph. Use your eyes, filters, light meter and subtle fill flash to enhance the beauty of the scene. Make use of all your photography skills to bring out the potential of the settings you'll encounter.

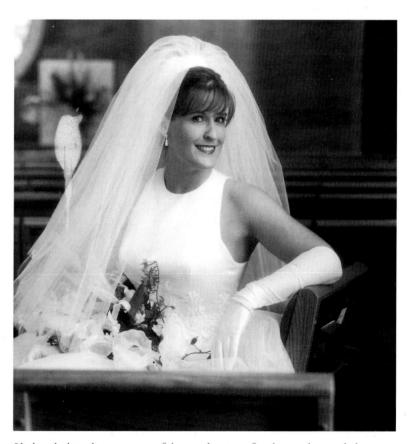

Black and white eliminates some of the considerations of working with stained glass windows, but certainly does not stop you from doing portraits in the church. In this wonderfully posed photograph of the bride, the pews are used as posing props.

The Group Portrait Right After the Ceremony

FFORE THE BRIDE AND GROOM EMERGE from the church, ask the wedding party and them to wait at the top of the steps for a picture in front of the church door. Have the bride and groom stand in the center and arrange the party around them. The amount of space and the size of the crowd may limit the posing options in this situation, but make the best of it.

Depending on the time of day and the weather, you may have to use fill-flash to open up the faces in the group. Shoot at a low enough shutter speed, say 1/60 second, so that the light has an open feel; too fast a shutter speed will create a well-exposed group with dark surroundings. You'll

have to direct your light right into the group, so make sure the strobe isn't tilted up from a previous shot in the church. Also check that all filters have been removed. Take an incident reading to make sure the light is right, and don't use the flash if you have a good natural light available, or use it just to fill shadows.

If the church has a series of steps leading to the entrance, you'll be shooting from a lower level than the group. De-accentuate any tilt you may have by stepping back and leaving room at the sides in the viewfinder. You'll be able to crop tighter in printing. Don't make the mistake of using a very wide-angle lens and getting close. A wide-angle tilted

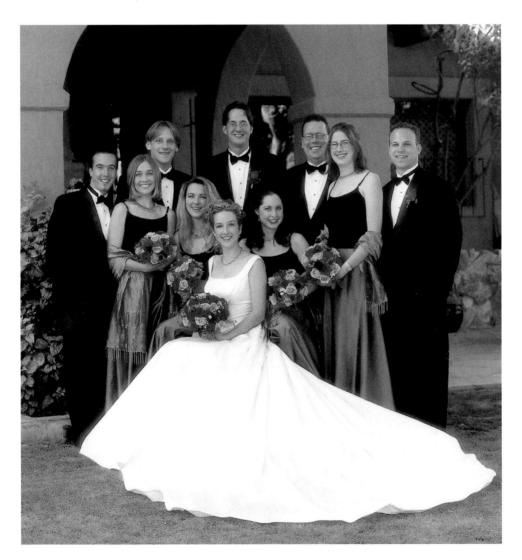

This classic pose includes a dynamic use of triangles and sweeping lines throughout the composition. Note the "V" created by the bouquets and the flourish of the bridal gown. There are diamonds and triangles throughout with heads never on the same horizontal line. One chair is used to arrange the group.

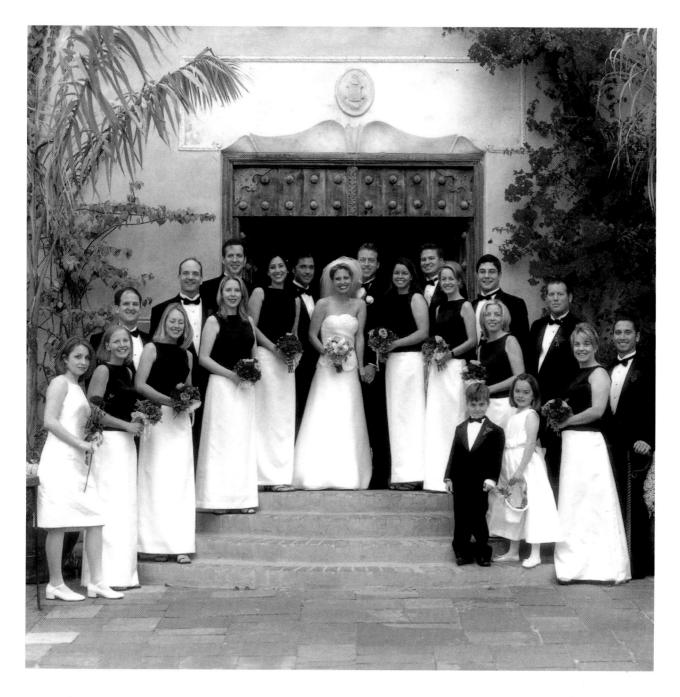

up can distort figures and give your unfortunate subjects long bodies with small heads. You're there to enhance your subjects, not just fit them into the frame.

Keep an eye out for people leaning into your frame while you're taking the picture. Have the crowd make a V on the sides of the steps. It probably would be better if they all stood behind you, but don't expect this to happen.

Pose the group on the steps in a fairly straightforward fashion, leading the eye towards the center of interest, the bride and groom. Pay particular attention to depth of field, and if you have one, make use of the depth-of-field preview button to verify sharpness throughout the group. If the camera doesn't have a preview button, use the depth-of-field scale on the lens barrel to check your settings. Focus to the

near and far subject and obtain your accurate distances, then set the lens so that the two distances fall between the f-stop settings on the scale.

Some photographers carry a stepladder for shots where they want a high angle of view or where perspective is thrown off due to a low shooting angle. Keep one in your car, but don't lug it around with you all day. It's a very cumbersome but useful tool for some of the shots you'll encounter.

Two or three shots are all that's necessary for this pose. Any more will take too much time in what should only be a transitional moment. Just as you have a shooting rhythm, the wedding day has a pace of its own. Get in step and make your work smoother throughout the day.

The Traditional Send-Off

s you're shooting the pictures at the church or after the ceremony, the guests are patiently waiting with rice or confetti in their hands. Throwing rice is a form of release for everyone involved in the wedding, and it may be the first really active outpouring of emotion in a somewhat controlled environment. As the director of the shooting script on the wedding day, you should take control and orchestrate this ritual, but once it begins don't try to stop it to get another picture.

Once the bride and groom are ready to come down the steps of the church, or are leaving the steps for their car, guests will crowd around and create an aisle for them (more like a gauntlet, according to some couples). At this point, you should already have your spot picked and be ready to shoot. As the bride and groom begin their approach, call out "okay everybody, on the count of three," and when you hit three start shooting. You may have a few enthusiasts in the crowd, ones who throw the rice before everyone else, and this action will usually ignite the rest of the "mob." If that happens, snap a few frames and get what you can. At best, rice-throwing shots are candids, and they only sell if you catch great expression from the couple and a lot of action from the guests.

If you'd like to help the bride and groom, suggest to the guests that they loosely toss the rice in the air. Hardgrained rice flung into your face at two feet can be painful. Don't expect or even try to stop-action the rice as it goes through the air; the action and the people will tell the story.

Include as much of the well-wishing crowd in the shot as possible—fill the frame with action. Shooting from a high angle will help this feeling, or you can venture in closer to the action using a wide-angle lens. Showing just the bride and groom cringing or fleeing doesn't have the storytelling impact that a shot of the two of them engulfed in rice-throwers, or moving toward their car like besieged stars in a Hollywood opening does. The action is very fast during this shot, so get off a few frames and hope for the best. The only posing control you really have is in camera angle, so be sure no one obstructs your view and that you have a clear shot of the bride and groom. Have the guests spread out from where you're standing. This will give you a better view, and probably assure that the bride and groom won't be injured by any close-quartered throwing of rice.

This montage shows a series of photographs as they were eventually used in the wedding album. Flower petals are used instead of rice, a nice touch and certainly less hazardous. Expression, action and motion are all expressed wonderfully here.

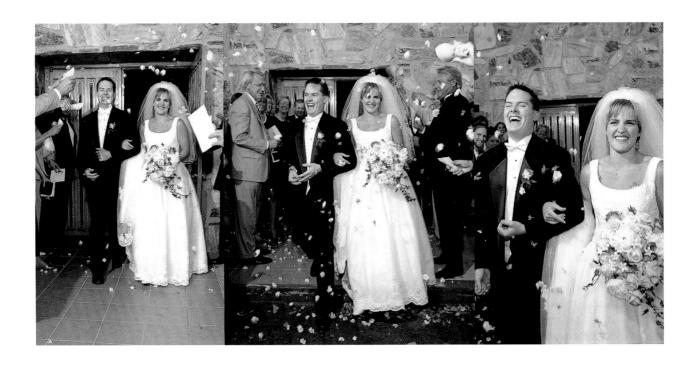

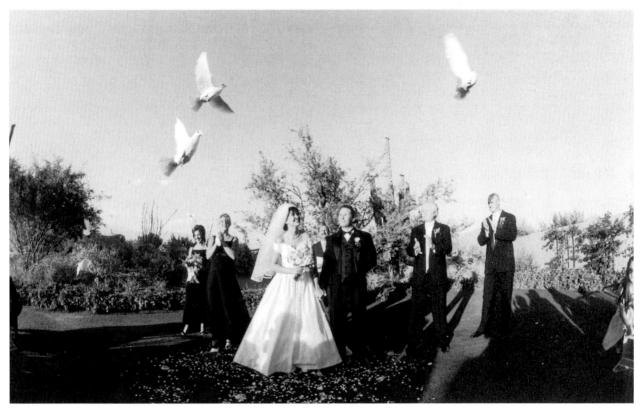

A wrinkle on rice and even flower petals is the release of doves. Needless to say this creates more challenges for the photographer.

Working with Assistants

There's no question that an assistant can help greatly in photographing a wedding. The helper can assist you with styling, posing, reloading film, holding a second light, checking light readings and so forth. Although many photographers work solo because of economics or choice, most would agree that the work is a lot easier with another pair of hands. Assistants can be friends, a wife or husband or a young photographer who's willing to do the work to learn the craft. In fact, many wedding photographers started as assistants for an important training ground in their careers.

Coordination between photographer and assistant is very important. Perhaps it would be better described as choreography. There should be a game plan along with understood

hand signals and body language. As the photographer you should train your assistant about lighting rules and direction. As an assistant you should pay attention to how light is angled and played throughout the day.

As photographer and assistant work together, the style and pace of the photographer become clear and the day's work goes smoothly. As an assistant grows in experience, he or she might be given second camera duty and eventually be sent on bookings of his/her own.

Although an assistant is a plus, most of the pictures in this book can be made by a solo photographer. You will have to work harder to accomplish some of the techniques but you can make it alone. This work is not easy, so consider an assistant an asset.

A Graceful Departure

FAVORITE SHOT FOUND IN MOST WEDDING albums is one of the bride and groom and their rented limo. These cars can be quite elaborate and they make for great props. Often, very fancy cars are used, and the couple will want to show off the style in which they were transported on their wedding day. If it's the bride and groom's own car, it may be "decorated" with cans, ribbons, and removable paint; make sure to get a shot of the festooned auto before they hit the road.

The shot of the bride and groom getting into the car can be accomplished in a number of ways. You can set up a simple picture with the groom opening the door of the car for the bride, and a crowd of well wishers behind them, bidding them farewell. Once they're in the car, you can shoot through the back or side window with the couple waving good-bye. If you're shooting from outside the car and the windows are rolled up, make sure to use a polarizing filter to cut down on glare.

You can follow the bride and groom into the car and shoot from the front seat. You'll have to use flash for this shot, so make sure you use bounce to fill the car with light rather than have the bright flash go off directly into their faces. This will prevent a harsh look and will cut deep shadows to a minimum. The bride and groom should be close together, with their heads touching or kissing. Don't waste a lot of time with this shot, but do look for details like the way the groom's jacket rides onto his collar or a bouquet that is cut off from the frame. A wide-angle lens comes in handy here, but don't get too close to the subjects or their features will be distorted.

Although many times the car seems to get more attention than the bride or groom, a fancy limousine can make a great prop for these shots. Rather than have the whole car in the shot, choose some identifying object (such as a fender, nameplate, or hood ornament) to establish the fact that the couple traveled in a special vehicle. Chauffeurs are usually understanding souls, but they probably won't drive their cars into odd locations like the edge of cliff or a muddy lawn. Gaining the cooperation of a chauffeur early on can make the difference between an easy setup and one where the owner of the prop makes the shot close to impossible.

Often, special cars will be hired to transport couples throughout their wedding day. Use the design of these cars for arrival and departure shots.

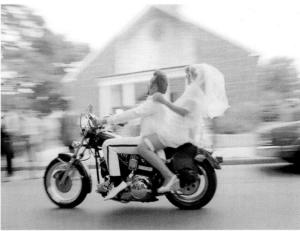

The "getaway" photograph is time for fun. Whether it be in a golf cart, a fifties classic, or a fancy limousine, use techniques such as panning, wide angle lenses and slow shutter speeds to get a special effect.

KODAK T400 CN KODAK 1400 CN KODAK 1400 CN 33 KODAK T400 CN

Sequences

T THIS POINT AND THROUGHOUT THE wedding day, you will see events and poses unfolding before your eyes. In general you are trying to find peak moments within this continuum that make for expressive photographs. In some cases, however, a sequence of moments can also help tell the tale.

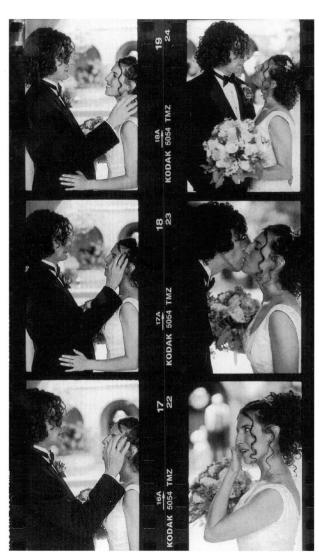

There will be times when you are shooting pictures when all you'll get is one photograph, and then the event moves on. There are other times when one picture can't tell the story, or when you see other poses and moods unfold. Moments when you can linger over such changes are luxurious, especially during the often hectic pace of a wedding. These contact sheet strips show a series of images made under these circumstances. They are like movie frames from which we can select a number of stills.

Sequences may or may not carry a narrative sense. Some are like still frames in those flip card movies we all played with as kids. Others show the unfolding of a moment that a series of images can help reveal. In essence, sequences are not merely a set of pictures, but, rather, revelations of moments that only a trio or quartet of images can do best.

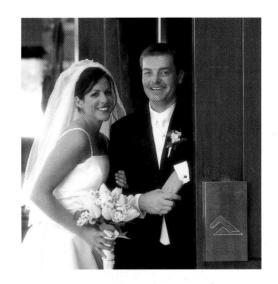

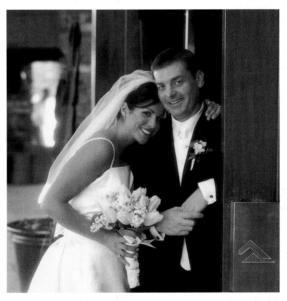

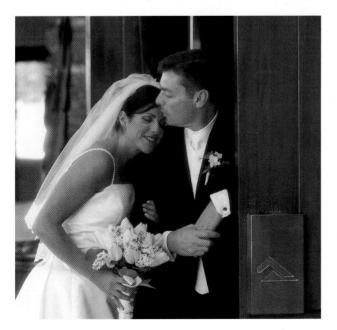

Each of these frames makes for a very good image, yet the sequence shows how a final pose might unfold. Allow people to follow their own instincts when you pose them and be watchful of changes that can affect the outcome. You might even prompt them during the sequence and keep photographing during the progression of events.

ENVIRONMENTAL PORTRAITS

the time, temperature, and weather, try to make time within the wedding day to make some environmental

portraits. What does "environmental" mean? According to some definitions, every portrait made on the wedding day is an environmental because it is made outside the confines of the studio. For our purposes, an environmental portrait refers to one taken in a park, on the grounds of the church or catering hall, or any other outdoor area where the landscape is used as an integral part of the composition of the photograph.

The choice of location is dependent upon its accessibility and the personal tastes of the couple and/or the photographer. Some couples may want a shot of themselves on the slopes of the Rockies, but this wish isn't likely to be fulfilled if the wedding takes place in Maryland. Of course, this is an exaggeration, but the location should be one that's not too far from the church and the catering hall. Racing to and from the location won't improve your pictures or anyone's disposition.

The location should have something to do with the lifestyle and personal tastes of the bride and groom. Confer with the couple before the wedding day, and select places that will be comfortable for both you and them. Have a map available to pinpoint locations, or even a few snapshots or sample pictures from other weddings to help them make their selection.

Many times, the couple may have a location in mind that has special meaning for them, although it may not seem particularly appealing to you. A couple may have met on the edge of a long beach, so you have to be prepared to trudge across an acre or two of sand. Or they may have met in a diner, and you'll find yourself setting up shots amidst the chromed interior complete with table-side jukeboxes and red cushioned seats. The point is that these pictures should be fun and meaningful to the couple involved.

If the break between the ceremony and the reception is only a short one, and the couple wants environmental shots, you may be able to get pictures on the grounds of the church or the catering hall. Many of the more elaborate wedding reception halls have picture spots all set up, complete with wooden bridges, gazebos and small ponds. While posing everyone around shrubbery or on a model bridge may not be especially meaningful, it does allow you to get variety within your shots. Natural settings and available light can add something to portraits and certainly help break up the otherwise all-interior pictures of the rest of the day. Many receptions

take place at night, so be prepared to make some use of the available light and single or multiple flash techniques.

When shooting in these setup areas, take the time to find the right light that's also most complimentary to your subjects. You can be flexible with your location, but you should be fussy about the type of light you use in the shot.

Generally, the entire bridal party will be in these shots, but if that seems cumbersome, you can just work with

the bride and groom and get the shots of the rest of the entourage a little later on in the reception. You can also use the break between the service and the reception as a time to take the couple to a select location for some very intimate pictures. Don't eliminate the bridal party from consideration, just use your judgement and make sure they don't get in the way of these special moments.

Be careful with the bridal gown when working outdoors. Muddy or damp ground and grass can easily stain the material. If conditions are poor in a chosen location, be flexible and move to a spot with better conditions.

Fill flash is a useful technique when making outdoor portraits, especially when the sun is high in the sky and shadows form on faces—particularly in the eye sockets and under the chin. A small burst of light can make the difference between a bleached-out face with dark circles around the eyes and a fully illuminated subject. Also, according to the shutter speed and amount of fill light you use, the back-

ground can be balanced with the subject matter or made dark. You can also make good use of depth of field or selective focus techniques to use the background as a context or as a soft-focus painterly effect in the image. Practicing with fill-flash and depth of field techniques certainly pays off on the wedding day.

Timing is also important during this part of the wedding day. You've got to give yourself enough leeway to make the pictures you want and still get the couple to the reception on time. This can prove difficult, so make it clear to the couple that if they put themselves in your hands, you'll get them on their way as quickly as possible. Know the pictures you want to take, and work as best and as quickly you can with the conditions that prevail.

Keep in mind that environmental portraits are an option for you when time and location allow. Don't feel that they have to be part of wedding coverage, although they certainly add a nice touch to any couple's album.

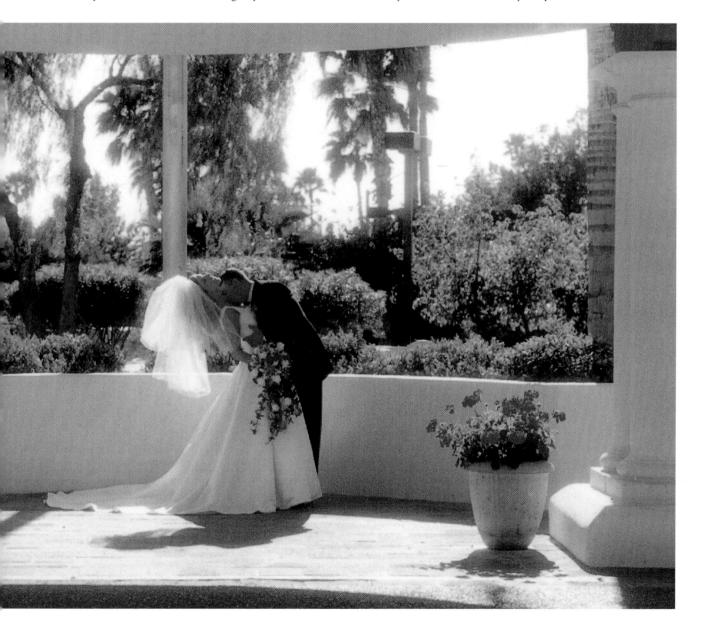

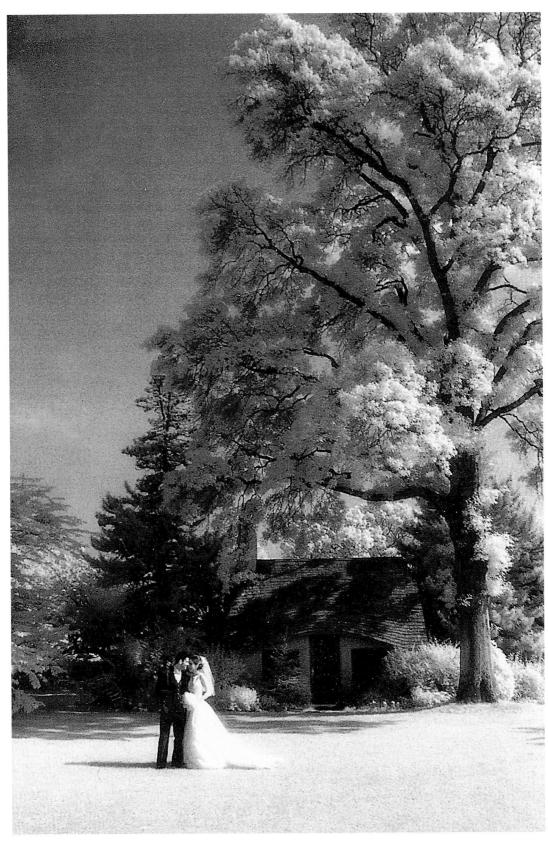

Photographed on infrared film, this image was made with a 35mm SLR and a 24mm lens. The height of the tree is key to the beauty and drama of the photograph. The couple is placed so that you can make out their faces and see them against the dark background area. When using infrared film, you must load and unload the camera in complete darkness, so don't forget your changing bag.

ENVIRONMENTAL PORTRAITS

Choosing the Appropriate Surroundings

groom, setting up the shots, and using all your photographic skills can yield some great pictures for the album, and be one of the most enjoyable times of the day. In comparison, much of the event's other portraiture may seem functional. The environmentals should evoke the mood and feelings of the couple and challenge you.

Try to treat the location as a set that reflects the couple's feelings. The beauty of nature and the light can communicate tenderness, warmth, hope, and strength. Trees can be symbols of growth; water suggests movement and change; flowers bring the picture beauty and softness.

It's important that you don't lose the couple in the environment or make them mere props in a landscape study. Yet placing the couple in a beautiful location can create a beautiful mood—obviously, a good portrait achieves a balance between its setting and subject.

When taking the pictures, aim to blend the bride and groom with their surroundings. Watch form and line, and have the couple's pose relate directly to the design of the surrounding scene. They can relate to the landscape or to each other amid the scenery, but they should always be the focal point of the composition.

Many environmentals fail when the couple stands stock still in the middle of a setting, posing as if they're in a studio with a painted backdrop. You don't have to make them prance through the fields, or row a boat in a lake, but you should make them look connected to their surroundings. This can be done by having them contemplating the area together, as well as by using props effectively.

A wooden fence, a park bench, rocks, or a row of flowers and trees can all be used as posing tools to help the subjects relate more directly to their environment. The couple can lean against a tree trunk, look at its blooming flowers, or lounge under it as if they're characters in a romance novel. Have them touch the bark or the branches of the tree, and use them as a natural vignette for the picture.

Use of auxiliary diffusers and vignetters can add to the beauty of the pictures, and here you'll be enhancing what exists rather than making inappropriate special effects shots. On a warm, hazy summer day, adding a low-density, warming (yellow) filter and a light vignette to a close-up will increase the soft, sentimental quality of the image. Don't load up on too many filters, but do keep an eye out for the "tendency" of the light and setting, and accentuate it with the discreet use of accessories.

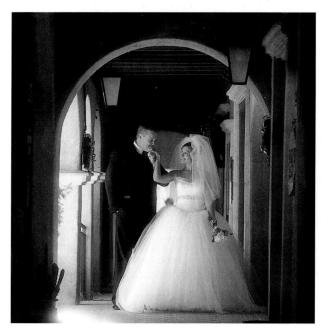

The beautiful surroundings and natural light make this a classic location photograph. This image was made with a 120mm lens at 1/15 second at f/5.6. Note the low camera angle and how the couple is focused on on each other and not on the camera.

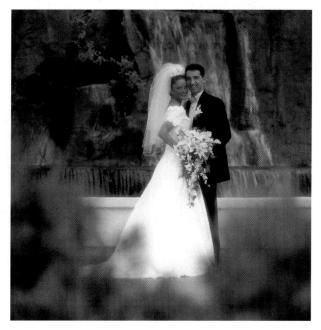

This image was photographed at ½ second at f/5.6 with a 250mm lens on a Hasselblad. Ken used a slow shutter speed to give a sense of flowing beauty to the waterfall. The unfocused foreground creates a border vignette around the couple.

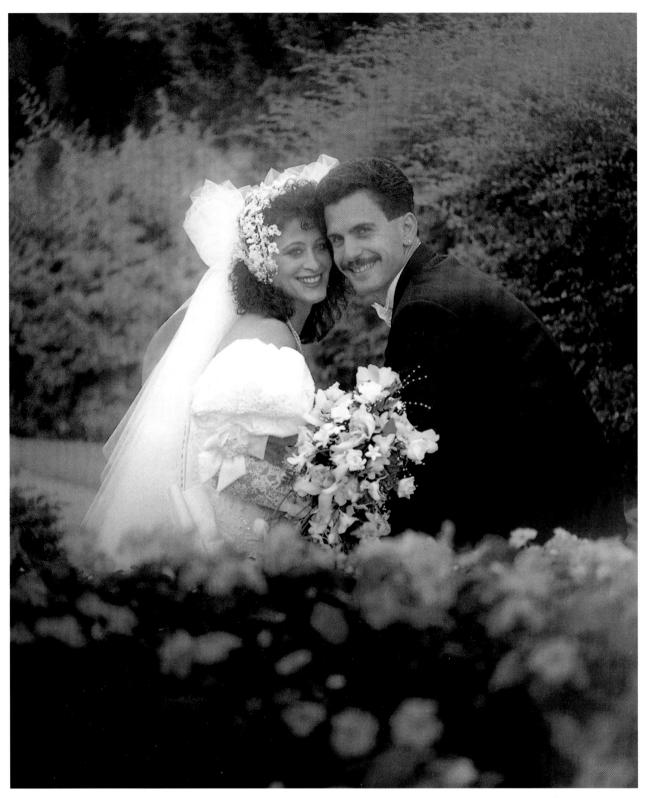

This classic pose is enhanced with the border of unfocused red flowers in the foreground. Note how the closeness of the couple is expressed through the cheek-to-cheek pose and how the way their heads are turned adds dimensionality to the shot. The bouquet connects the couple and completes the line from head to head through shoulders and flowers.

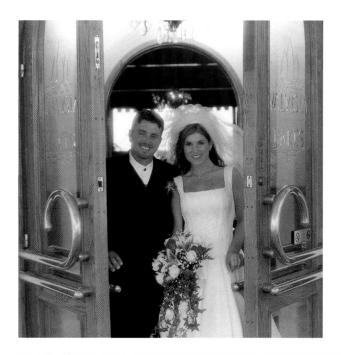

Watch Your Framing

There are some basic concepts of composition whose purpose is to keep the viewer's eye within the frame and focused on the main subject. As with any advice, consider these as guidelines and not hard-and-fast rules. For example, many photographers do what they can to avoid a mass of white or highlights at the edge of the photo's frame. This is why edge burning came into being and why some photographers still use

vignetting diffusers to break up highlights. Another framing pointer is to avoid distracting attention from the primary subject by making it the center of light, wherever it may occupy the frame.

In these two images Ken intended to incorporate the doors of the reception area within the frame. In one, he shot from a center angle and in the other, from a lower camera angle to eliminate the distracting window in the background. The lower viewing angle also emphasizes the presence of the couple.

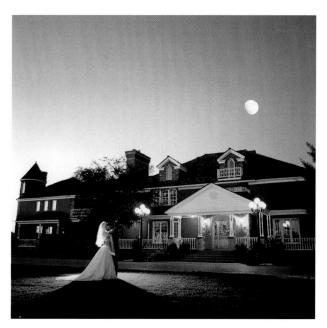

As the sun sets, you get ambient light to fill in details and a beautiful aura of light in the image. This scene was made on the back lawn of the reception hall. A flash was placed behind the subjects to create a silhouette, triggered by a radio transmitter.

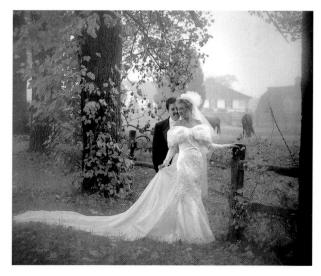

The diffuse light of this fall day was enhanced by the use of an edge diffusion filter. Note the spread of the dress and the line created by the bride's left arm, extending to the end of the gown.

ENVIRONMENTAL PORTRAITS

Dealing with Changeable Light

tioners—as the date of the trip approaches, the weather report becomes the most important item on the news to them. Long-range forecasts are eagerly watched, and the dreaded rainstorm is wished away with offerings, invocations, and prayers. If there's one uncontrollable factor on the wedding day, it's the weather. You'll have to make the best of whatever light and outdoor conditions exist. You might even have to dance between the raindrops.

Though rain certainly poses a problem, harsh, open sunlight can be just as difficult. Too much sunlight, particularly in the middle of the day, can create havoc with shadows on faces and can cause squinting eyes. Too much light is often more of a problem than too little light in effective outdoor portraiture.

If you could control the conditions and/or time of day to shoot environmentals, a light, overcast day or one where billowy clouds pass over the sun would be ideal, as would shooting the pictures in the late afternoon. No other light is quite as complimentary to skin tones, or to any other sub-

ject, as that cast in the "magic hour," the last hour or two before sunset. Shadows are soft and the long rays of the sun make the world and your subjects glisten. In fact, given a choice, many photographers simply wouldn't pick up their camera to work outdoors on a sunny day between the hours of ten in the morning and four in the afternoon.

A slightly overcast day, similar to those so frequent in the northwestern coastal regions of America, has the perfect light for outdoor portraiture. Dutch painters and early masters of natural-light photographic portraiture made this light famous. Quiet light is perfect for color film, where too harsh a light often goes beyond the contrast range of the film itself. So if you're praying for particular weather for the wedding day, a bright, sunny day isn't necessarily the best choice.

Given that you can't control the weather, it's important that once you arrive at the chosen location you scout areas for the best possible lighting situation. Open fields will cause a problem if the light is too harsh, so the positioning of your subjects is very important. When you've set up a shot,

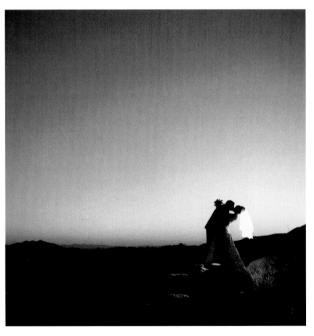

Waiting for the sun to get below the horizon and then using a radioactivated flash for the backlight "blast" made this silhouette photograph. Note how the strobe is aimed at the veil to give the couple a bright aura.

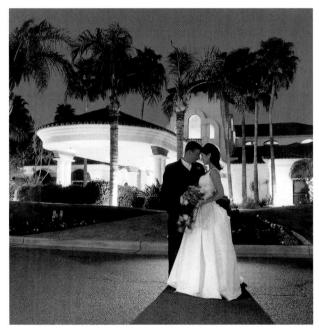

Ambient light, artificial light, backlight flash, and foreground-fill all combine to create a harmonious blend in this image. The best time for such images is right after the sun sets when there is still some available light in the sky. This "catalog" of lighting techniques is something that comes after years of testing and working with light and represents a true appreciation of the craft.

look very carefully at the way shadows fall on faces and whether the subjects are squinting when they look in the direction of the lens. Sidelighting is best, though backlighting can certainly be used.

If possible, pose your subjects in open shade, and have them covered by a tree or other natural umbrella. Open shade on bright days is perfect because you avoid harsh light and have enough fill-light from the surroundings to give your subjects a pleasant look.

There are two things to look for in open shade. One is a hot spot in the background. You may get a reading of f/5.6 under a tree, but the greenery or lawn in the open area of light may read as high as f/16. Watch for those hot spots, and pose and shoot from an angle that eliminates them from the scene or at best uses them as part of the composition. Dappled shadows from the leaves falling on your subjects are another potential problem that cause an uneven, blotchy look. Take care to avoid those odd patches of light that can ruin a picture.

Groves of trees are good locations because they pro-

vide ample coverage for outdoor portraits. If there aren't any available and you have no other choice than shooting in open light, a fill card mounted on a light stand or held by an assistant can provide a certain amount of illumination to help balance it out. Tilt the reflector toward the subject to bring the light reading to an even, modeled look. Fill flash technique is an absolute necessity for a wedding photographer, important for balancing out the foreground, background, or shadow areas of the picture.

Even with its occasional problems, natural light still provides a wealth of beauty for making pictures. No amount of filtered strobes can provide the warmth and depth of natural light, and if natural light is used correctly it can contribute much to the wedding coverage. Keep an eye out for tunnels of light, where the light moves through a defined space and plays on your subjects, or broad streams of illumination, where light enters into the picture as if spotlights in a theater were shining on the couple.

Light has an inherent color and tone whose properties affect the picture as much as the light's intensity. The tones

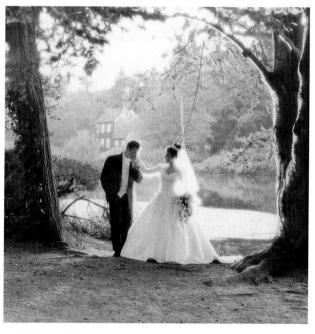

Backlight might be considered a problem, but Ken always sees it as an opportunity for adding an ethereal touch to images. Here the edge glow adds to the romantic pose.

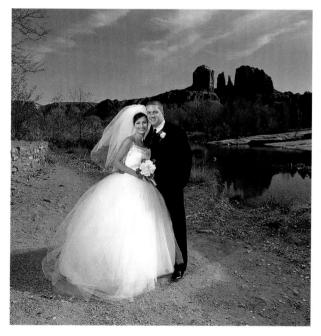

This fill flash is handled with the light coming from the side rather than solely from camera position. Two-light or sidelight fill is a great way to give your fill photographs an extra special touch. This photograph was made in the middle of the day. The background was intentionally underexposed to give an afternoon or early evening feel. The exposure was 1/500 second at f/22. A leaf shutter (found in medium-format cameras) will sync at every available shutter speed.

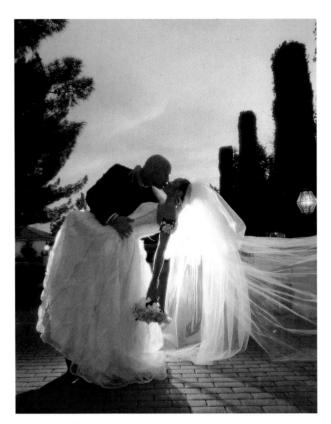

The beauty of the sky at sunset becomes an essential part of this scene. The backlight flash is used to add brilliance to the veil while ambient and slight foreground fill yields some details on the couple. The use and manipulation of light enhance the excitement and romance of this photograph.

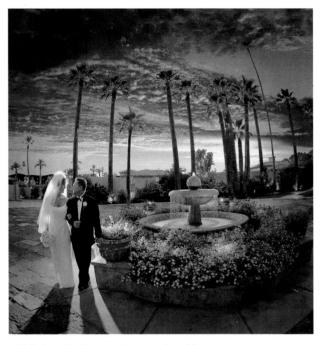

Fill flash and ambient light are combined here to give an amazing study of light and pose. Backlight flash brought the couple forward in the scene and gave them a magical edge glow. Fill flash on the foreground added detail.

can be cool, warm, or neutral-gray, filled with moisture or crisp and dry. You can enhance or change these properties with the subtle use of filters, and even darken edges when they appear too bright with the use of vignetting or gradient filters. Gradients have a higher to lower density range from top to bottom, and there are even types available that yield a density range in a halo effect. When using these gradients, take care that the horizon line of the filter is even with the horizon line in the photograph.

Meter readings are critical for outdoor, natural-light shooting. Be careful not to underexpose, as this will result in loss of detail and poor color. For "normal" shots, make sure all the elements in the scene fall within a manageable range, and that you average the readings so all the elements will fall within the proper printing range. Natural light also allows you to make interpretive pictures, and you can use backlighting or create special effects by overexposing certain elements within the scene. Your negative will determine how the print will look; so manipulate the meter readings to get the negative you want. Make tests of any film you work with so you understand how it "behaves" when over- or underexposed. Create catalogs of effects through various exposure techniques. In short, get to know your film and you'll get better results in every shooting situation.

When doing environmentals keep these pointers in mind: find the light that's right; eliminate contrast problems through posing and light readings; consider enhancing the beauty of the light through the subtle use of filters; and work with rather than against the light. Location, the time of day, and the feelings you want to communicate are all factors that go into making effective environmental portraits.

Opposite, top left and right: These classic waterside poses are enhanced through the use of a diffusion filter and some vignetting techniques. They use essentially the same locale, one with the couple standing and the other using a seated pose. Note the difference exposure and ambient light makes in the scenes. It's like lighting a set in different ways.

Opposite, bottom: This is a classic fill-flash image. The couple is posed under a tree for open shade illumination. The light is streaming from behind throwing a warm spotlight on the lawn, giving the bride an edge glow and creating a beautiful color in the tree. Fill flash is handled with subtlety to add just enough illumination to the couple.

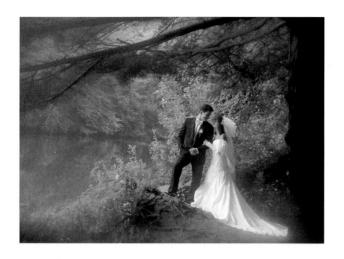

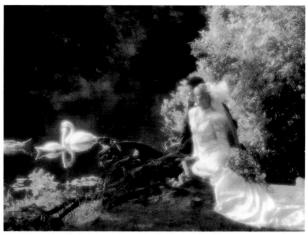

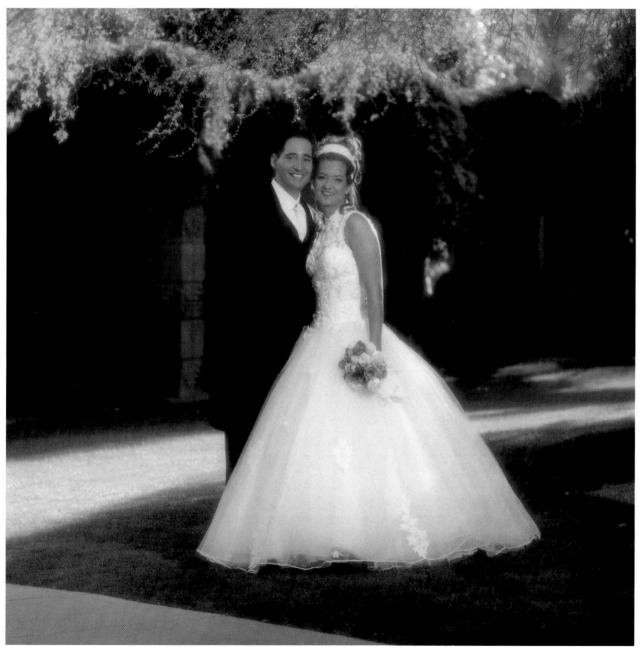

ENVIRONMENTAL PORTRAITS

Photographing the Bride Outdoors

HE SCENE IS A ROCKBOUND SHORELINE WITH waves crashing in on it while the sun slips below a mountainous horizon. A woman stands alone on the rocks, the wind sweeping through her hair, her dress flowing in the breeze. She looks out over the sea; the camera sees her in profile and her eyes glint in the day's waning light. She's looking for an answer to her future in the endless seas, and the glow of love and hope surrounds her. If this sounds like a scene from a mini-series, or a book jacket on some romantic novel, you're wrong—it's part of what's being done today in environmental bridal portraiture.

The trend toward romantic portraiture comes and goes, but it has always been a part of wedding photography. Many photographers let their fantasies run wild. While it may seem overdone, or even corny, it's all a part of this business. Whether your tastes run to the dramatic or the simple and you're just interested in getting a good shot of the bride in a nice setting, you should pay attention to feelings and moods in all your pictures. The point is—don't be content with a picture of a woman in a white dress on a lawn. You don't have to construct elaborate story lines, but you should pay attention to light, lines and expression. If you choose to

go for a "storyteller" cover, be sure to know exactly what you're doing and why. Nothing comes off worse than a failed attempt at romantic sensationalism.

Part of all this is knowledge of the bride's personality and what's natural to her. If she's poetic or artistic, you can pose her contemplating a flower or looking out to sea. But if she's more of a pragmatic person, these shots will be phony, and the people involved will recognize them as such.

The way the bride poses is, of course, very important. The gown has a part to play. Suggest some stances and veto others. Never pose the bride standing flat on both feet squarely facing the camera; have her turned slightly to the side with her weight on one foot or the other. If you're using a posing prop such as a park bench, spread the dress gracefully and use the bouquet as a hand prop.

Take care when spreading or draping the gown—stains can mar the material and cause problems in your pictures.

The bride's hair and veil may blow around in the breeze. Although this can produce a good effect, don't let them get out of control. Carry bobby pins in your camera bag just in case the bride has left her kit back in the car. In all the poses, look for gracefulness and simplicity, and have the dress

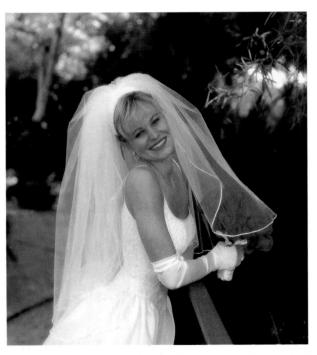

This intimate portrait was made under shade trees, so a slight touch of fill was needed to balance the light and fill in any shadows. This simple, straightforward pose uses diagonals, a careful fall of the veil, shallow depth of field and of course a wonderfully radiant smile for its completion.

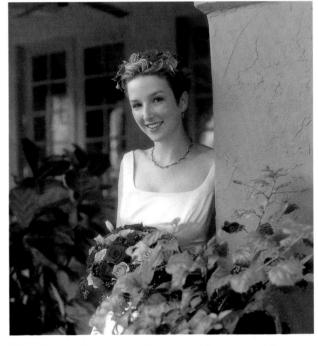

When photographing portraits keep in mind that some modeling or lighting ratio from one side of the face to the other helps. Without this difference many portraits, particularly close-ups, can take on a "pass-port" feeling. This beautiful bride was photographed with natural light. Posing into the light created natural modeling.

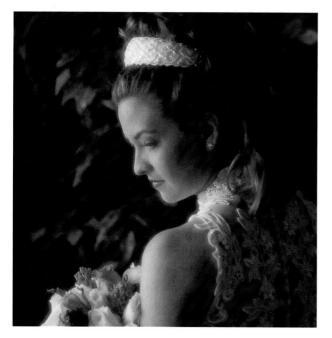

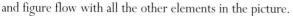

There's no rule that says you have to pose the bride in the center of the frame. In fact, keeping her slightly to one side can aid in the balance of the composition, particularly if the location is one that contains strong emotional content. Have your subject and setting complement one another, and make the outdoor-bridal portrait a little different than the one you'd make in the confines of a studio.

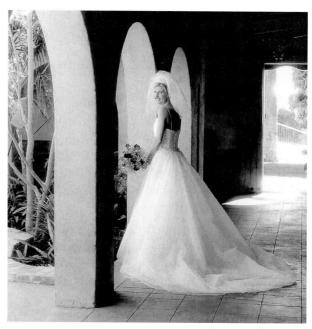

Natural light is a great ally in portraiture, particularly if you can use it when it is reflected or diffused by buildings, trees or the overcast sky. This bride was posed within the arches with the main light coming from the left. The turn of her head creates the beautiful modeling of light on her face. The very bright light coming through the doorway in the upper right is contained within the top of the frame and serves as an ethereal presence in the image.

Using Fill Flash Outdoors

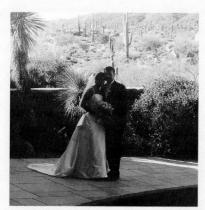

Fill flash is the most effective technique used in environmental portraiture. It not only can help you when light is strong and contrasty, but can also be used for creative techniques as well. Many of the images you see on these pages were done using fill flash. The trick is to not make it apparent.

Some wedding photographers use fill on all their outdoor photographs, although this may not always be necessary given the right lighting conditions.

How you handle fill also depends on the type of strobe you use and how it dedicates to the camera's exposure system. Check the instruction book that comes with strobe and camera and study and test the fill-flash techniques. Happily, many camera/flash exposure systems are closely aligned and auto-fill techniques are now

the norm. But there may also be times when you want to compensate flash to work with power ratio controls for a subtler look than auto flash can provide.

You can also balance the foreground and background light using fill techniques, at times deliberately underexposing the ambient light and using the strobe light as the main source of illumination. If you are working with a strobe that syncs at higher shutter speeds or with a camera with a shutter that syncs at all available speeds you can also control background depth of field more easily.

In this set of images the first shows the proper reading for the background light level. To control this contrast gap a burst of strobe is used to fill the foreground in the second picture. Without this technique the foreground subjects would look as if they were standing in front of a dark background.

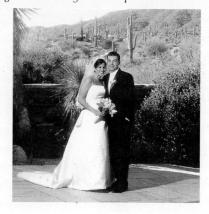

ENVIRONMENTAL PORTRAITS

Photographing the Groom Outdoors

OSING AIDS CAN BE VERY USEFUL WHEN doing environmentals of the groom because he doesn't have the resources of a gown to add to the grace of his stance. Don't pose the groom standing alone, hands in pockets and looking into the distance as if he's waiting for a bus. Use trees, benches, and walls to help balance the pose and take special care to pose his hands and arms in a graceful fashion. Though the environmental portrait should feature a pose that's more casual than a studio setup, don't just have the groom stand in the woods unsure of what he's doing there—have a reason for the picture, and seek some involvement between the man and the location.

Natural light can be used effectively in the portrait of the groom, and you'll have somewhat more leeway in using strong, high contrast light in your picture. First off, there's no white gown to make trouble. The man is usually clad in black or dark clothes. Also, the strength of light can help produce a more masculine "image." This won't apply to all the men you take pictures of, so use your judgement as to which men will benefit, and enjoy, this type of shot.

There's nothing wrong with having the man contemplate flowers in the same manner you asked the bride to pose, as long as his particular ego seems compatible with that theme. Some men may feel silly or artificial in such a pose, so you may have to resort to a more traditional stance, like posing the groom with his foot on a bench or rock, with one arm resting across his knee. You can also get a picture with the groom leaning against a wall or a tree, or a close-up with his arm resting on a boulder used as a posing bench.

Utilize the location to the best of your ability. If you're photographing in a marina, you can have the man posing on or near a boat. If you're in a field with a wooden fence, use the texture and direction of the wood as a counterpoint to his stance. Use whatever's handy to involve your subject, and keep it in line with what he's comfortable with, and the sensibilities he's allowing himself to show.

Diffusion filters are rarely used when making portraits of the groom. You might consider them if the individual has a particularly ruddy face or a blemished complexion. This form of visual makeup can compliment the subject without being overdone. A dark vignette can also be used since this filter will go along with the dark clothes the groom usually wears. Vignettes also help center the light on the groom's face in close-ups, and can help remove any distracting elements in the background.

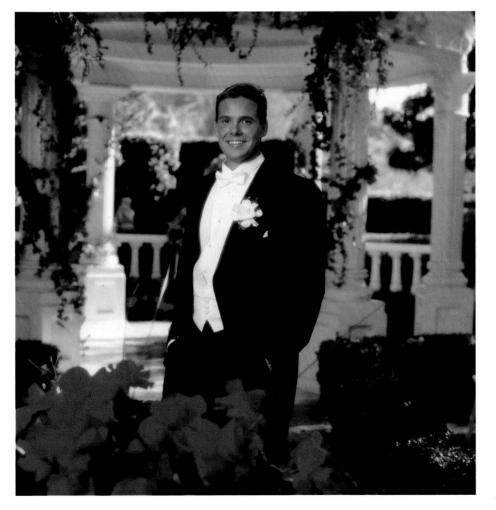

The groom has been placed within a vignette of architecture and flowers in this image, with a slight touch of fill flash to eliminate stray shadows. Note the slight turn to his pose and the radiant smile on his face. Many times images of the groom show serious expressions. The genuine happiness of this subject makes for a much more successful image.

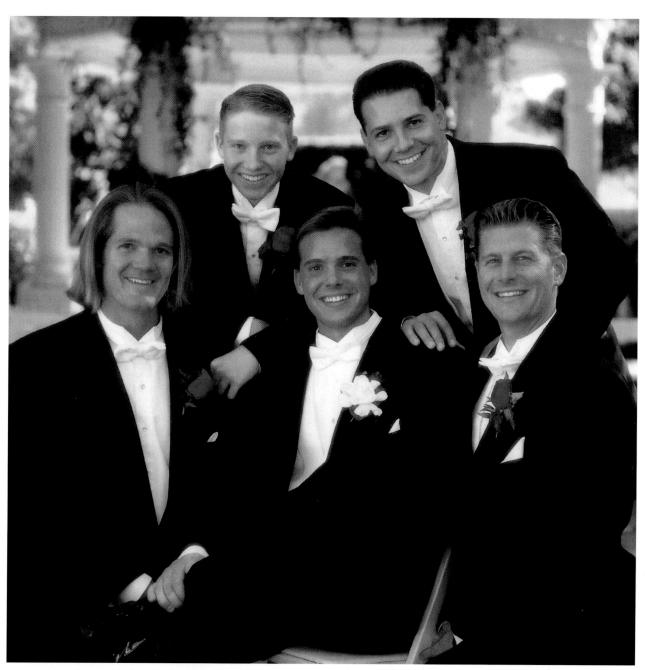

Hands on shoulders show support while the extra lean-in shows closeness. Ken has used one chair as a posing tool for the five men. Getting close also allows the viewer to relate directly to this handsome group.

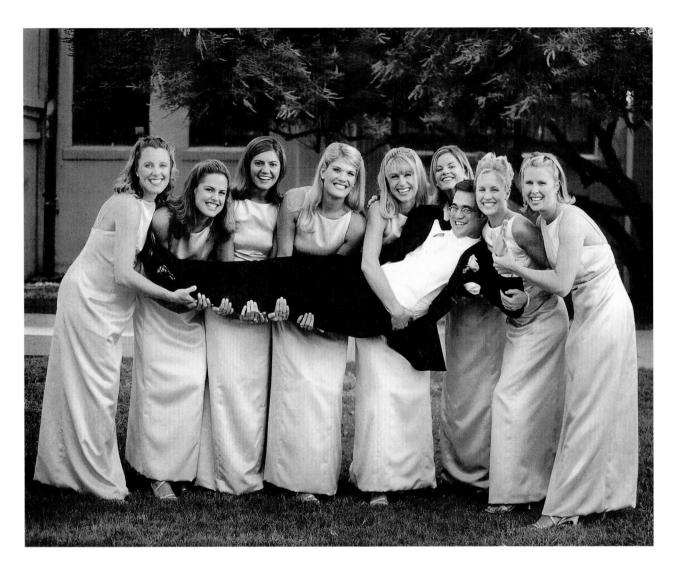

ENVIRONMENTAL PORTRAITS

Arranging a Large Group Portrait

party might mean doing a portrait of a substantial number of people. The tendency is to line everyone up to get a picture of record, something you may be forced to do if the group is ten or more people. This doesn't mean, however, that you have to get a stiff, formal pose. You can make this picture express the intimacy and feeling among the people involved.

The wedding party may consist of people who've never met before, or it may be a tight bunch of close friends. Whatever their relationship to each other is, the people involved are bound by their connection to the bride and groom. It's your task to communicate that bond, and to do it in a way that shows everyone to best advantage.

You can accomplish this by photographing the group in

a number of different situations. Involve the group in an activity, or photograph them in a pose or location they suggest. One possible pose is a "walking" shot, where the group links arms and walks toward the camera. As they walk, back up and shoot on the move. As the group picks up steam there'll be more expression in their faces and body motions. The bride will have some trouble moving fast in her dress, so don't ask them to charge down a hillside. Another option is a "hug" or lean-in pose. After making the usual arranged photo of the large group, have everyone give their neighbor a hug. The result can be a fun picture.

Pictures of the group relaxing together can also be good for communicating togetherness, so have your camera ready for candids between the formal takes. Don't be afraid to refine their poses once you see a shot, although too much

interference may spoil the mood. You can encourage this type of shot by having them sit and talk together, perhaps reminiscing. Ask some of the group to stand, some to sit, but make sure everyone in the group is involved in what's happening. The point is to use your instincts with these group shots, and to mix formals with more casual, relaxed shots.

Although you may have already photographed the wedding party at the altar and may plan to take a few shots at the reception, the outdoor location gives you many opportunities to pose the group in a less straightforward manner. Use whatever props are available, such as benches, trees, gardens, and other natural elements. Intertwine the group with the environment, and then with each other. Find those moments of intimacy, and bring them all together when you snap the shutter.

Opposite: Of course not every moment or pose need be classic or serious. This unconventional pose for the groom and bridal party helps keep the mood light and the picture-making fun.

Below: This is a classic group pose with a special extra—the "hug." After making the type of image where the large group is kept balanced and carefully arranged, Ken asks for everyone to give each other a hug. This takeoff on the classic pose has proven to be a popular photograph in many albums.

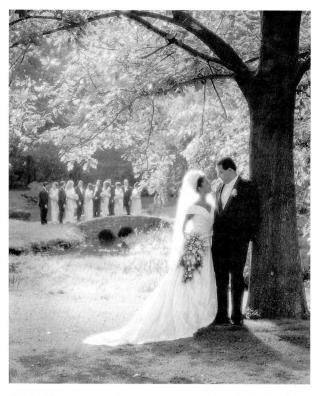

This backlit scene is another interesting way to pose the bride and groom with the wedding party. Of course other images will be made that show the faces of the bridal party close in with the bride and groom. Use of backlight and fill flash creates a wonderfully wistful scene.

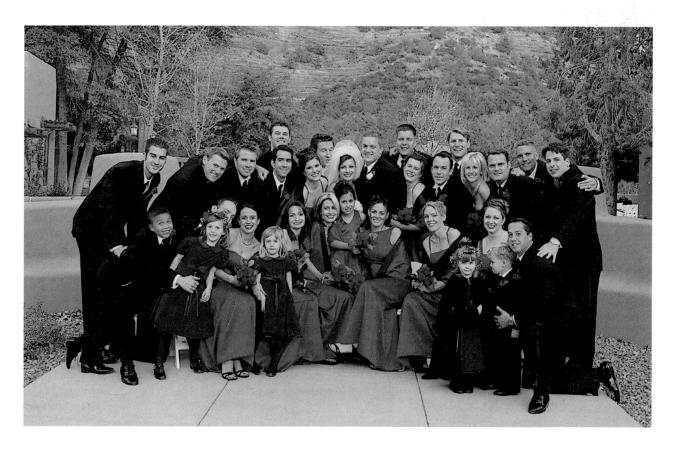

AT THE RECEPTION

T THE RECEPTION, ALL YOUR instincts and talents will be called upon; you'll have to be a portraitist, photojournalist, candid photographer, designer, and

director in an environment where things are happening quickly and different people are coming and going. Discretion is very important at this time. You'll be involved in a situation where everyone is there to have a good time, and you're there to work. Keep a sense of balance and get your shots, but don't intrude on the flow of events or impose too much on the people involved in them.

Try to maintain a sense of control by being knowledgeable about the course of events. Some receptions may have their own whimsical plan. Don't get caught napping or changing film when an event is about to occur. Confer with the bride and groom beforehand, or make contact with the band leader or maitre d' at the reception hall. One or all of these people can fill you in on the reception "script," and cue you in when an event is about to take place. The best man and maid of honor may also be helpful at this time, but more often than not they are there to enjoy themselves and probably won't be much help after a while.

The maitre d' or party coordinator is important in that he or she often controls the pace of events as they unfold. If there will be extended toasts by a number of people, or a time when a few wedding guests gather for a blessing, the maitre d' can make sure that each person holds for a picture, or that a group stays in position as you reload film.

This liaison can also let you know where and how the bridal party will enter, when the first dance is to commence, and where the cake will be placed for the cutting ceremony. Most of these people have experience with photographers and with weddings, so you can expect them to be helpful and cooperative. Remember, however, that the hall is their domain, so don't stride in expecting to tell them how to run their show. The right attitude can make things go very smoothly—the wrong one will make problems for you throughout the day. Establish your rapport early and work with the maitre d', not against him or her. If the maitre d' wants to, he or she can really make your life miserable.

There are a number of shots that are almost obligatory during the reception, including the entry procession, the toast, the first dances, the bouquet toss and the cutting of the cake. Most weddings share these events, though there are exceptions and variations on each theme.

Aside from the setup shots, you should keep your eye

out for interesting candids. Roam about the room as you would at a public relations event, and look for interesting small groups and situations. These can include pictures of small children with grandparents, couples and groups dancing, people enjoying conversation with one another, and especially, quiet shots of the bride and groom alone or with friends. You might even want to occasionally borrow the couple from the main room for some portraits using the decor of the reception hall. Most of all, get shots of the guests having a good time.

Increasingly, photographers are doing these candids without flash, with high-speed film and with wide-angle lenses. This is when the wedding photojournalism approach truly works and when the pictures mirror the spontaneous fun of the affair. It is also when people are at their most relaxed and when you can have some fun with your photography. Don't think, however, that this means you can be inattentive to picture quality or technical excellence. Though more casual, your images should always be the products of a professional eye, and not a random snapshooter.

There are also some photographs that are better left untaken, such as shots of people eating, large groups where half the people have their backs turned to you, and too many pictures of nebulous groups on the dance floor. Also, if people do lose their cool or drink too much, don't embarrass them later with a photograph of their bad behavior. These rarely, if ever, sell and they don't serve to highlight particular people or events. You can get carried away with candids and waste a lot of film and energy. Make the pictures specific. Even though they are candids, approach them as part of the wedding story.

During the course of the reception, you may be approached by any number of people requesting that you take pictures of them or their relatives. "Please get a shot of my aunt and uncle," one may say, "they're here from far away and we never see them." Make the shot if you have the time, but don't interrupt your own schedule to do it. Some photographers carry small order booklets with them, and have people sign mini-contracts to buy the picture on the spot. Don't exchange money at the reception, but make sure these pictures count and that they'll result in an actual sale. Posting a selection of the photos on a Website can help sell such pictures because anyone who attended can look them up and see them, not only the couple, and can then order themselves pictures later.

One way to handle requests from guests for such pictures is to set aside a period of time during the reception

Whenever possible, Ken tries to get a photograph of the reception room prior to the ceremony to show off the beautiful decorations. He also likes to include the bride and groom in the scene. The wedding decorator or reception hall manager also appreciates these photographs.

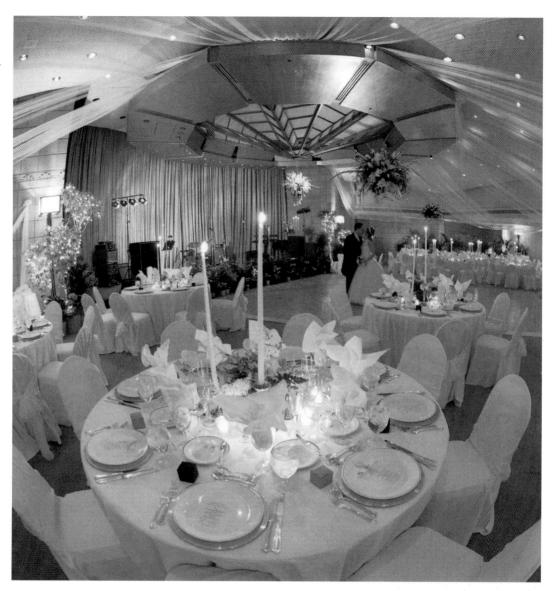

when all formal shots can be handled. Have the maitre d' announce that, say, during dinner and dessert, or after the cake cutting, you'll have a small studio set up in an area of the hall and that anyone who wants an individual or group portrait can report to have their pictures made. This is a good way to handle family groups. You can also arrange this beforehand with the bride and groom, but don't count on them being able to gather everyone together. Experience shows that these group shots can take a lot of time and energy. You'll be able to handle them better if you arrange a specific time and place.

You won't have to spend time chasing down people you don't know, either. Announcing a time and place for such photos puts responsibility for showing up on the people who want their pictures taken. This will avoid endless hassles and delays. Put a time limit on the operation of the "studio." If people don't come during the designated time, you can't be faulted for shirking your duty.

Some couples want table shots of select groups or of all the invited guests. This is a troublesome task, and I recommend you make these pictures on a sales-guaranteed only basis. People are forever roaming during the reception, and you'll often have to wait around for everyone to assemble. One good technique is to insist that the bride and groom be with you when you make the rounds, and that they appear in every shot. This usually guarantees the cooperation of the sometimes reluctant guests. Another approach is to get everyone involved in one large group photograph. The maitre d', bandleader or disc jockey can be helpful in this matter. One large group picture eliminates the hassle of table shots.

A reception can be a harried affair, but if you follow a script, set up a specific time for formals, and shoot only those candids that are important in the context of the overall affair, you can possibly relax enough to enjoy what's going on and get good pictures. You'll work hard, but all your energy will be directed to the task at hand.

AT THE RECEPTION

The Introduction of the Newlyweds

OST RECEPTIONS BEGIN WITH THE formal entrance of the bridal party, with the band leader or maitre d'announcing each couple's name just before they enter. It's similar to stars being introduced at a gala, and the process is accompanied by fanfare and applauding guests. Find out where the group will enter and then set up for a good camera angle.

It isn't always necessary to photograph each couple as they enter, especially if you already photographed them in the procession down the aisle at the church or when you did your environmental portraits. Photographs of the bride and groom, however, are another matter. Take a shot when they first enter (with the guests in the corner of the frame) and include the guests cheering them if possible.

Some entourages line up in rows, as if they're about to dance a reel, and then the bride and groom walk down the aisle they have formed. This can be a great chance for candid pictures. Be sure that none of the bridal party is blocking your view, and that the flash doesn't bounce off an intruding shoulder or gown. Also, place any children at the front of the rows so they won't be lost in the crowd.

The bride and groom's entrance procession is more formal sometimes, and the bride and groom will walk between crossed swords, raised arms with hands linked

> together, or some other type of personformed enclosure. Get down low for this shot, and include the special formation with the couple going through it.

> Once the bride and groom have come through the group, have the party stand together for a quick group shot and back up enough so that you include some of the hall, and especially the standing guests, in the picture. This should be a quick pose, and it serves to show the presentation of the bridal party in the context of being received by the guests.

These events happen very fast, so be sure to have a fresh set of batteries, or a flash set on fast-recycling time, for the whole series. You can't interrupt the flow of events by asking the group to wait or the maitre d' to slow his pace of announcing them just because your flash decides to lose power on you. This is true for many events during the reception, so be ready for the action.

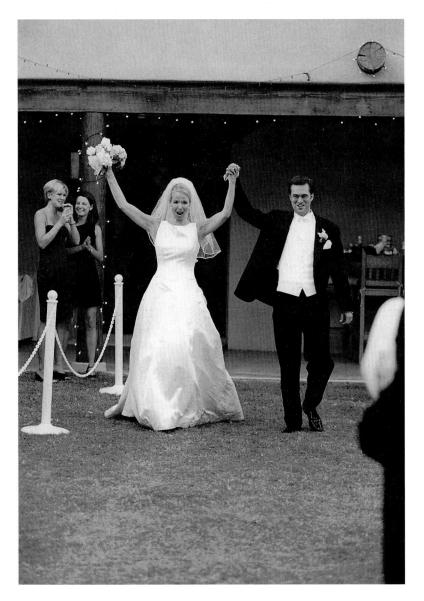

This more candid approach catches the spirit of the moment and the exuberance of the bride and groom. Because the action is taking place outdoors there is less concern with lighting placement. The candid style makes for a more spontaneous feel, although there's no way that you can script this kind of action.

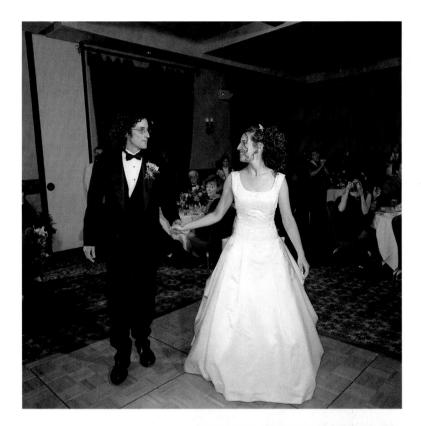

The first introduction of the couple as "Mr. and Mrs." at the hall starts the reception and is a key moment in the coverage. Position yourself to have a clear photographic line to the subjects as they move into the hall and be ready with focus and second light, if needed. You don't want to stop the couple as they enter. As with many photographs during the reception, timing and instinct rather than setups will get you some very good images.

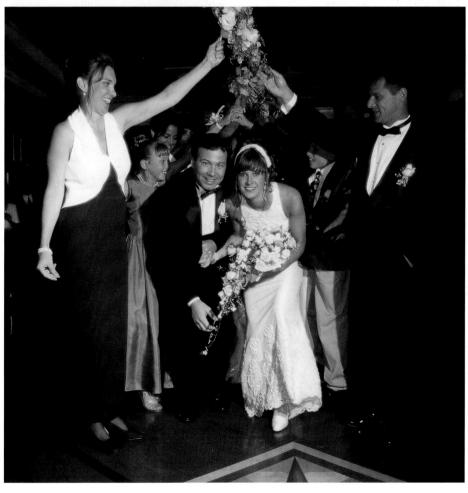

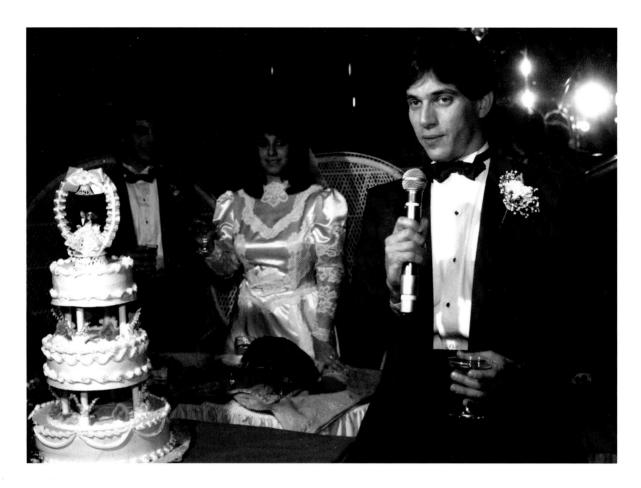

The Celebration Toast

NCE EVERYONE IS SETTLED AT THE DAIS OR wedding party table, it's usually time for the toast to be made. If it's a large hall, the toaster will have to come to the microphone on the bandstand, but more often than not the toast will be made right from his or her table. You can get a shot of the person making the small speech, glass raised in hand, but proper positioning can yield a much more effective photograph.

Move around the table until you have the person giving the toast and the bride and groom in the viewfinder. Don't be too concerned with depth of field if you can't get the bride and groom in the background in crisp focus, just keep them in the frame so the connection is made. While the toast is being given, the bride and groom will be sitting close together, their eyes on the speechmaker. Take a few shots of this pose, and establish giver and receiver with your camera angle.

Right after the toast, move in close to the bride and groom seated at the table and get a few shots of them with glasses in hand. Have them toast one another, or get some pictures of them with their heads leaning in toward one

another. You can get a few smiles out of them by asking them to intertwine arms and drink from each other's glasses. Unless they're practiced at this technique they'll fumble a bit, and once they get it right you can get a few images of them laughing about it.

A wide-angle shot of the whole wedding party table toasting the bride and groom can also be made at this time. Just step back, set up the shot quickly and make your exposure. Watch out for centerpieces and table decorations, making sure they don't block the view or reflect light back into the lens. There won't be much time to rearrange these setups, so just find the proper camera angle that gives a full view.

A variation on the toast is the blessing that, in Jewish weddings, takes the form of the cutting of the challah bread. A favorite uncle, grandfather, or other male elder comes forward and says a blessing while he cuts into the bread. This is an important shot in the reception sequence, and you should get one shot of the man alone performing the blessing, and then a group shot of him with the bride and groom.

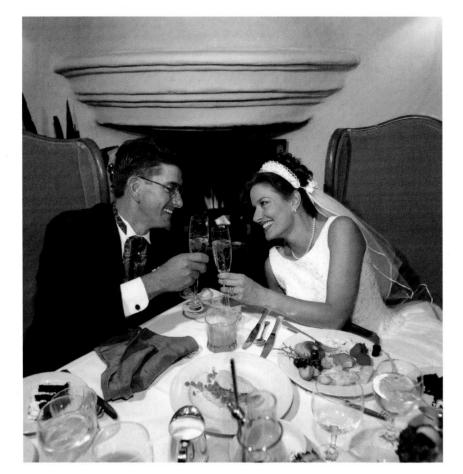

Right: Right after the toast is made move in for a photograph of the bride and groom as they clink glasses together. Have them relate to one another rather than to the camera. The extra touch of the fireplace and flames highlighting the couple's glasses is no accident here.

Below: The toast can be funny or quite serious, depending on the flow of life at the moment or the skills and humor of the person giving the toast. It's a great time for reaction shots from the bride and groom.

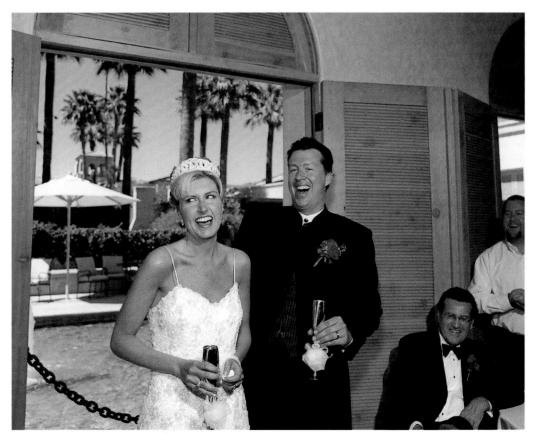

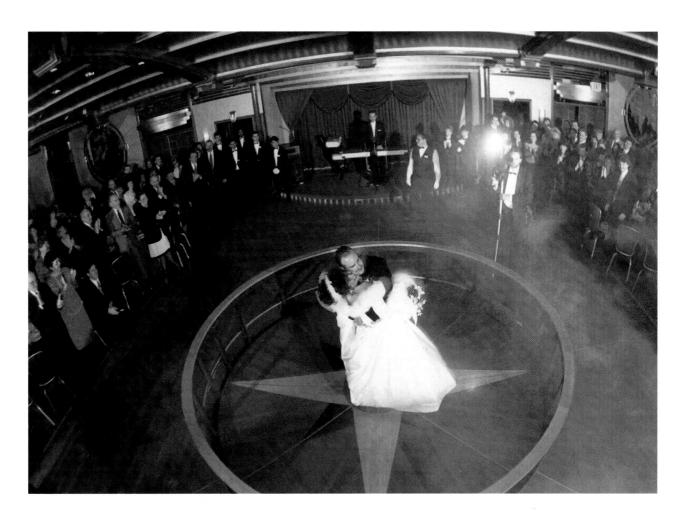

The First Dance

s soon as everyone's seated after the toast, the bandleader or maitre d' may call for the first dance. This sequence of events involves a number of couples—the bride and her father, bride and groom, groom and mother, and so forth. These dancing partners may change often and quickly, so move in and get the shots at the first opportunity. The most important shots are the bride and her father, and the bride and groom.

The "first dance" pictures are ones that exemplify the need for discretion in wedding coverage. These are very intimate and touching moments. You can't rush in and pose people just because you need the picture. When the bride is dancing with her father, for example, take a few shots in their natural poses. This may mean the couple is facing in opposite directions. If you're lucky, they may look at each other once or twice during the dance, and then you'll take the pictures.

If you haven't gotten the shot you want by the time the song is ending, approach the couple and quietly ask them to look at the camera. Shoot one or two close-ups and then

move away and leave them to their moments together. Don't circle them about the floor, jutting in and out pointing your camera in their faces. Get the shot you want, but don't intrude on their intimacy. The same holds true for other dancers.

When the bride and groom get to dance together you can be a little more forward in your posing, although your movements and directions should also be discreet. Be aware that soon after the couple begins dancing, the rest of the guests are invited to join, so don't dawdle too long waiting for the right shot. Pose the couple so their hands are up and close to their faces, and compose the shot as if it's going to be placed in an oval mat.

You can get a few good dancing candids of the rest of the party at this time, but it might be better to get these shots as the affair goes on and the crowd gets looser. Avoid shooting general scenes of various couples dancing. A shot of the group on the dance floor can be effective, though be forewarned that these pictures rarely sell.

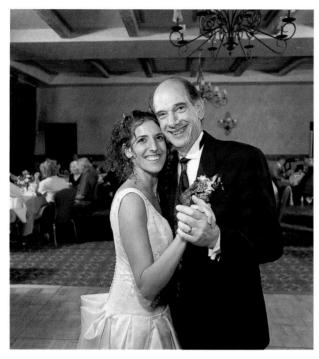

The father and daughter dance is usually a very touching moment. Here the two people relate directly to the camera and their pose shows their happiness and closeness. It's best to take this kind of picture right at the end of the dance, allowing the people their privacy and guaranteeing you the shot.

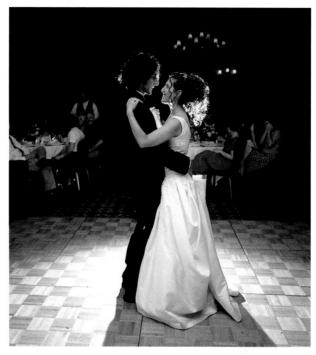

A backlight flash was used here to separate the couple from the background. Note the direct eye contact between the couple, rather than having them look directly into the camera. This type of photograph portrays a very intimate feeling. The lighting creates and enhances the mood of the couple being in their own world.

Opposite: This very wide-angle point of view encompasses both the first dance and the guests applauding the couple. Here the lighting is used to illuminate the room and the other guests.

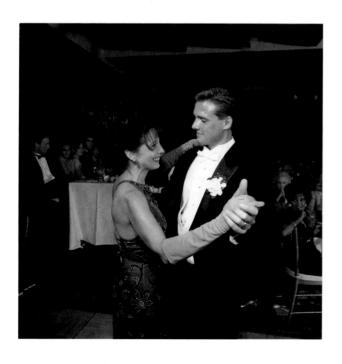

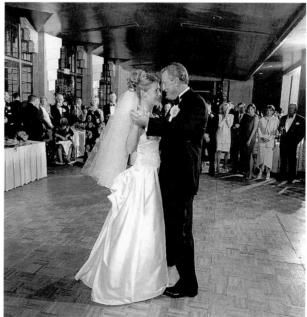

These candid dance photographs give people their space yet accomplishes the goal of showing their closeness together. It's a good idea to make photographs of each couple, including the father and daughter and mother and son. Note how different background light setups change the character of each image.

AT THE RECEPTION

Honesty Captured Through Expression

HEN POSING SHOTS OR DOING CANDIDS, you'll find that the best pictures are those where the subjects project an honest expression of their feelings. Making everyone smile or look as if they're in a constant fever pitch of enthusiasm may be false to what's really going on at the wedding, and is a dishonest way to portray the event.

Gleeful smiles are not only sometimes false, but also less likely to make good selling photos. There are other ways of capturing a subject's happiness. The eyes, as the cliché goes, are the windows on the soul, and more emotion shines from them than any toothy grin. People are less likely to hang a stiff, smiling portrait of themselves in their homes than one that shows natural warmth and love from the eyes and the positioning of the head and body.

You can help evoke such honest expression through

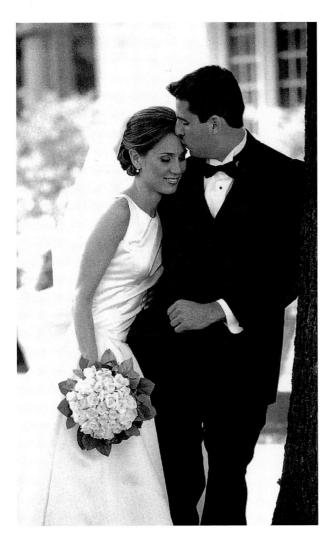

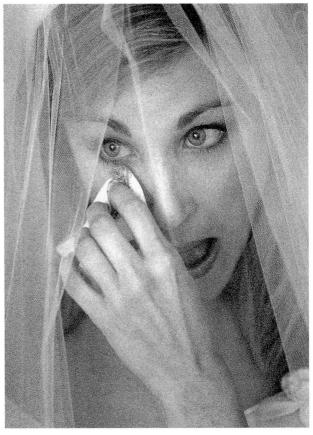

verbal communication with your subjects or by being watchful for the moment when they are truly revealed. When you are posing people you can, to a certain extent, control what your subjects project by the thoughts you plant in their minds. If every time you take a picture you have everyone say "cheese," you're merely fulfilling the role of a snapshooter. But if you say "show me the love you feel at this moment" you'll get an entirely different response.

If your subject feels contemplative, tender, or caring, show that in your pictures. If they seem far away, bring them back with a few words, or snap the picture and see how others read the scene. You may have captured a genuine characteristic of that particular person, something others will immediately recognize in the portrait.

Be honest about your interpretation of what's going on around you, and don't be artificial about the depth of emotion your subjects are capable of displaying. You don't have to ask people not to give wide smiles, but don't force them or act the fool just to make everyone appear jolly. Very touching moments occur on their own during the course of the wedding day, and it's your job to record them.

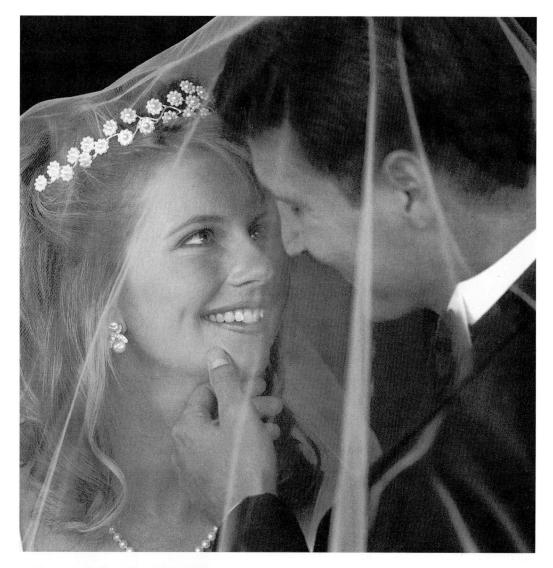

Above: A wedding day reveals the whole gamut of emotions and it is your job to convey the story of the day through pictures. This also means that there are moments when your coverage should be discrete. You should also allow emotions to grow and mature, and not to cut off people's natural feelings by rushing in and asking to refine the pose. If you catch people crying, stay out of sight, but perhaps make the picture with a zoom lens. Ken carries a 35mm SLR with a 70-200mm f/2.8 lens for such moments.

Right: Emotions run strong during the wedding day, and you shouldn't hesitate to photograph people's interactions. A candid shot like this one tells a great deal about what these two people share.

AT THE RECEPTION

The Traditional "Garter" Shot

VERY WEDDING HAS ITS RITUALS, AND THE garter scene is one of them. What may have once been a slightly titillating show has now become a bit of a cliché, but some still do it at their receptions. The groom removes the garter from high on the bride's leg, tosses it like a bouquet to a crowd of eager bachelors. The catcher places the garter on the leg of another woman, usually whoever caught the bouquet. It's a bit silly, but all in good fun.

The garter throwing is usually orchestrated by calling all the single men onto the dance floor. They assemble around a chair where the bride is sitting. The groom then kneels down and slowly raises the bride's dress until the garter is revealed. This is the time to begin taking pictures.

Position yourself to the side of the bride and groom, and have the crowd of men a few feet behind them. This will give you a profile shot of the couple and include the action around them. Get a shot when the groom reaches the garter (some brides wear it low on their leg, others quite high).

Usually there will be funny expressions on their faces, as well as raised eyebrows among the bachelors.

You needn't motor-drive the sequence as the groom removes the garter, just wait for the peak of action when expressions are the best. Once the garter is removed, the groom may twirl it a bit, and you might get a shot of that. He then positions himself with his back to the crowd and throws the garter over his shoulder. Time the shot so you get the garter floating through the air and the men reaching for it.

These shots will be popular only if they exhibit some good action and facial expressions. Get a general shot of the ritual, but concentrate your lens on people's faces to get some good candids.

When the catcher places the garter on the woman who caught the bouquet, decide whether to take the shot or not. Only take it if both people are very good friends of the bride and groom. Otherwise you may make one for the record, but don't count on it to make a sale.

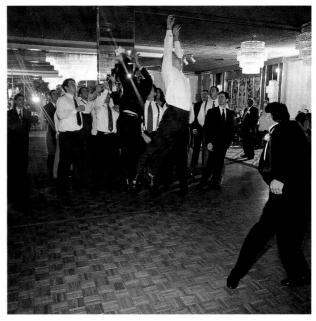

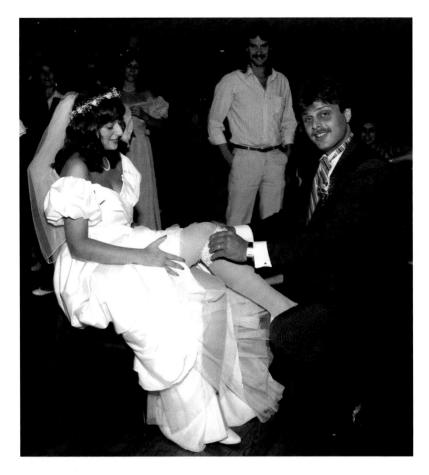

Opposite page: The groom makes an over the shoulder toss as the photographer works with two lights, one on the groom and the second light on the crowd behind. The same two-light setup catches one exuberant guest who looks as if he's trying to block a field goal. This page: These spontaneous photographs show the fun times at the wedding.

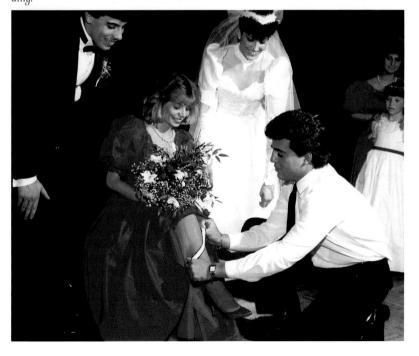

Dealing with Unruly Individuals

Unfortunately, some wedding guests may overindulge. In general, this is none of your affair unless those individuals behave belligerently towards you, interfere with your work or just cause mischief. Some may be overtaken with a sudden artistic impulse and feel compelled to direct all your images, or may even interpose themselves between you and your subjects. You will meet all kinds. Others may be well-meaning enough but bother you with constant questions about what camera they should buy.

You must be firm with these people. Inform them that you are working and ask if they'd like you to show up at their job next week and behave in a similar fashion. Tell them that the bride and groom want the best pictures you can make of the day and that they're interfering with the process. Going along with them may just encourage them to greater heights of rudeness.

If this does not work you may be forced to request the best man to intercede. He is, in a sense, the sergeant at arms of the affair. Make it clear that the individual is making it impossible for you to do your work. If that does not work, your last appeal should be to the bride and groom. Use peer pressure as much as possible. Never deal physically with anyone in such a state. Your main task is to isolate the individual socially so that his friends or others in the wedding party will handle his or her misbehavior.

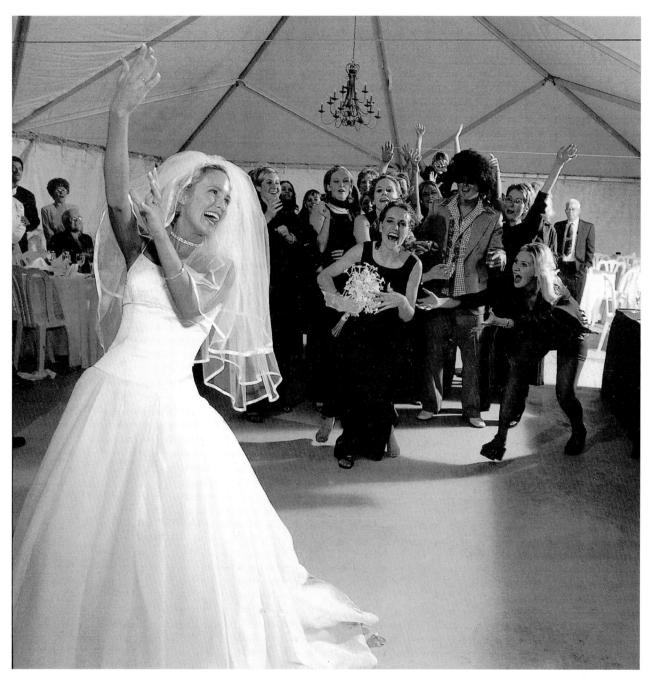

This photograph can be made with two lights to illuminate both the bride and group behind her. Here the room lights were turned up for the background. Timing is everything in this photograph. The shutter is snapped when the bouquet lands in someone's hands.

AT THE RECEPTION

The Bride Tosses the Bouquet

CLASSIC SCENE NEAR THE END OF MOST receptions is the tossing of the bouquet. The bride flings her wedding flowers over her shoulder into a group of the assembled single women. According to the tradition, the woman who catches the bouquet will be the next to marry, and there can be quite a scramble for the flowers—or away from them. This shot is best with either the bride in the foreground and the group behind her, or with the bride on the right side of the frame and the group on the left. A second light played on the waiting women is an excellent idea. If there's no second light, be careful not to overexpose the bride and have the group in the shadows. If you have a single light, have the bride stand so that equal light falls on both her and the group.

Unlike the garter shot, where the removal picture is more popular than that of the toss, the moment the bride lets loose of the bouquet is decisive for this shot. Many photographers pride themselves on getting the bouquet in mid-air, with a profile of the bride and the reaching arms of the

women behind her. It's much like getting a baseball shot when the ball is just coming off the bat.

Set a fast shutter speed in order to freeze the bouquet in mid-air, and count down the toss with the bride. When you hit "one," wait a second and then hit the shutter. You won't get two shots out of this scene, so practice your timing. Gain the cooperation of the bride, since you'll be looking through your viewfinder and won't have control over when the bouquet is actually tossed. Your instincts and ears will tell you when the moment is right.

Once a woman catches the flowers, you may want to wade into the group for a shot of her with her friends grouped around her, but don't count on selling this shot to the wedding couple.

The bouquet shot will be a seller if it shows action, expression, and excitement in the people involved. Don't kick yourself if every bouquet picture you make isn't a zinger—it can be a difficult one to get right. Just find the right position, time your picture and hope for the best.

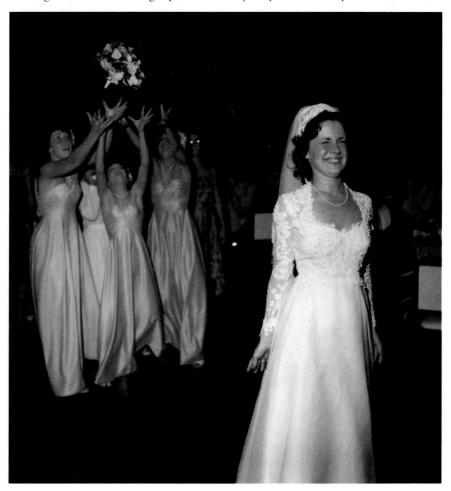

Here, the look on the bride's face, the reaching of the group behind her, and the balance of the light make for a selling picture.

AT THE RECEPTION

The Cake-Cutting Ceremony

HE CUTTING OF THE CAKE IS ONE OF THE MOST important ceremonies in the reception, and one that usually signals the near-completion of your shooting duties. Much pomp surrounds this event, and you may have a crowd around the table where it's taking place. Establish your spot, and be sure to mention to the guests who are close at hand that you'll allow them to take pictures after you've taken the shots you need. This is a crucial picture in most albums, so don't let people prevent you from taking the best one possible.

Confer with the maitre d' about where the cake table will be set up and how it will be arranged. Explain that it can't be set up next to a mirrored wall or in any other location that will throw reflections or obstruct your view. Have the maitre d' help you arrange the silverware, napkins, candles and other tableware so that they won't get in the way of the picture. Go for simplicity in the table arrangement, and ask for help if you need to move things around so they look right.

Ask the bride and groom to stand so they're to the side of the cake, and set up your camera so the cake is to the left.

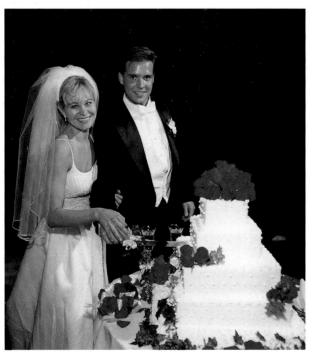

The cake-cutting photograph is usually one of the most important to get right. Make sure that the cake does not become so overexposed that it is a printing problem. Arrange the table carefully and have the couple lean in slightly for a classic hand in hand pose. Here an additional flash has been placed behind the cake to both illuminate the bride and groom and show texture in the cake.

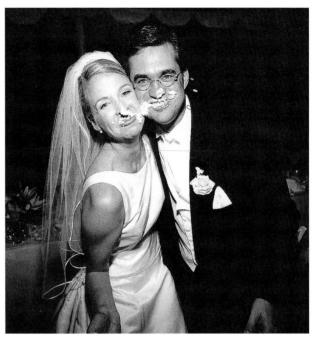

The "feeding the cake" shot and its consequences are fun pictures. Here the bride and groom have both played and posed for this memorable image.

Have the bride stand in front of the groom, and have his arms come around her sides so they form a flowing line that runs from the cake through their arms and over their bodies. If this seems awkward, pose them side-by-side, but keep them close together. Have them hold the knife gracefully, with hands intertwined on the handle, and have their arms extended slightly into and toward the cake. Bring motion into the picture by having them lean slightly toward the cake, and get a few shots before they begin the actual cutting. Watch for detail in the way they hold their hands and the angles their bodies and arms create.

This picture presents you with two large masses of white—the cake and the bride's dress—and that's why it's important to have a camera angle slightly off to the side and not one in which the cake dominates the foreground and the couple behind it. If your camera angle is not slightly to the side, you'll get an "overexposed" cake, and the white of the gown will blend in with the white of the cake. If the cake does overexpose a bit, request that your lab "burn it down" in the printing.

After the cake is cut, move in for shots of the bride and groom feeding each other, but don't eliminate the cake entirely from the picture. Some people smash the cake into each other's faces. You can't stop them from doing this, but

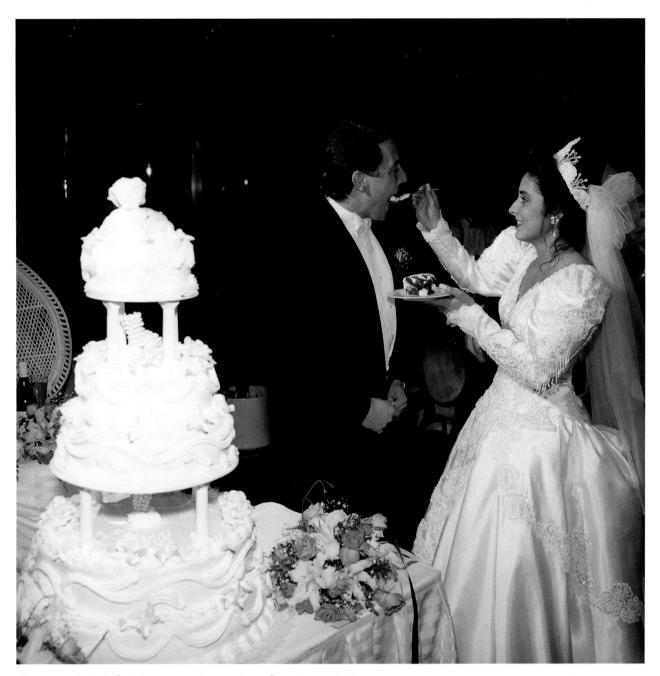

The moment the bride feeds the groom is also a good time for a photograph. Note that many of the "cake" photographs include the cake itself along with the action

certainly don't encourage it. Hold the pose right before a bite is taken, and then take quick shots during the actual feeding. Once you've gotten the shots you want, back off and let those with cameras take their snaps. Offer to pose the bride and groom if people so desire, and be cooperative with

the guests who want to take pictures. You needn't pose the bride and groom in the same fashion you did in your own shot, and the table may be in a bit of disarray, so don't worry about competition for sale of the pictures. Just be sure that these guests don't intrude while you're taking your pictures.

AT THE RECEPTION

The Candid Photograph

ANDIDS COME FROM TWO SOURCES DURING A reception: those taken literally on the spur of the moment and those that are refinements of naturally occurring situations, i.e., seeing the bride hugging her grandmother and asking her to hold the pose, or do it again for the shot. Making candid photographs should be a natural process for you, and you should occasionally roam the hall in search of pictures. Look for scenes that tell the story of the wedding and highlight certain individuals who are taking part in the festivities. There may be shots of children sitting on their grandparent's knee, or pictures of the bride and her mother standing hand in hand. You may come across some men sharing a drink and a laugh, or the ringbearer dancing shyly with the flower girl.

No one will object to being the subject of your candids if you ask permission to take the picture; after all, that's what you've been hired to do. What may cause a problem is shoving the camera into people's private moments and shooting without asking. You may get a sneer, and you may also get a poor picture in the bargain. Roam the hall, see the shots, request permission to shoot, refine the pose, shoot, and

move on. You can also work with longer lenses and faster film and get unintrusive, truly candid photographs without the subjects' knowledge.

After a while people, will get used to you being around with a camera, and the greatest compliment you can get is if they consider you "invisible" or like a member of the wedding. Keep in mind that people can get a little loose at weddings and may do things they look back on with regret later. If they do this in front of everyone, they're fair game for a picture. If they do this privately, or in a small group, just leave them be. Never shoot pictures that will humiliate or embarrass people—as you shoot more weddings you'll understand the distinction.

Spontaneous candids are those you shoot on the run, and these are fun pictures that chronicle the events of the reception. Perhaps an aunt will get up and belt out a few tunes with the band, or an uncle will decide to lead a folk dance; these are unplanned happenings that certainly come under the heading of wedding memories. You can't pose these shots, so just use your best photojournalistic skills to capture the action.

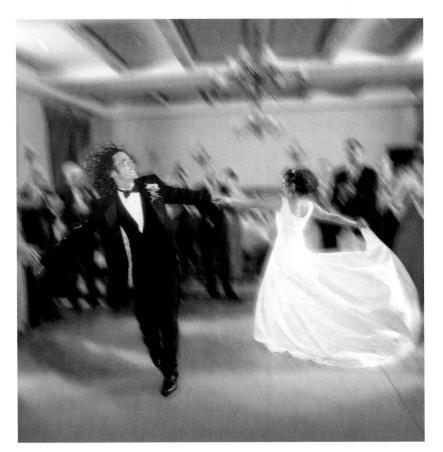

Left: A slow shutter speed combined with flash, with a handheld camera, creates this dynamic expression of movement and joy. The couple seems to be elevating off the dance floor.

Opposite, top left: Off angle, no group posing, and spontaneous expressions—all these are hallmarks of the candid photograph today.

Opposite, top right: Although this photograph is more posed than usual for a candid, it expresses a very relaxed and fun moment within the wedding day. These group photos are more often than not organized on the spur of the moment. The couple relies on you to recognize the potential for such images and to make the most of them without impeding the fun of the day.

Opposite, bottom: Always take the opportunity to photograph relatives, especially when requested by the family. This wonderful photograph of this couple will be cherished by many generations for many years.

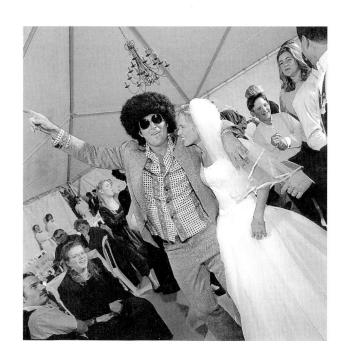

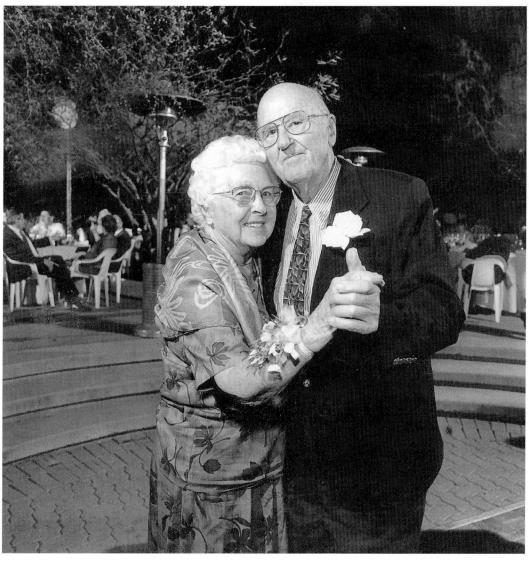

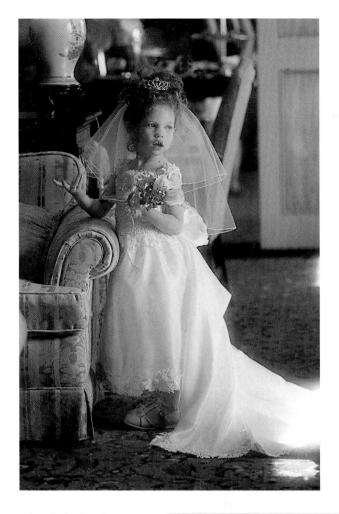

Strike a balance in the number of candids you shoot, and confer with the bride and groom on the type of coverage they desire. Some want lots of candids, others may prefer only a few shots for fillers. Heed their words, but don't miss out on the really fun parts of the day. They may not think they want the pictures before the wedding, but may change their minds when they see the great moments you've captured. Candid shooting can be one of the most enjoyable parts of a wedding because the process challenges your eyes and instincts.

Children are always great subjects for candids. Their parents will adore the photographs of them in wedding clothes.

When the bride and groom visit the tables during the reception keep an eye out for wonderful moments such as this. You needn't trail them as they move around the hall, but be aware of the potential of such images.

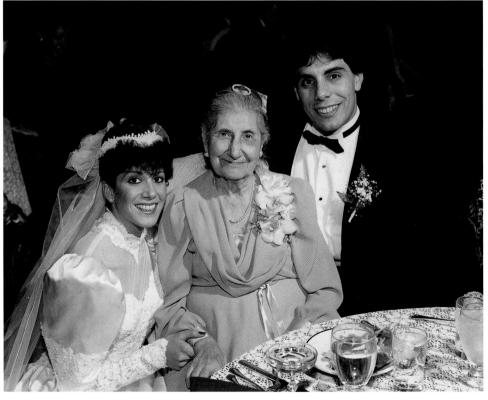

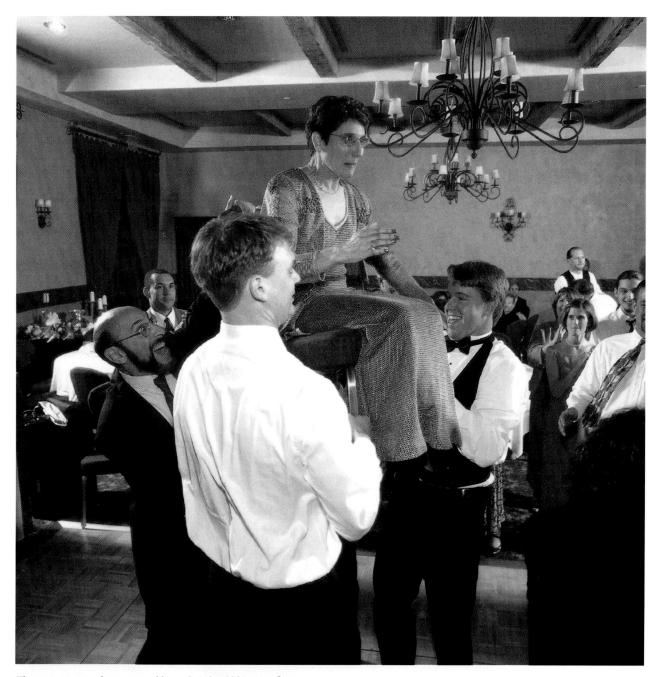

There are many traditions at weddings that should be part of your coverage. These define both the people and their way of celebrating. Be prepared for these candids and always have your camera, flash and film ready.

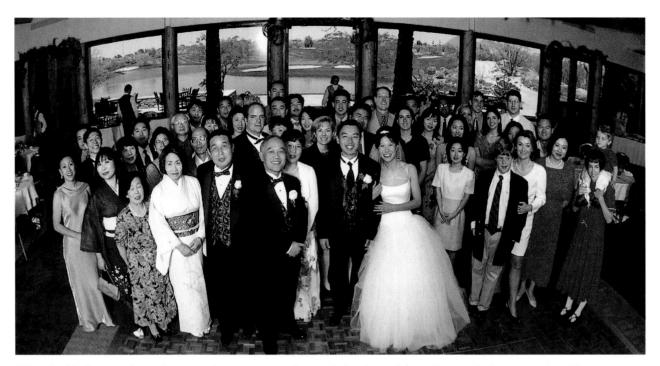

Although table shots are often used to insure that every guest is photographed, perhaps a better solution is the large group photo. This is a great tradition in banquet photography and can work well with groups this size and larger. This photograph was made with four flashes and used a 30 mm fisheye lens. The photograph was made at f/8 and 1/250 second to balance the interior and exterior light.

The Guests

ALK WITH A NUMBER OF WEDDING PHOTOgraphers and you'll get varying opinions on table shots, most of them unfavorable. Table shots do provide the bride and groom with a record of who attended the wedding and ensure that everyone who did attend has his or her picture taken. Although they may seem like simple group setups, they can be among the most bothersome shots of the entire day. Some of the people at the table may be hesitant to have their pictures taken; others have drunk too much and won't cooperate with directions. The greatest headache comes when you try to assemble everyone who's at the table for the picture. An uncle has always wandered off, or the sisters decide to go visiting right before you make the shot. Sending scouts from the group out to gather absentees can be equally frustrating; they'll often get waylaid on their mission and end up missing themselves.

If you're contracted to do tables, the best time to shoot is during open periods in the reception's activities, usually before or right after dinner. A good technique to gather the forces is to enlist the services of the bride and groom in getting everyone to cooperate. Have them do the table tour with you, and when you arrive at the table say, "The bride and groom asked me to get a shot of this wonderful group with them so they can have a memento of sharing the day

with you," or something to that effect. This will make the shots much easier, and place greater emphasis on having everyone at the table when needed. Don't let the bride and groom begin to chat while you're posing the picture—a three-minute shot could turn into a fifteen-minute wait.

Arrange the group around one end of the table, with half of them sitting down and the other half standing up behind them. Direct people firmly, and make sure that glasses, bottles, and other debris aren't blocking your angle of view or throwing reflections back into your lens. Centerpieces can be monstrous affairs, so move the group to the side if necessary.

A wide-angle lens will let you stand fairly close to the group. With large groups and a normal lens, you might have to stand too close to the guests at the next table. Set your flash and depth of field so that you can guarantee that both the front and back of the group are in focus. Setting the lens at f/8 should do it for most groups, although a three-deep-stacking might require f/11 or even f/16. Always take two shots. Someone is bound to have their eyes closed in one of the pictures.

Ken Sklute, who took all the photographs in this book, opts for the large group shot. I heartily agree, having chased too many errant guests at one too many receptions.

AT THE RECEPTION

The Portable Studio

favorite aunts and uncles, or entire sides of families are often requested at the wedding reception. A wedding is one of the major events in a person's life when their whole "gang" is together and dressed up. Rather than take these pictures helter-skelter and be distracted from other important moments at the reception, assign a particular time and place when all the pictures can be made. Organize a time and place and take the groups and couples as they come. You'll save wear and tear on yourself, have better control over the lighting and posing, and keep the requests reasonable.

The location of this studio should be away from the main hall, either in an anteroom or other unused portion of the building. If this is not possible, set up in a corner of the reception room itself, away from the ebb and flow of activities. Choose a background suitable for portraiture. This can be an area with heavy curtains, or some corner of the place where sittings can be handsomely arranged. Scout the hall when you first arrive, and get permission from the manager

to set up. The maitre d' can be very helpful in suggesting locations.

Some photographers haul backgrounds and supporting poles with them, and this is a good idea if the reception is being held in a paneled room or one with poor shooting backgrounds. This isn't usually necessary, as many reception hall interiors and exteriors are specifically selected by the couple for their attractiveness and are decorated for the occasion. Some photographers still carry backdrops; it's your choice.

A portable studio setup can consist of two self-contained strobe head-umbrella or soft box combinations, although you can get as elaborate with lights as you like. You might even want to include a slave or radio remote powered strobe for a background light for small groups and close-ups. The lighting can be as simple as an on-camera strobe and an extra light on a light stand or pole. There's no doubt you'll get better pictures with the two-light setup, but don't feel that you can't make the shots without it.

Assuming you have two lights, for large groups set your lights at a 45 degree angle back from the group to attain

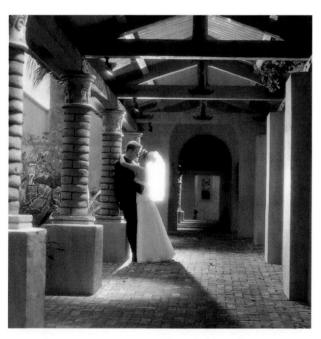

Use the architecture and light together to create great sets on location. Posing the couple at the third pillar and keeping the first two in the frame creates the strong diagonal feel. The two sets of columns create leading lines to a vanishing point in the center of the framing. A light placed behind the couple creates edge glow and background separation. Exposure here was 1 second at f/5.6 to insure that ambient light graced the scene.

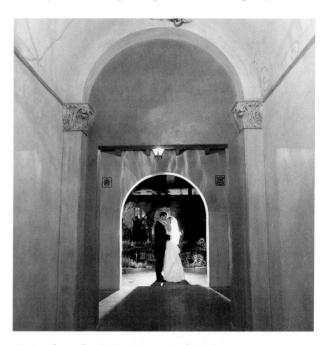

Flash in front of and behind the couple filled the corridor and created a beautiful backlight effect. A long exposure time allowed the ambient light in the background to record. The star flare in the bulb above the couple's head was a happy bonus.

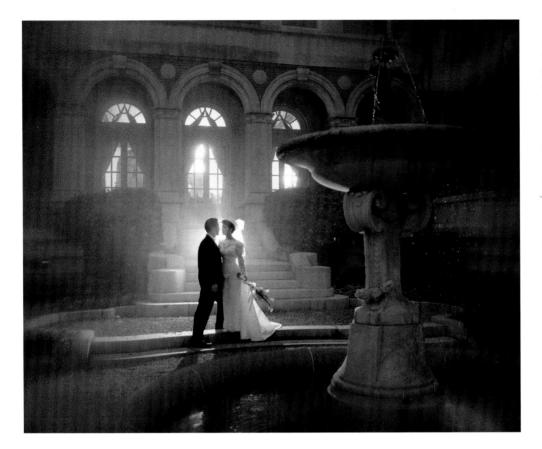

Consider the reception hall or area as a stage set in which you can pose your bridal couple and other groups. Scout the area for great location possibilities and light it as you would an architectural study. This photograph was made using ambient and flash in combination. Exposure was I second at f/5.6 with a flash placed right behind the couple.

full lighting coverage. Take strobe readings from the front, back, and sides of the group, making sure the light evenly covers the assembled troops. Put the strobes at equal power, and feather the umbrellas or soft boxes so that an even, open light spreads over the group.

Set the strobes so that you have enough power for the lens setting to give you sufficient depth of field, and make sure that everyone from the front to the back of the group will be in focus. If you have a set of stairs, you can stack the group and minimize "lost heads" in the crowd. Use a wide-angle lens for the larger groups, especially if your shooting area is cramped.

Shots of small groups or couples should be taken with a normal or telephoto lens; the wide-angle may distort their faces or bodies. Also, these should have more intimate lighting, so set your lights for a 1:2 lighting ratio, a quarter-power less on the fill than the key light. If time is short, and moving lights around is cumbersome, shoot all the groups and couples with the even lighting setup, metering each group as you go. Lighting ratios and setups are something you will develop with experience and will mirror your taste and eye.

Posing shouldn't be sloppy just because your time is limited; you may have to go into some preset formats in order to do the job quickly. You may have a number of groups waiting for pictures, so you can't dawdle and fuss with every shot. Ask for everyone's cooperation, and don't allow your subjects to chat and visit too much while you're setting up the pose. Large groups are always difficult because of the

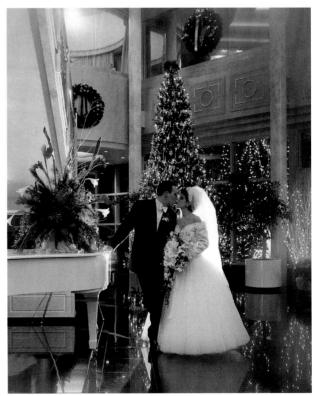

This photograph shows the beauty of the hall, the season and the couple's affection. Ken used the piano as a posing prop and worked with the ambient light and floor reflections to create a dreamlike image.

social nature of the event—not because they want to give you a hard time. Play along, gain their cooperation and make your work part of their fun.

Groups of ten or less can be set up around a chair or posing bench, and you'll probably want to have this prop ready in any case for the very elderly people who may be included in the groups. Look for diamonds and triangles, make sure two heads don't lie on the same vertical line and pose for flow and design.

Pictures of couples should be taken middle-range or close-up, and you might want to keep the camera and tripod in one setup and switch to a moderate telephoto lens. This will prevent you from having to change lights and camera angles for each shot. Have the couples stand, turned slightly toward each other as if they're dancing, and right before you snap the shutter, have them lean slightly in and toward the lens.

Many areas of the reception hall can serve as intimate posing areas for just the bride and groom, but remember, only take the bride and groom away from the reception for a few minutes at a time for pictures. Make use of the hall's light and colors to make strong, informal portraits of the couple. Don't lug around your big lights for this shot. If you have worked a hall before you'll know the angles. Use as much of the ambient light as possible by combining slow shutter speeds with flash techniques.

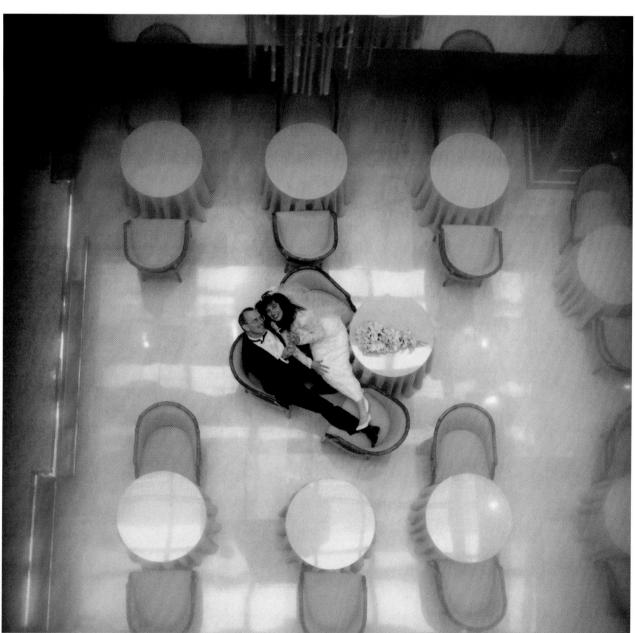

You never know where you'll find great sets on location. Dappled light shines through the above skylights here. Ken is positioned in the atrium above the couple on the floor. He includes circular forms around the couple to create a sense of visual play.

COMPLETING THE SALE

OW THAT THE PHOTOGRAPHIC portion of your wedding work is completed, you'll have to go about getting the film processed, sorting proofs, selling extra

enlargements, and packaging the final selections in albums. Although preparing for and shooting the wedding was hard work, you'll have to apply yourself with equal dedication to

the task of completing the sale.

Digital imaging has changed the logistics of the selling and completion of orders, but there are a number of other important steps for you to follow that will ensure your success in this business. The first step, finding reliable partners to process your work, should be arranged before you photograph any wedding.

The key ingredient in the final steps of your work is organization; planning and clarity will spare you hours of work and confusion. Without a plan of action, the final phase of the job will become a nightmare of misplaced negatives and stress. Organize the process in a way that is logical for you, but use the following guidelines to help you streamline it.

Finding a Lab

Even before you have your first roll processed, take the time to find a professional color lab that offers reliable quality and services that will make your life easier. Never send your film out to an untested lab! Go through the phone book, talk to other photographers, attend professional trade conventions and check listings in professional photographic magazines for sources. If you have a lab in your area, visit them and ask to see the workplace and samples of their work. Find out what special services they offer (such as digitization and print finishing services such as mounting and texturing, special cropping, and rush service). Note whether they have custom and candid divisions.

One of the most profound recent changes in wedding photography is the growing use of digitization. Some wedding photographers have begun to use digital cameras for on-site imaging or for the creation of novelty and take-away items at the wedding itself. It's more common, however, for photographers to use labs offering digital services to scan their negatives for use in selling, presentation, and even the completion of an album itself. I will discuss such services and their profound impact on completing orders and making sales in detail later in this chapter.

Make sure they have a distinct customer service department, one that will work directly with you and can give you prompt answers about the progress and problems with your work.

While on your visit, see how they do the work coming through. Note how organized the facility is and the care with which orders are handled. Most importantly, make contact with a steady employee or manager. This person will be your inside contact, your lab troubleshooter. Communication is key to every photographer/lab relationship.

The quality and care with which a lab handles your work is a key element in your success. Remember: you may have taken the greatest wedding pictures ever shot, but an

inefficient lab will always give you poor results.

Professional labs have in-house salespeople who can sit down with you to discuss the terms and details of your relationship. They'll lay out the costs and advantages of different levels of service, and let you know the best way for you to get the type of work you want. That's what makes them custom labs. Each professional is treated like an individual, and his or her likes and dislikes are catered to. It's in the lab's best interest to keep you as a customer, and in your best interest to know how they work, so listen to what they

have to say and submit your

orders accordingly.

Testing is always a good idea. Prior to shooting your first job, submit a number of rolls to three or four different labs for testing. Upon return of the film, note the turnaround time, care in processing, and how the film is packaged. If the lab offers digital and Web services, have them post your tests on their site, then visit the site and place an order. Submit cut negatives with special cropping and custom printing instructions and see how that work is handled. There can be a great difference between labs, and this testing should help you find the right one for your needs.

Once you've settled on a lab, give them another goaround. Submit images photographed under various lighting conditions. Everyone has a different eye for color, and you might like prints warmer (more to the yellow side) or cooler (more to the blue side) than other photographers do. Let the lab know your tastes, and discover the buzzwords that will make them respond to

your desire for a certain way of printing. If you've chosen a truly custom lab, they should print to your specifications. Many labs keep customer profiles in their computers and will post those profiles when any job comes through. This is the way you can personalize a custom lab even further.

Filing

BEFORE THE WORK ORDERS START PILING UP, you'll need to set up a system for filing, storage, and retrieval of negatives, CD-ROMs or whatever type of storage system you will use. Some labs may even archive digitized copies of your jobs for a set period of time. Think seriously about the type of filing system that will work best for you. You can file orders by name, job number, or date. You may even set the whole system up on computer, using a database program. Each order should have a worksheet that lists customer name, number of proofs shot, date proofs were picked up, albums and enlargements ordered, and so forth. This becomes a quick reference on the status of the job and serves as a holding file should clients want further prints down the road.

As the jobs pile up, you'll see your files expand, so it's important to have a cutoff date for eliminating inactive jobs from your collection. You can toss the jobs, or store them somewhere in your home or office. Many photographers clear their files by offering proofs for sale for a set period after the delivery date of albums, and negatives three to five years after the wedding. Better to have some cash coming in than have old orders cluttering up your workspace. Give clients this option, and you'll be surprised at how many of them will be happy to take the old material off your hands.

Proofs

THE FIRST STEP IN HAVING CLIENTS SELECT PRINTS is getting a set of proofs made. As we'll see, there are two ways proofs can be distributed—by using prints or by posting electronic versions on the Web. Some photographers deliver the proofs to the bride and groom and use the Web for attracting additional sales from distant family and wedding guests. Others have come to rely solely on the Web.

Print proofs are 4 x 5, 4 x 6, 5 x 5 inches in size and represent the bulk of images photographed during the wedding. If you are not going to use digital services, make sure that every proof is numbered by the lab with the roll and

The quality and care with which a lab handles your work is a key element in your success. Remember: you may have taken the greatest wedding pictures ever shot, but an inefficient lab will always give you poor results.

frame indicated. Don't work with a lab that doesn't supply numbered proofs. Matching prints to negatives can be a tedious process, especially if you have taken two or three shots of the same pose.

Proofs should be rigorously inspected. Make sure the color is balanced and that faces have proper fleshtone; check

for dust marks and sharp focus. These proofs are essential selling tools—poorly done proofs will result in poor sales. If you' re unhappy with their quality, send them back to the lab for remakes, and be very specific about the reason you're returning them. If you just say, "I don't like these," the lab won't know how to reprint them. Be picky—it's your livelihood that's on the line. Also, keep in mind that clients may think that proofs indicate what final prints will look like. Be sure to inform them about the differences between a proof and a custom-finished print, especially for portraits and formals. You may even want to enclose a custom print with a proof to show them what can be done with burning and special finishing techniques. You can also do this at the studio or at the time of proof-presentation with a sample book or wall print.

As most labs have different levels of print quality (from custom to candid to economy), you can choose from their service levels for your proofs. Part of your pre-job testing should include discovering which type of proofing service gives you satisfactory results. Most modern labs have video analyzing even for their economy runs, so you may find that the most inexpensive proofs meet your needs. But if the quality difference is appreciable, spend the few extra dollars for candid or even custom proofs and watch your sales increase.

After you receive proofs to your liking, you'll begin the editing process. Undoubtedly there'll be some clunkers and shots where key people have poor expressions or their eyes closed. Remove these from the set you present to clients. Only show prints that you think will sell, but don't limit the number of proofs in your presentation. If you have 200 good shots, show all of them. Prior to placing prints in a proof album, stamp your copyright notice on the back of each one. The notice should read something like this:

© (Your Name), Date, Unauthorized Reproduction Prohibited.

Copyright is even more important now that scanners at home and in copy shops are readily available. You can't police such matters, but at least you have given your clients legal notice. Ethical businesses will refuse to reproduce your copyrighted prints, though you won't have absolute control. Some photographers even stamp PROOF on the front of the print, or hole-punch a corner. Although this detracts from the look of the proof, it does help guarantee that you'll be the only source of enlargements.

Arrange proofs in chronological order and place them

in expandable proof albums. These selling tools are laid out so that clients can write their own orders next to or underneath the actual prints. Many styles actually encourage extra sales by hinting that prints can also be ordered for friends and relatives. Some photographers

like to use the cheapest proof albums they can find, thinking that's a way to save a few pennies.

Proof presentation books are one of your

most important selling tools—go with

a quality book with order sheets inter-

leaved between each photo page.

Proof albums are reviewed many times before the final order is made, and friends who attended the affair will be called upon for advice as much as the family. These friends can also be sources of picture sales, and even if only a few wallets and 5×7 print sales result, the purchase of a book with order pages is worthwhile.

Another way of presenting proofs is making slides of each negative and then giving a "slide-proof" party at your place of business or the client's home. Though these slides rarely match the quality of prints, they represent a dynamic selling tool, especially when projected to large size. This technique allows customers to visualize enlargements, and gives larger groups an opportunity to view the work at the same time. Prices for these slide sets are moderate, and you may want to experiment with them to see if they increase your sales.

If you digitize images, you can also present proofs on a CD-ROM or use a computer and digital projector to make the presentation. This is a thoroughly modern technique that uses the same method as the slide presentation. Using software such as Kodak's "Portraits and More" (note: the name or version may have changed by the time or after this book goes to press), you can even crop and enhance proofs prior to presentation and arrange them in suggested album sequences.

Another option is the ProShots software program. There are many labs that offer services specifically meant to be compatible with ProShots; these labs scan and digitize your film when they process it. The film is then kept in longroll form and stored at the lab. Images are then delivered to you on floppy disk, CD-ROM or via the Internet—it's your choice. With ProShots software loaded on your computer, you gain access to the images and then begin the process of editing, sequencing and sizing images via drag and drop techniques. Proofs are then presented to the customer on screen. And, as we'll see, as orders are placed, the software generates both a work order and customer invoice. You can also work with Montage, a computer layout program by Art Leather, to create a suggested album and album page layouts. This gives the customer the ability to approve a packaged album right at the point of sale. If desired, the layout and pages (with cutouts and masks) can be printed right at your desk for a take-away. You also get a copy and, if desired, a contact sheet of all the images picked for the album, along with the file name or negative number of each image.

Web Proofing

TRADITIONALLY, WEDDING PROOFS were delivered to the bride and groom in the hopes that they would show them to as

many people as possible and thereby get extra print and enlargement sales. "Hope" is the operative word here. In truth, newlyweds are more concerned with setting up their household than adding to your print order, and may show proofs only to their immediate family. Today, proofs can be seen even by people who couldn't attend the wedding by using the Internet.

Here's how it works: if you sign up with a lab that hosts Web viewing, they will scan the negatives you send in for processing and post them to a Web page. Make sure that you can edit the presentation prior to posting and eliminate any poor images. You then pass the word to the wedding party, or hand out cards at the wedding that give access to the Web page. If possible, have the bride and groom provide you with e-mail addresses of those people they want on the viewing list. Potential clients can then view the on-line album—perhaps entitled "John and Jane Smith Wedding."

Pictures appear in an album and each image can be enlarged to full screen with a click. An order form comes along with the album page. When the new clients are finished filling their shopping cart, they pay via credit card or a toll-free number, and prints are shipped directly to them. You are then paid a set amount by the lab or hosting service.

If you have the time, staff, and patience, you can set this up yourself using your own Web site. Or, if your lab does not offer this service, a number of independent sites such as e-prints.com offer picture sharing services. You submit images and they are placed in an album. You send images using your Web browser or dedicated FTP client software. If you are going to upload images yourself, you will need a cable modem or other high-speed connection. You can also submit images via removable media, such as a Zip cartridge or CD-ROM or even a pile of floppies. Digitized images can be downloaded directly from your lab to these sharing sites.

Many alliances between software companies and labs have been forged to take advantage of this technology, so check with ProShots and Kodak to see the many services they offer. Using ProShots software, for example, you can select the images you want displayed and sequence them in any way you desire. You then e-mail a small data file generated by the ProShots software with the editing and sequencing instructions for your on-line presentation album.

Sharing services can be used to log site traffic and even record and show viewer feedback. Many of these services will even watermark images to prevent downloads. Some even offer chat rooms that allow viewers to record their wedding stories and keep in touch with distant rela-

tives. This added value service will truly impress clients.

However you deliver proof prints to clients, be firm about when you want a decision made about the print order. Make a cutoff date for orders and stick to it. It's in your best interest to complete the order and go on to your next client. Also, you'll want to get the extra cash flow generated from enlargement sales. Some clients can hold on to proofs for months, and all this does is drag out the whole process. Quite frankly, most enlargement sales are made when wedding couples are still in their "blushing" stage, and as time goes on their enthusiasm for extra prints wanes.

Enlargement Samples

A PROOF APPOINTMENT should be a time when you encourage extra print sales. Though there's no set rule, you should try to double the initial price of the wedding with enlargements. If you meet with clients in your home or workspace, have plenty of sample enlargements around to show them examples of how their prints can be finished. Have framed and canvassed prints, even some with special printing effects. Photo lacquers on the market can even add effects like brush stroke or "crackle," giving photos a painterly look.

Most labs will help you get these samples together; some will even offer reduced rates on those that will be used as selling samples. Work with a professional framer for mounting, matting, and framing of your samples. Have a selection of wood and metal frames, as well as special bevel cut mats. Every print benefits from matting and/or framing, and the more attractive your samples look the higher your sales.

Album Samples

The same goes for albums. There are more than a dozen companies that offer professional wedding albums, and styles and prices go from budget to custom. As the person who's responsible for taking the pictures, you're in the best position to advise people on how to preserve, protect, and present their valued memories. Although most clients will request the traditional main album and two "parent" albums, they aren't always aware of the scope and variety of albums available. Educate yourself, and have samples and/or brochures ready to show them.

Some clients might want to put their own albums together, thinking they'll be able to save money that way. Remember that an album is as much of a calling card as the pictures in it. Emphasize to clients that a wedding album is not just a snapshot folder, and that it's assemblage should be the job of a professional.

Types of Covers. Albums can be divided into a number of categories according to the way they're covered, how they're bound, and the fashion in which photos are placed in the pages. Some albums are covered in synthetic materials that are durable, stain-resistant, and give a quality look at a

good price. The main distinction between this style and its cheaper counterparts is the amount of padding in the covers and the durability of the stitching or binding glue. Other distinctions include the way in which prints are inserted (some have protective slipcases for each page) and the embossing on the front cover.

The style range on these synthetic covers is very extensive. They approximate leather, suede, or a variety of woven textures and colors. Many of the albums carry logos on the cover, such as "Our Wedding," "Wedding Memories" and "Nuestra Boda," or have embossed scrollwork. White and brown seem to be the most popular colors. Prices on synthetics vary, and you should check into manufacturer specifications on both their economy and custom lines.

Wood album covers are also available, and most manufacturers now carry lines of this type. Some wood covers are handcrafted, made of hardwoods that are individually rubbed and stained. Some feature a cameo for a front picture, and some of these are decorated with elaborate framelike carvings. Prices on the wood covers range from economy to custom, with the less expensive styles made of recycled wood fibers and a wood grain veneer, and the more costly composed of natural woods worked by hand. There are even wood cameos offered on synthetic and natural leather album covers.

Natural covers, like leather and suede, are also available. Many of these albums have library-style bindings, special leaves for holding prints, and carry a prestige and elegance that make them a truly "limited edition." Natural covers come in a variety of colors ranging from ginger to wine to antique black. A new look is a picture-wrap album, where one image is placed under a protective lacquer covering, thus resembling a coffee-table book.

Types of Bindings. There are a number of ways to bind, or hold the individual pages in an album. Your choice of bindings will depend on price, ease of assemblage, and the resultant ease of viewing. There are companies that put together the album for you, and these are actual bookbinding operations that lacquer prints and seal them into book form with a special spine. Although these custom operations certainly won't be a part of every sale, they should be a part of your offered services. The main style of bindings in albums you put together yourself are pin (or metal rod), post-bound, and multi-ring. Metal rod bindings are slipped through the edge of each page and then assembled into a receiving spine on the album—each page has metal loops through which the rods slide. These bindings allow for easy page turning and for the pages to lie flat while viewing.

A post-bound book is one with pages that are slipped over two or three expandable posts that rise from holding areas in the album cover. These are quite easy to assemble and are almost infinitely expandable. Multi-ring binders are economical lines that have a series of wire spirals that receive pages, much like a spiral-bound notebook. These are also easy to assemble, and have various trigger mechanisms and snap closings.

Wedding pictures come in both vertical and horizontal formats and some even benefit from the soft lines of an oval matt. These different formats all fit into one album using multi-format inserts. The inserts, which serve the purpose of mats, slide into Mylar sleeves that are the actual pages of the album, or cover pictures that are applied through mounting or adhesion in the album. On any leaf of the album you can fit one vertical or horizontal 8 x 10, or two 5 x 7s, or a number of 4 x 5s, or wallets—whatever layout pleases you and the client. The ability to customize albums with the mat insert system becomes endless and opens up possibilities for very creative designs. The 8 x 10-album page is still the most popular, but it's good to know that there are options available.

Many companies now offer album-arranging software, such as the Art Leather Montage program mentioned previously. This allows you to arrange albums using drag and drop techniques, and will even generate an order for the binder, pages and inserts as desired. If you are digitizing your images for proof presentation, be sure to take advantage of this very convenient method.

Cropping and Retouching

FOR THOSE PRESENTING PAPER PROOFS, a cropping tool should be part of your selling kit. You can make one simply from four pieces of white matt board. With this you'll be able to show clients how final prints can be enhanced

Another service you'll want to make clients aware of is retouching. Acne, scars, and even stray hairs can be removed from prints—you can even open eyes in group pictures! Backgrounds can be cleaned up or made softer and lights can be dimmed. There's no end to what a talented retoucher can do. Have before and after print samples made and show them at the presentation, particularly if you feel the pictures could benefit from a little work. Digital retouching can do magic with less expense than traditional airbrush and pencil techniques. Kodak's Portraits and More software, Adobe Photoshop and other sophisticated programs even allow you to make montages and add special effects to any image. Show samples of what this software can do and you can increase sales.

through cropping. Though many of your pictures will be fine as they are, others will definitely benefit from having some of the top, bottom, or sides removed in printing. Not everyone is aware that prints can be cropped, and showing and explaining this technique can open clients' eyes to new print possibilities.

For example, a shot of the bride taken from waist up might have the best facial expression of all the bridal portraits you've made. By cropping, and printing a full face, the picture might be more effective. A family grouping may have been done hastily, and one of your light cords may be slicking out in the corner of the print. A simple crop can help "clean up" the picture.

When selling cropped pictures, make sure you're aware of the standard cropping masks of the lab and how they line up with your negative format. Don't send them a picture cropped in a 2:5 ratio and expect them to make a full bleed 8 x 10 print. Labs will supply you with acetate sheets with crop masks on them that you can lie right on the negative. A number codes each mask, and when orders are made, you supply them with the crop number and an idea of where the crop should begin and end on the print. Samples of full frame and cropped prints will help explain all this to clients.

If you are using software for presentation, you can make crops right on the screen image. This has two advantages: it shows clients what the finished print will look like without having to resort to a cropping tool, and generates the cropping instructions right on your print order. This feature is found in the ProShots, Kodak Studio Lab Link and other digital service lab software.

Aside from the frames you have on your sample enlargements, you may want to have sample matts and frame corners to show clients. These provide extra options for photo decor. Not everyone will go with the styles you've selected with your stock enlargements. Many times, people will select frames that go with the interior of their homes, so have modern, traditional Americana, metal, and other frame corners to show. Your local framer will provide you with these samples at a nominal charge.

The last item for your presentation kit is a price sheet listing charges for extra enlargements, framing, retouching, and any other special services you plan to offer. These prices should be made in accordance with prices from suppliers, and your markup depends on your overhead and the amount of work you'll expend performing the services.

The Face to Face Presentation

While you may be selling over the Internet, many times the main sales order will be made directly with the clients. Once you have all your selling tools in order, including sample enlargements, proofs, cropping tools, and sample retouched prints, make an appointment with the clients. Try to get the main picture-buyers assembled at the same time, including the bride, groom and parents.

Your goal throughout this meeting is to educate and

sell at the same time. Before you begin, outline all the special services mentioned above and convey your excitement about what you can offer. You needn't make the appointment a mini-lecture on photography, just go over all the options as simply as possible. Set up your enlargements on easels, or have them on the wall, and have the proofs and selling tools on a central table for all to see. Also, have the initial contract and checklist available, so clients can see what they asked you to shoot and how you've successfully completed those requests.

Even before you show proofs, make your enlargement and album presentation. Show the albums they may have chosen for the package deal, but also show albums that may end up costing them a few dollars more. Explain how albums are assembled, and point out that if they want extra prints, an album can easily be expanded. When putting together sample albums, use the storytelling concept. Keep the prints in chronological order, or in another arrangement that makes sense as you begin to sort out the proofs. The first print is very important, as this is the first image people will see when they open the book. You can use a portrait of the couple, a ring shot, or even a shot of the invitation surrounded by flowers. From there, start with the houseshots, the groom's pre-ceremony shot, coming down the aisle, reception, candids, cake-cutting, and so forth. While there are no hard and fast rules about album design, keep in mind that the book should "read" like a story of the wedding day.

With enlargements and wall decor, let clients examine your samples and show them how canvassing and texturing can add a certain painterly feeling to the prints. Then begin an explanation of cropping. Be sure to emphasize how format ratios work. Finally, show them retouched prints and sample collages. Don't discuss price at this time, but make sure each person has a copy of the price list in his or her hands. Most labs don't charge for standard crops, so you might want to emphasize that some of the extra services you offer come at no extra charge.

Once you're sure there's an understanding of your main points, open up the proof books or begin your slide or computer projector presentation. Now is not the time to shrink from the crowd. People will have plenty of time to contemplate the proof books on their own later. Walk them through the book, suggesting prints for albums and enlargements as you go, or show them your computerized album suggestions. Also help them choose a picture for a thank-you card, and recall incidents of the wedding day evoked by particular images.

Your clients will give you cues about the pictures they like. Write down their comments on the proof-order page opposite the picture in the album. This will serve to remind the actual buyers about who wants what prints when they place their final order. It's guaranteed that there won't be agreement on all the pictures—this is human nature. But as the presentation moves along, both you and the clients will get a feel of how the final albums will look, and what enlargements are going to be ordered. Of course, not everyone will want a 30 x 40 print of the couple for their

home, so be prepared to get a number of wallet size and 5 x 7 orders. After you've gone through the proof album, wrap up your presentation by reviewing the main points. Assure them that you're available at any time for clarification and questions. Let them know the approximate time you want the proofs returned and orders placed, and be firm about the necessity for getting the order back on time.

Remember: sharing the wedding pictures with clients should be an enjoyable experience for all concerned. Though selling has been emphasized here, make your approach subtle and part of the overall event. Yes, be a salesperson because that pays the rent, but don't use high pressure tactics.

Filling the Order

BECAUSE OF THE IMPACT OF THE INTERNET on the wedding business, we'll approach this section in two ways—covering traditional and digital sales. Let's start with the traditional route.

After a certain length of time (hopefully no more than a month), your customers will return the proofs and order sheets to you. Add up the extra print, retouching, and custom enlargement sales and have the client pay 50% of the cost of any extras they have ordered to cover your lab costs. Let them know the balance due, and request that payment be made on delivery. Before you let them out the door, go over the order with them and verify all prints and services requested. Have them initial the order forms and give them a receipt for their payment. Because you've used a proof book with opposite-page order sheets, filling out the order is a simple matter. First, get individual negative order sleeves or bags from your lab. These holders are work order sheets, with areas for size, quantity, and quality standard, plus cropping instructions and a line or two for special instructions. Match the number on each print to the number on the negative. Double check that it's a match, put the negative in your work sleeve, and fill out the order. (Many labs ship negatives in work glassines to start, so you can save this step.) Leave the print in its place in the proof albumthis serves as a check when prints are returned from the

Pack the whole order together and bring or mail it to the lab. If mailing, take out the maximum insurance on the package and get a return receipt. Enclose any special instructions, and make a note to your inside contact at the lab to handle the contents with tender loving care. While you're waiting for the prints to be returned, place your order for albums and sleeves. Always order a few extra refills just to be sure, and keep them in stock to fill future orders. Sleeves are generally sold in multiples of six or eight per package, so you may have overruns in any case.

Once the prints are returned, examine each one carefully to be sure that they're printed to specifications and that the colors are correct. Sometimes, you'll notice that smaller prints and enlargements of the same negative have color

mismatches; this is due to the fact that some labs may print different sizes on different enlargers. Also, watch for dust marks, poor flesh tones, and other print faults. Be very picky. Your whole day's shooting, your reputation, and the success of the sale rests on your final product, so don't hesitate to return prints for makeovers. Quality control and keeping on top of your lab are essential. If you let a few poor prints slip through, you're doing the client, the lab, and yourself a disservice. Send prints back, insist on prompt makeovers, and make sure the lab performs as a partner, not an adversary. If the lab won't work with you, find another one. Of course, not all the problems in returned orders are the lab's fault. Poorly phrased cropping instructions and underexposed negatives can't be printed to specifications, and there hasn't been an enlarger or a computer made yet that can refocus a totally out-of-focus image. Be demanding with your work, but don't expect the lab to perform miracles. Set parameters for acceptable quality and stick to them so that your lab will know what you will and won't accept.

As time goes on, you might want to consider doing your own album prints, which may require considerable time and money, but is a way to get the exact type of pictures you want. Very busy freelancers and studios often go this route, although most leave proofing to a custom lab. Also, many one- and two-person custom labs are available, and they usually only accept a limited clientéle. If you find such a lab that suits your needs, it will probably result in a very personal relationship. Do whatever you have to do to get the right lab.

Now for the second route, digitization. Its real benefits come into play in the order-completion stage of your work. Software can help you arrange the order and define cropping and printing instructions for retouch and even for order tracking through your lab. Kodak's Studio Lab Link software is a prime example of how this works. This software is in a constant state of evolution, and it will eventually make every possible service available. The software program starts by working in conjunction with the lab that processes your film and scans all your negatives. When you're ready to place your order, you go online and fill out an order sheet that defines negative number and size of the print, cropping and other printing instructions. There are no negatives to sort or match and masking or aperture cards are unnecessary. This is a profound change in how orders are placed. You can post the order right after your clients leave your studio or home, and even after others have made orders from your Web site or by mail. Once the order is placed, you receive a confirmation via e-mail and final posting of your costs. You can then link the order and generate an invoice for your clients, as well as attach it to your client records.

The same convenience simplifies your album ordering and creation. Once you send the order to the lab, you can include album assembly choices which the lab then forwards to the album bindery or assembler. Or, you can place orders for albums and inserts simultaneously if you prefer to put the album together yourself. Some labs will even fulfill the

order direct to the customer and handle collections for you (usually via COD). Art Leather's Montage program is an impressive one for those who go the digitized route. Their software allows you to design an album on screen. It then prints an invoice of the completed job along with print orders, album orders and an album assembly guide. When coordinated with designated labs, you never have to touch the prints and you receive the finished album.

Keep an eye on quality control throughout the process and before you deliver the final work to your client. If you sent prints out for framing, give them the same scrutiny you use for work from your lab. Make sure matts are even and that no stray dust has settled under the glass. Check the surface of the prints to make sure no marks occurred during mounting. You should have agreed in advance on a damaged print policy. Most labs offer mounting services for large prints, and this is fine as long as prints aren't returned to you in the mail dog-eared. If you get too many bent comers-back, have the lab ship the prints unmounted in a tube and find a local framing service that can handle your needs.

Proof Sales

When you deliver the order to the client, they may offer to buy the full set of proofs, and the more savvy ones may even want to order the negatives. If you agree to do this, it might be better to wait six months to a year before you let them go. Waiting may result in further print sales; at that time they'll see the pictures anew and may order more. Even later on, perhaps a year or so, you might want to send a follow-up letter and offer to sell clients the full set of negatives. Though this eliminates the possibility of any further print sales, it does clear out your file and bring a little cash flow into your operation. Besides, after two years it's unlikely they'll be ordering more wedding pictures, although the follow-up letter might get you some offers for baby pictures.

Many labs have begun to offer long-roll archiving for reprints. ProShots labs will hold your film as long as you've agreed upon for reprint orders. This can save you a lot of storage space and worry. Reprints these days are more than just proof size or enlargements. Scanned images allow you to offer add-on sales, including creative thank-yous, screen savers, calendars and even CDs. Numerous services offer CDs with stills, voice-overs and even video clips. You can offer these products to your prime clients as well as to other wedding guests over the Internet. Creative marketing is the name of the game. Be sure to attend professional trade shows for the latest developments.

What if There's a Problem?

THINGS HAPPEN. There is a possibility that the lab may mangle, scratch, or even lose your order. Though it's rare with reputable labs (that's why it's *so important* to thoroughly check out a lab before you send an order), it does happen.

If these mishaps occur during the proofing stage, you're in trouble. Though some pictures can be retaken, most cannot. The whole wedding party can't be reassembled and made to act as if they're having a good time.

Professional associations offer wedding insurance policies, and they help pay for film, processing, cost of rerenting formal wear, and even a wedding cake. Though you can go through the motions, most clients will be very unhappy. Some pictures (such as bridal portraits) can be sal-

vaged to save the whole deal from going sour.

To protect yourself from such an unfortunate turn of events, it's essential to have a "release from liability" clause in your wedding contract. You will still lose money, time, and harm your reputation if film is damaged or lost, but at least you won't risk legal problems. Both the photographer and the client suffer when film is jeopardized. No lab wants this to happen either, for obvious reasons.

If negatives are lost or mishandled on your final print order, it's bad news, but not devastating if you at least have proofs in your hands that you can use to make copy negatives. If you had your work digitized by the lab first thing, you're covered. If the lab damages your negatives, you can always make a good copy negative from the digital file. To cover yourself up front, be sure to check out the lab's "lost and damaged negative policy" before you work with them, and at least be assured that they'll cover copy negative, digital recreation and print work if your precious negatives are lost or damaged.

If there is no way to reproduce the negatives, let the client know what's happening as soon as you find out, and spell out the options very carefully. It's probably best to return their money if disaster strikes, but determine what's appropriate for each individual case. Don't try to fool or conceal anything from the client—you'll just create more trouble for yourself down the line. The situation is sure to create grief for all concerned. Just be direct and honest and hope for some understanding.

Though the above is a worst-case scenario, it's all a part of the experience of being a wedding photographer. In a way, it's what makes the trade so real, so much a part of life. Ideally, you'll be able to share in the love and happiness of all concerned, and contribute something memorable to the most important event in a couple's life.

A Final Word on Digital

Professional photographers have long perceived digital imaging as a threat. That attitude has changed. While most weddings are still photographed on film (even though we're seeing more all-digital wedding coverage), digitization has offered wedding photographers a wide range of products and services that expand the potential for more sales. While the sky's the limit, digitization's main benefits are creative flexibility and speed. Using the Internet and working with forward-looking companies can eliminate written orders, extra paperwork and even negative archiving at your place of business. Photographers can also eliminate album assembly and inventory from their workload. In short, digitization allows more time for selling and creating images. And anything that eliminates paperwork must be praised. The digital revolution is a boon to wedding photographers, and the Internet will change the way commerce is conducted.

EQUIPMENT

requires mobile, portable equipment that also has the durability to handle heavyduty professional use. It must

also be capable of producing salable photographs, ones that meet high standards of sharpness and color rendition. Many manufacturers produce cameras, lenses, lights, and accessories for the demanding wedding trade, and although I'm not making any specific brand-name recommendations here, you should consider certain features before you purchase equipment. Special items should be included in your work inventory; the equipment checklist included in this chapter should help you keep track.

One cardinal rule pertains to wedding equipment: always have a spare. That goes for camera bodies, film backs, strobes, and especially cords and connectors. There seems to be an unwritten law that at every wedding a flash sync cord will malfunction, or that film will get jammed in midroll. Some of these problems can be prevented with maintenance, others result from the hectic nature of the job. For camera and strobe maintenance, check your instruction manuals; for pressure on the job, relax and have confidence in your instincts and knowledge.

Cameras

WITH THE PHENOMENAL GROWTH AND POPULARITY of wedding photojournalism, 35mm has at last entered the respectable realm of wedding equipment. Many photographers now use 35mm for almost all their "candid" photographs, and some even use it exclusively for coverage of the entire event. I believe 35mm films and lenses have improved to such an extent that they can be used for both purposes,

but that medium format should still be used for formals, portraits and even for candids. While there's no disputing the quality of today's 35mm cameras, there's also no argument that a larger negative will allow for bigger, sharper enlargements. The larger size of the medium-format negative allows for cropping, retouching, and yields tonal detail the 35mm just can't match. For that reason, I still recommend using both. Match the camera

Another point in the medium format's favor is that most custom labs are geared to handle wedding work from 120 and 220 film, and have their cropping masks and enlargers set for those sizes. Unfortunately, cropping too tight off a 35mm negative yields poor, grainy enlargements, and retouching is next to impossible on the miniature negative. Blemishes are fairly easy to remove from a medium format negative, and fairly substantial cropping still allows for quality enlargements.

format with the type of photography you are doing.

For 35mm, choose a camera based on the lens system and the flash exposure automation. Every major brand of 35mm camera has fast lenses as well as those that provide some sort of camera-shake protection when you get into slow shutter speeds. If the 35mm will be used for candids, get the lenses with the widest maximum aperture possible. While a f/3.5-4.5 zoom lens is certainly versatile, you'd be much better off with a fixed aperture of f/2.8. For fixed focal length lenses, follow the same guidelines. You can get a 50mm f/1.4 lens with most camera systems, and that extra stop or two of light will really come in handy for available light candid work.

Automated flash also comes in handy. Candids require you to work quickly and spontaneously and you won't want to fiddle with your flash at those moments. Get a flash system that allows for both ambient and flash compensation so you can control the light for more pleasing effects. Some systems also allow for TTL multi-flash exposure and a preflash system that guarantees a good exposure.

A number of medium-format cameras on today's market are ideal for wedding coverage. The differences between them are in the ratio of the height to width of negatives and the number of extra features that they have built-in. Some cameras yield a 6 x 4.5 cm negative, others a 6 x

6 cm negative, and some even a 6 x 7 cm one. Some units have interchangeable backs that cover all these formats, including the ability to handle 35mm film and Polaroid backs for testing. The 6 x 4.5 cameras tend to be the most lightweight; 6 x 6 cameras are the traditional workhorses. The 6 x 7 units are often a good choice for studio and tripodonly work, although many sturdy individuals have been known to carry them around for an entire

Words to remember: unless you have a spare, or know how to fix equipment on the spot, be prepared to find yourself at a wedding with no way of taking pictures, most of which could never be recreated.

wedding.

Aside from dependability, two other camera features are important for wedding work. One is the ability of the 35mm SLR camera to sync with a flash up to speeds of 1/250 second. High-speed flash sync is a creative necessity, especially when you're using daylight fill-flash techniques. Most times you'll be using flash with slower speeds, but having a fast shutter speed with flash allows more creative possibilities. Medium-format cameras generally allow you to sync at all available shutter speeds.

The other important feature for medium format users is an interchangeable back. This pre-loaded film cassette slips neatly onto the back of the camera. It's necessary because you can't always stop the action in order to reload film. Even though you'll get 30 exposures on a roll of 220 film with a 6 x 4.5 cm format camera, you may still face sequences of action during which you'll run out of film just as the event is reaching its peak. Though you'll often be able to plan shooting by counting frames as you go along, many times you may lose track. With interchangeable backs, you'll be able to clip another loaded film back on with no "break in the action."

An "optional necessity" for most wedding work is a motor drive with a remote cable release. Pros have gotten on for years without these units, but they do make portrait sessions smoother, especially if you like to roam while posing and setting up shots. Being able to walk away from the camera can also be a technique for relaxing subjects. They won't feel they're being examined under a microscope every time you shoot a picture. Motor drives are also useful for candid and action sequences, although winding film between shots is second nature to most photographers. For some techniques you should consider a radio trigger for your flashes. This comes in handy for hands-free second lights and special effects photographs.

Twin-lens, medium-format cameras are still available, although their popularity has declined with the widespread use of the more modern, eye-level viewing reflex cameras. If you choose one of the twin-lens models for your work (and their price, particularly on the used market, is quite attractive) make sure you get a model that can take interchangeable lenses, rather than one that relies on screw-on optics for wide-angle or telephoto shooting.

The latest medium-format cameras incorporate many of the features of advanced, electronic 35mms, including autofocus operation. These cameras have multi-mode automatic exposure, micro-processor-controlled functions, LED readouts, and integral motorized advance. More and more are coming with autofocusing as well. All of these marvels can be fun to play with, but they don't necessarily improve your results. As you'll see, wedding work doesn't require all these "bells and whistles"—it requires a photographer behind a dependable camera who has a sense of what makes a good picture.

Lenses

Three lenses are necessary for wedding work, with a fourth "special effects" lens that can be added as an option. The first is the "normal" lens, the one ordinarily supplied with the camera, usually an 80mm for $2\frac{1}{4}$ square formats and 90mm for 6 x 7 format. This yields an angle-of-view equivalent to the 50mm on a 35mm format. You'll probably be using this for the majority of your wedding work.

The second most-used lens is the wide-angle (usually around a 50mm on medium format and 28mm or 35mm on 35mm format), which helps when photographing large groups or getting an overall photo of the scene. You might be called upon to shoot very large family groupings at a wedding, and without the wide-angle you might have to go into the next room to get the shot. The wide-angle lens also aids in covering overall shots (such as a full picture of the church), and wherever movement is confined but you need to cover a lot of the action, such as the cake-cutting shots. Wide-angle lenses are among the greatest problem solvers in the wedding trade, but they shouldn't be overused, particularly with close-up portraits. You might inflate noses or enlarge hands more than you, and the bride, want.

Moderate telephoto lenses, such as 105mm for 35mm format and 150mm for medium format are also useful at weddings. They can be used for candids, portraits, and for shots around the altar while the ceremony is in progress. With a telephoto, all of your pictures can be taken without being obtrusive.

An optional lens for your wedding is a soft-focus portrait lens. These come in the standard portrait focal length (90mm for 35mm, 150mm for medium format). The best are those that allow you to dial in the degree of softness and may have a 1, 2 and 3 option, with the higher number yielding greater softening effects. True, you can use a soft or diffusion filter over the lens, but the dial-in softness effect of these lenses makes them much more efficient in practice. They can be used to make subtle changes to help cover blemishes or wrinkles, or to full effect for a more ethereal, romantic effect. They also can be used to break up hard highlights in a scene, or create halos around candles. Most are best used at around f/5.6, as too much stopping down tends to diminish the effect Of course, for those on a budget or just building their equipment, add-on filters can be used instead.

Lens Accessories

ALMOST EVERY EXPERIENCED PROFESSIONAL wedding photographer has a series of filters, diffusers, and vignetters in his or her bag of tricks. While some are best bought ready-made, others can be made from recycled filters that are floating around gadget bags of the past. If you're not in a do-it-yourself mood, you can buy all these effects filters in most camera stores.

Vignetters are used to give a soft edge to pictures and disperse the light around the edge of the frame. You can make a vignetter by taking an old UV or skylight filter and putting clear nail polish around the edge. Cutting out neutral density filter material and attaching it to the edges of the filter can make a dark vignetter, suitable for pictures of the groom and small groups of men. Different densities will yield lighter and darker effects.

Similarly, diffusers can be made of any number of translucent materials, including gauze, Scotch tape, stockings, or even by dispersing beads of clear nail polish over an old glass filter. Experiment and you'll find an amazing array of effects available with different types of translucent diffusers.

Other filters you might consider for your gadget bag are cross-stars, prisms, and diffractors, as well as any you see in the large filter catalogs available from various manufacturers. One word of caution: over the years, many of these filters have been overused, causing many of the pictures taken with them to look like worn-out clichés. Have filters available for the occasional shot, but don't make their use a tiresome habit.

A matte box system is one easy way to efficiently engage and change filters. With this system, a bellows attached to the front of the lens allows quick insertion of color correcting, diffusing, and special-effects filters, as well as block-out screens for in-camera double exposures and montages. You can also get block-out mattes in different shapes (such as keyholes and hearts), and give the resultant negatives to a custom lab for special print-in effects, such as sheet music or champagne glass montages. While still in demand in some areas, these effects may have seen their day. Montages can be interesting, but overuse is boring.

It's best to start with a few vignetters and diffusers and add from there. Although kits with hundreds of types of filters are available, the "straight" photo should be the heart of the wedding album. Just have the filters along should the right picture opportunity present itself.

Lighting Equipment

While the ideal situation would be to shoot every picture with natural light, many wedding shots must be taken indoors, often under poor or difficult ambient lighting conditions. On sunny days outdoor fill-in flash is necessary to help remove shadows. Inside, few churches have the illumination necessary for a good exposure—even if you use the higher speed films. And reception halls always need flash work.

Although we might like to work in natural light, strobes, power packs, cords, meters, stands, brackets, and all the other artificial light paraphernalia that adds so much weight to a wedding photographer's kit must be included in your day's baggage.

You should train yourself to work with two types of flash setup: formal, or off-camera lighting, and candid, or on-camera lighting. Off-camera lighting should be used for formal portraits of the bride, groom and family groups, and actually represents a mini-studio location lighting system. On-camera lighting is the unit that is attached to your can-

did, ceremony, and reception camera, and may also include a radio triggered or "slaved" second light placed on a stand or carried by an assistant.

The off-camera or mini-studio setup should consist of a key light, a fill light, and an optional background kicker powered by a slave trigger. The key light is the main light source, and consists of a flash tube powered by a power pack, or a flash tube power pack combined in one head. The light is mounted in an umbrella reflector or soft light box, which serves to disperse the light over the subject. Because of the high reflectivity of most bridal gowns, it's best to use a muted, rather than a super-silver reflector.

The fill light is of similar design, but the reflector should be smaller or the power output should be set lower than the key light. Most strobe heads have variable power output, and the settings should be verified by the use of a flash meter. For example, if the key, or main light, reads at f/8, the fill should read at f/5.6 for all other than special effects shots. This means that the fill is one stop lower than the key. Some lighting effects will call for a 1:3 lighting ratio, while certain dramatic effects may call for the elimination of the fill light altogether.

A slave-powered or radio remote strobe mounted on a small stand behind subjects can be used to even out backgrounds, give a glowing edge to subjects, or to eliminate shadows thrown by the other light sources. While the fill light and key lights are charged by power packs, the slave is usually a battery-powered unit that is set off by a light sensitive switch or radio signal. Light slave or radio remote units come in very handy and cut down on the cords needed for a job.

Reflector boards, flash diffuser heads, and soft boxes simplify and refine the lighting process, keeping the frontal lighting setup to a minimum. Many photographers overlight and use too many light sources for their work. This is fine if you have the luxury of a studio space, but location-shooting equipment should be kept to a bare minimum.

Reflector boards fill in shadow areas and bounce light wherever directed. They can be used when shooting in natural light as well, and will help to correct lighting ratios that might otherwise result in dark, uncomplimentary shadows. Reflector boards and discs come in all sizes. Reflectors can be clamped to light stands, leaned against furniture, or even held in people's laps during shooting. Diffuser heads, and especially soft boxes, have created a revolution in strobe photography.

Many manufacturers are offering portable, snaptogether units that make electronic light a soft, caressing type of illumination. Soft boxes come in squares, stars, and hexagonals, and they certainly improve upon strobe that formerly only came from a silver umbrella reflector. These strobe units lend themselves to wedding photography, just as the umbrella reflector is perfect for commercial work.

Along with lighting equipment, the mini-studio will require a sturdy, versatile tripod, cable releases (short and long), optional background paper, and paper stands, lighting stands, and any other accessories you've come to rely upon

in your formal shooting setup.

On-camera lighting consists of a portable strobe with an independent power supply. You can choose from one of two power supplies: one is to connect the strobe to a battery pack worn on a shoulder strap or a belt case; the other is to use rechargeable batteries that fit into the neck of the strobe itself. Some photographers prefer the rechargeable setup because it eliminates another cord to get twisted, while others like the battery pack because they know they'll always have power for their flash. With rechargeable or belt pack there's one rule: always have backups.

Lightweight strobes and those that mount directly on the hot shoe of the camera usually don't have the staying power of pro units. In addition, a strobe mounted too close to the lens yields too flat and direct a light, not the type of illumination we look for in wedding work. For that reason, the strobe is usually mounted on a bracket up and away from the lens. Some strobe mounts allow the flash to "move around" the lens, while others are fixed or can be moved slightly. Be careful of connecting cords on those navigable brackets. If you only have a shoe-mount flash, use a diffuser or some other device to soften the point source of light it delivers. Wedding strobes must have the capability to give bounce lighting—this means that the flash head flips up and down from straight ahead to a 90 degree angle.

Though many professionals still work with manual, dial-setting strobes, a whole new crop of high-tech flashes that work in conjunction with the in-camera metering system are now on the market. Many have auto-exposure features, green go-lights, and even LCD readouts of exposure calculations. You should definitely take advantage of this new technology, and use it to make more subtle pictures. Half of your battle is working with and manipulating light, and the new strobes certainly aid in this situation.

Light Meters

WITH ALL THIS LIGHT BOUNCING AROUND, there has to be a way to measure and balance it. Although many strobes are made with auto-exposure features, it's still necessary to carry along a handheld incident light meter. Most of these meters are made to read both ambient and strobe light and many have the capability to read cumulative (multi-pop) flashes. Many can also be used for cord and cordless flash readings. Use the light meter to check strobe power, to take outdoor and natural light readings, and to help you control lighting ratios. Remember to read from the subject position when doing flash and always test your meter before you go out on a job. These incident meters are an essential piece of gear, so learn how to use them well.

How much film is enough? That depends on the type of job you've booked and the extent of the wedding itself. The average wedding requires between 125 and 200 pictures, which gives room for bracketed and blown shots. Use of 220 film with medium format cameras and 36-exposure rolls with 35mm gear will require less film changing, but you should have a few rolls of 120 and 24-exposure and

Additional Accessories

With the lights, cameras, and action of wedding photography, a lot of equipment gets banged around and twisted up during a job. That sort of treatment necessitates two things: a sturdy set of bags and cases to protect the equipment, and two sets of everything that might snap, crackle, or pop.

Aluminum reinforced cases are excellent for carrying equipment, including the attaché case sized ones for cameras and the "stage hand" models for all the other gear. Wheeled caddies, like those used by veteran travelers for their luggage, are recommended for saving the neck and back muscles. Soft cases, made with the newest synthetic fibers, are excellent for on-the-job handling of lenses, film and cords. In addition, it's not a bad idea to have clothing with lots of pockets.

Always have extra batteries on hand, as well as modeling lights for strobes and even an extension cord with a grounded junction box outlet. (Somehow, they never have grounded outlets in catering halls.) Bring extra flash cords and slave-triggering mechanisms, and one or two extra oncamera strobes. Weddings are tough on equipment, so be prepared!

even 12-exposure 35mm film handy for those end-of-theday shots. A 6 x 6 cm camera will yield 24 shots per 220 roll, so ten rolls should be sufficient for the job.

The main reason professional color films are recommended is that these films are made to give optimum color balance at the time they're produced, and this should give you less variable results. Amateur films are meant to age, and their results can change greatly over time. When buying film, try to buy the same batch number, make sure the shop has them refrigerated; keep them in your cooler up until the day of your shoot, and have them processed immediately after exposure. Letting them sit around, or keeping them in the glove compartment until you get to the lab, will have dire consequences.

Negative film is the only way to go for weddings. Prints from negatives are still vastly superior to prints from slides, and the negative film captures a much higher tonal range than slide film. In addition, negatives allow a certain leeway in exposure; even if you're off a stop, you can still salvage a good print. Black and white has made a huge comeback in the wedding trade, especially for candids. Indeed, some weddings are now shot exclusively in black and white, a medium that had been ignored since the 1950s. Some photographers have even taken to working with infrared, very fast color negative films and other specialized film types.

The most widely used film speeds are ISO 160 for color negative and ISO 400 for black and white, although the latest ISO 400 color negative films have exceptional quality. This photographer's rule of thumb is to use the slowest film speed the shooting conditions will allow, thus insuring the best color rendition and sharpness. There are times, however, when you will want to break the rules for certain effects. This is a matter of personal taste and what the clients have in mind. If you plan to use exotic films or unorthodox speeds, show the client samples of this type of work before you use it.

Digital Imaging

THE CONTINUING IMPROVEMENT OF DIGITAL CAMERAS and sensors is beginning a trend toward using digital to cover at least part of the wedding day. Indeed, some photographers have ventured into all-digital coverage using high-end cameras and gear. I am not ready to recommend this, as film and film equipment still have the advantage and track record. This may not be the case in future editions of this book, but for now I still recommend sticking with film.

Digital can be very useful at a wedding by providing extra services and sources of income from novelty and event imaging products. Some photographers are bringing along digital cameras, computers and printers for the creation of party favors and takeaways. Prior to the wedding day, they create templates with the bride and groom's name, the wedding date and reception hall and make a series of portraits that can be created with drag-and-drop ease. Or they create instant thank-yous or other novelty items. Some even sell quick portrait images of people who are unlikely to order prints later.

Perhaps someday the digital camera will be the mainstream camera for wedding coverage. There will be very distinct advantages if it does, especially when it comes to finishing a print order. That day will come when digital can match film in leeway, quality and enlargeability. It will also arrive when professional photographers are convinced that it can deliver better images than their present equipment can now. There's no doubt that digital has already had a major impact on the print, album and even sales side of this business. Eventually it will become common in the photographing of the event as well.

As you work, you'll discover other types of equipment

and accessories that will help you complete your work to your satisfaction. This is on-the-job learning, and as your confidence and expertise grow, your gearbox may expand, or it may shrink to the essential tools of your trade.

The Checklist

PACKING FOR A WEDDING IS LIKE PACKING FOR A TRIP—you always seem to get to the hotel without a toothbrush. The following checklist will help keep track of the day's inventory. This list may evoke a number of reactions, the first being "How can I carry all that stuff around?" and the second being (if you're just starting out) "How can I afford all that gear?"

As for hauling gear around, this rather extensive checklist covers almost every situation you'll encounter at a wedding. As time goes on, you'll make up your own list, and add and subtract items as you see fit. Yes, there can be a lot of equipment at a wedding, and being organized will make a major difference in how it all works for you.

As for the second question, you don't need all the equipment listed to shoot a wedding, so don't despair if you can't go out and put down a few thousand dollars. You will need a medium-format or professional 35mm camera with a normal and wide-angle lens, a portable strobe with bounce capability, a few filters, and film. This, plus a light meter, should handle most of the situations pictured in this book. You can always rent equipment (such as a mini portrait-location kit) from dealers, and this might help you fill your equipment gaps when just starting out.

In other words, start with what you've got and build your equipment by reinvesting money earned. When buying equipment, don't get seduced by fancy hardware; wedding photography is not a high-tech scene. It's more about seeing and caring, and being able to make the best of the light and the settings, than it is about gizmos and fancy gear. The beauty is in your vision.

You do need basic, dependable tools and an understanding of their capabilities and limitations. Wedding work can be hectic—mastering your tools allows technique to give way to realizing and manifesting your vision.

EQUIPMENT CHECKLIST

	First Camera	Film
	Second Camera	□ 120 rolls
	3 220 backs	35mm rolls
	1 120 back	220 rolls
	1 50mm lens	
	1 80mm lens	Filters
	100mm soft-focus lens	
	1 135mm lens	☐ Diffusers
	(Equivalent for 35mm format)	☐ Vignetters
	1 motor drive	☐ Special Effects
	Lens and body caps	☐ Matte box with adapters
	ı standard cable release	☐ Block-out masks
	1 short cable release	Other Assessaries
	1 long cable release	Other Accessories
		☐ Background paper
Li	ghting	Grip clamps
	ı light meter	☐ Pinch clamps ☐ Tripod ☐ Lens cleaning tissue ☐ Air blower ☐ Step ladder ☐ Camera bag ☐ Cases ☐ Airport caddy ☐ Wedding contract and shooting checklist
	2 power packs	
	3 strobe heads	
	key light accessories	
	fill light accessories	
	umbrellas	
	soft boxes	
	radio remote	
	2 spare flash tubes	
	4 modeling lights	
	2 slave lights	Additional Items
	2 slave triggers	You may want to include safety pins, a needle and thread, hairpins, brush and comb, and other necessary "repair kit" items
	4 light stands	
	various reflector boards	
	2 portable strobes	
	kicker cards	
	2 strobe brackets	
	2 extra long sync cords	
	4 standard sync cords	
	3 sets batteries	
	2 belt battery packs	
	ı extension cord	
	2 chargers	
	1 extension cord with grounded outlets	
	2 pole stands	

INDEX

Affection, of couple, 28–31
After the ceremony, 74–87
Aid, enlisting of, 32
Aisle, coming down, 61–62
Aisle shot, after ceremony, 71–72
Album samples, 131–132
Appointment, 17–18
Architecture, of site, 76–77
Arriving at church, 60
Artificial light, 50–52
Assistants, 83
Atmosphere, candlelight for, 75
Attendants, posing bride and, 42–43
Available light. See Existing light

Before the ceremony, 32–53, 54–63 Best man groom and, 58 talking to, 55 Bindings, album, 131–132 Bouquet, tossing of, by bride, 116-117 Bridal veil, 24 Bride and attendants, 42–43 elegance of, 22–25 and father, 38–39 giving away of, 63 and maid of honor, 44-45 and mother, 36–37 nervous, 45 in outdoors, 98–99 tossing of bouquet by, 116–117 Business cards, 16

Cake-cutting ceremony, 118–119 Cameras, 136–137, 141 Candid moments, 68–69, 120–123 Candlelight, for atmosphere, 75 Cards, business, 16

Business side, 10-19

Celebration toast, 108–109 Ceremony after, 74–87 before, 32–53, 54–63 during, 64–73 Changeable light, 94–97 Checklist, equipment, 140, 141 Church arriving at, 60 portrait in, 74 Church light, 78–79 Closeness, family, 40–41 Coming down aisle, 61–62 Competition, 13 Components, of packages, 12–13 Contacting, of wedding site, 54 Contracts, 13–16 Copyright, 13 Costs, estimating of, 12 Couple, affection of, 28–31 Covers, album, 131 Cropping, 132 Curves, designing with, 47–49

Dance, first, 110–111
Daughter, father and, 38–39
Departure, graceful, 84–85
Designing, with lines and curves, 47–49
Digital imaging, 135, 140
Dressing for occasion, 35
"Dressing" shot, 34–35
During the ceremony, 64–73

Elegance, of bride, 22–25
Engagement portraits, 19
Enhancement
with light, 29, 37
through pose, 37
Enlargement samples, 131
Enlisting aid, 32
Environmental portraits, 88–103

Equipment, 125–127, 136–141
Estimating costs, 12
Exchanging
of rings, 66
of vows, 64–65
Exclusivity clause, 16
Existing light, 50–52, 67
Expression, honesty through, 112–113

Face to face presentation, 132–133
Family closeness, 40–41
Farewell, "final," 53
Father, bride and, 38–39
Filing, 129
Fill flash, outdoor, 99
Filling order, 133–134
Film, 141
Filters, 65, 141
"Final" farewell, 53
Financial records, 16
First dance, 110–111
Flash, fill, outdoor, 99
Flower girl, 46
Formal portrait, 20–31

"Garter" shot, 114-115 Getting started, 11 Giving away of bride, 63 Graceful departure, 84–85 Groom and best man, 58 nervous, 45 in outdoors, 100–101 reflections of, 56–57 style of, 26–27 and ushers, 59 Group photo, vs. table shot, 124 Group portrait environmental, 102–103 right after ceremony, 80-81 Guests, 124

H

Honesty, through expression, 112–113

J

Internet, 10–11 Introduction of newlyweds, 106–107

Labs, 128–129
Lens accessories, 137–138
Lenses, 137
Liability release, 13, 16
Light. See also Candlelight
artificial, 50–52
changeable, 94–97
church, 78–79
enhancement with, 29, 37
existing, 50–52, 67
Lighting equipment, 138–139, 141
Light meters, 139–140
Lines, designing with, 47–49
Location, wedding site, scouting of, 54

 \mathcal{M}

Maid of honor, bride and, 44–45 Marketing techniques, 16–17 Matte box, 77 Meters, light, 139–140 Mother, bride and, 36–37

M

Nervous bride and groom, 45 Newlyweds, introduction of, 106–107

0

Order, filling of, 133–134 Outdoors bride in, 98–99 groom in, 100–101

Payment clause, 16 Portable studio, 125–127, 136-141 Portrait(s) in church, 74 engagement, 19 environmental, 88-103 formal, 20-31 group, 80–81, 102–103 Posing techniques, 25, 37, 42–43, 102 - 103Presentation, 12, 132–133 Price lists, 12–13 Problem resolution, 134–135 Proofs, 129-131, 134 Prospecting, 10-11

Reception, 104–127 Records, financial, 16 Reflections, of groom, 56–57 Rehearsal, wedding, 54 Release, liability, 13, 16 Retouching, 132 Ring bearer, 46 Rings, exchanging of, 66

Sale
closing of, 18–19
completing of, 128–135
Sample book, 11–12
Samples, enlargement and album,
131–132
Scouting, 32, 54
Send-off, traditional, 82–83
Sequences, 86–87
Shooting areas, in house, scouting of,

Shot
aisle, 72–73
dressing, 34–35
"garter," 114–115
Site. See Wedding site
Special effects, 77
Special traditions, 70–71
Starting off right, 32–33
Stipulations, 13
Studio, portable, 125–127, 136–141
Style, of groom, 26–27

Time, value of, 12 Toast, celebration, 108–109 Traditional "garter" shot, 114–115 Traditional send-off, 82–83 Traditions, special, 70–71

Unruly individuals, 115 Ushers, groom and, 59

Veil, bridal, 24 Vows, exchanging of, 64–65

Web proofing, 130–131 Wedding rehearsal, 54 Wedding site, 54-87. *See also* Ceremony When to begin, 32 Work order, 13